WAR STORIES
A GRAPHIC HISTORY

WAR STORIES
A GRAPHIC HISTORY

MIKE CONROY

COLLINS DESIGN

An Imprint of HarperCollinsPublishers

First published in the United States and Canada in 2009 by

Collins Design
An Imprint of HarperCollins*Publishers*
10 East 53rd Street
New York, NY 10022
Tel: (212) 207-7000
Fax: (212) 207-7654
collinsdesign@harpercollins.com
www.harpercollins.com

Distributed throughout the United States and Canada by

HarperCollins*Publishers*
10 East 53rd Street
New York, NY 10022
Fax: (212) 207-7654

This book was conceived, designed, and produced by

I L E X
210 High Street
Lewes
East Sussex BN7 2NS
www.ilex-press.com

Publisher: Alastair Campbell
Creative Director: Peter Bridgewater
Commissioning Editor: Tim Pilcher
Managing Editor: Nick Jones
Art Director: Julie Weir
Designer: Jon Raimes
Design Assistant: Emily Harbison

Library of Congress Control Number: 2008943599

ISBN: 978-0-06-173112-9

Printed in China

First Printing, 2009

CONTENTS

FOREWORD

War comics?

Battle was my favorite. Thirty pages a week of smudgy black and white, with bad color on the covers and centerspreads. Printed on what seemed like recycled bog roll. Some of the best comic strips of all time.

It was British. Lasted from '75 to '87, though the glory days were done by '83. You got work by writers like Pat Mills, John Wagner, Tom Tully and—of course—Gerry Finley-Day. Artists like John Cooper, Joe Colquhoun, Mike Western, Ron Turner, Mike Dorey, Carlos Pino, Carlos Ezquerra, Jim Watson, Cam Kennedy, Eric Bradbury, Geoff Campion, Phil Gascoigne and Pat Wright. A hard list to beat.

You saw a lone, ragged Hurricane blasting its way across the Russian Front. English boys hanging on the barbed wire as German MGs swung to catch them, screaming that their Generals lied. Joe Darkie turning Tommies into demons. A strange little man digging his own grave in the Burmese jungle, inviting the Japanese army to climb in along with him. Otto Von Margen drinking ersatz coffee, waiting for the firing squad, telling an aging Wehrmacht jailer how it felt to lead a Panzer Army.

You read things like, *That's where she lies, lad. That wreck buoy marks her grave. Not much of a tombstone for a good little ship and eighty good men, but they wouldn't mind. You didn't expect frills on a corvette. You lived hard... you fought hard... and you expected to die hard.*

And it might just have made you curious. It might have made you pick up a book. Wherein you might have found out what the Royal Navy did at Dunkirk, and what went on between the *Jervis Bay* and the *Admiral Scheer*, and why the name PQ17 still has the power to make strong men tremble. You might have read about a kind of bravery that would humble you forever. One day, who knows, you might even have picked up a pen.

Here's an excellent look at some war comics just like *Battle*, each with the same power to spark the imagination, to send inquiring minds on their own journeys of discovery. The same kind of great art and great writing, applied to stories you wish there could be more of. The best way to go to war, really: ink on the page, and nothing more lethal than a papercut.

Enjoy.

Garth Ennis
New York City
December 2008

INTRODUCTION

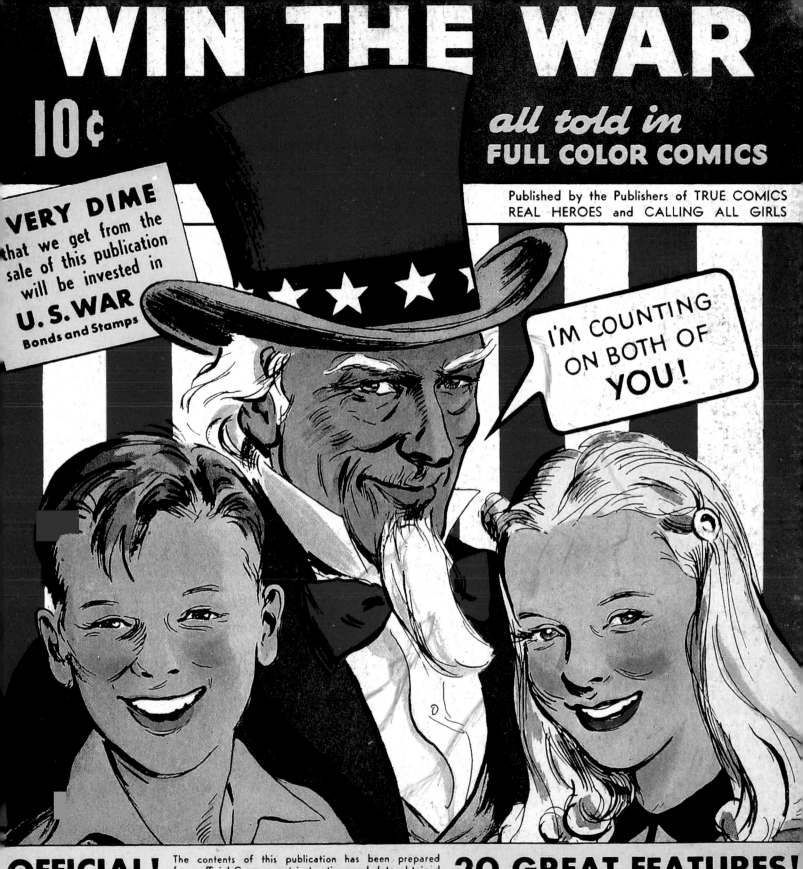

U.S.A.

is ready!

10¢

WAR, WHAT IS IT GOOD FOR? ABSOLUTELY NOTHING!!

So sang Edwin Starr back in 1970. But in arriving at the answer to his rhetorical question, he neglected to ask storytellers, balladeers, poets, and painters from down the ages for their opinions. If he had polled the likes of Homer, Mallory, Chris Collingwood, Mort Kunstler, Terence Cuneo, or even Alfred Tennyson, he might have reached a different conclusion...

Since before records began there have been those who recounted—and often exaggerated—the heroism displayed on the field of conflict by their fellow man.

The triumphs of Alexander the Great, Hannibal, Julius Caesar, Attila the Hun, Genghis Khan, Chaka Zulu, and other such great military leaders echo down the ages, as do Wellington and Nelson's victories over Napoleon's forces, Drake's weather-aided destruction of the Spanish Armada, and the American Civil War exploits of Grant, Jackson, Lee, and Sherman. Equally, the bravery exhibited by heavily outnumbered or out-gunned forces at Thermopylae, the Alamo, Rorke's Drift, the Little Big Horn, Camerone (the French Foreign Legion's Alamo), Balaclava, Gallipoli, and the sites of other monumental battles continues to resonate into the 21st century.

With the coming of cinema, movies began to tell tales of valor on the field of conflict and of the pain inflicted on those whose loved ones had gone off to war. Among the many were *The Birth of a Nation* (1915), *The Big Parade* (1927), *All Quiet on the Western Front* and *Hell's Angels* (1930), *The Dawn Patrol* (1930 and 1938), *Forty Thousand Horsemen* (1941), and *In Which We Serve* (1942).

From their beginnings as newspaper strips, US comics tended to shy away from the subject. Certainly it was not ignored entirely, as in, for example, Milton Caniff's *Terry and the Pirates*, where the backdrop was the Japanese invasion of China, although battles were never a focus in the early days. That reluctance may have been down to the medium—which had started out as an outlet for humor—initially being considered too superficial a platform to address such a heavy topic for an audience still recovering from the tragedy of World War I—the war to end all wars.

Then came comic books. Initially simply reprints of newspaper strips, the format proved such a huge success that within two years it began requiring original material.

Influenced by genres popular in the movies and the pulp magazines, publishers urged writers and artists to produce Westerns, stories featuring detectives and funny animals, or tales centered on sports. Following the trend set by the strips, new tales of adventurers and aviators were also created to feed the voracious demands of the new format.

In 1938 Jerry Siegel and Joe Shuster's Superman debuted in the historic *Action Comics* #1. A new genre was created with the super-powered alien's instant and huge success, changing the face of comic books forever. Costumed crime-fighters had been around for several years both in the pulps and comics, but superheroes were the new big thing and, as time would attest, no passing fad.

Every publisher wanted their own roster of superheroes, but these new four-color heroes did not drive other genres into extinction. In fact, their enormous popularity was good for the medium as a whole. Comic books flourished as a side effect, and war stories, which were already creeping into the anthologies—Eastern Color's *The Battle of Manila Bay* (a historical one-pager in 1936's *Famous Funnies #22*) being an early example—started to gain in popularity, as evidenced by, to name but three, K-51 (a US spy fighting the Germans in Occupied Europe, beginning in Fox Features' *Wonderworld Comics* #3, 1939), Speed Martin (an ace newsreel cameraman who filmed the war and fought it, too; first seen in Dell's *The Funnies* #45, 1940), and American Ace. A skilled pilot-cum-mining engineer who gets involved in a war between two small European countries, he made his 1939 debut in Timely's *Marvel Mystery Comics* #2. There were also titles like MLJ's *Top-Notch Comics* (1939), Hawley Publications' *Sky Blazers* (1940), and Key Publications' *Flying Aces* (also 1940), which showed a decidedly martial bent.

The growing number of series with a war setting was in part a reaction to the war in Europe. Numerous comics creators were Jewish, and more aware than the majority of Americans of the nightmarish acts being perpetrated on the other side of the Atlantic. Hitler and his Nazis became major villains with, for instance, Joe Simon and Jack Kirby (born Jacob Kurtzberg) famously depicting Captain America socking Der Fuehrer on the chin on their cover to the

1941 first issue of *Captain America Comics*, which introduced the patriotic Timely superhero.

By the time Cap slugged Adolf, however, Dell had already premiered the first comic book entirely devoted to war. The aptly titled *War Comics* hit the newsstands in early 1940, bringing with it a diverse roster of characters that included Sikundar the Robot Master, Sky Hawk, and Scoop Mason, War Correspondent. It also featured nonfiction, with the first issue focusing on *Scapa Flow* and *Lt. Frank Luke, World War Ace*. The series, which became *War Stories* with #5, lasted only eight issues, but it had served to establish a beachhead. In its wake came a small flotilla of military-themed titles, among them *Wings Comics* and *Fight Comics* (Fiction House, 1940) and *Liberty Scouts Comics* (Centaur, 1941).

Then, on December 7, 1941, the Japanese attacked Pearl Harbor.

Suddenly the US was at war, and comic book superheroes flocked to do their four-color bit, while publishers rallied to the flag—or at least the newsstands—with titles like *War Heroes* (Dell, 1942), *Devil Dog Comics* (Street and Smith, 1942), *United States Marines* (Magazine Enterprises, 1943), and Simon and Kirby's *Boy Commandos* (National Periodicals, 1942). They joined *Military Comics*, *Rangers Comics*, and *Air Fighters Comics*, which had been launched in 1941 by Quality, Fiction House, and Hillman respectively.

True Aviation Picture Stories, *True Comics*, *Real Hero Comics*, and such other nonfiction series took to including real tales of bravery in combat, and was also the focus of Dell's aptly titled *War Heroes*.

Harvey, in collaboration with the US Treasury, published *War Victory Comics*, a 1942 title that promoted savings bonds with all profits going to USO and army/navy relief funds. The first issue—reprints of newspaper strips with nary a soldier, sailor, or airman in sight—was followed by two more, a year apart. Re-titled *War Victory Adventures*, these had more affinity with their military purpose, 1943's #2 including a retelling of the Battle of Stalingrad.

In a similar vein was Parents' Magazine Press' *How Boys and Girls Can Help Win the War*. Proceeds from sales of this 1942 one-shot were also used to purchase war bonds.

Public service comics aside, the vast majority of early 1940s war comics were gung-ho, jingoistic, and—at least in their depiction of the Japanese—blatantly racist to 21st century eyes. But they gave the public what they wanted and were extremely popular during the war years.

Post World War II, comic book sales in general faltered, with the popularity of superheroes in particular taking a nosedive; the heroism and sacrifice of the armed forces over the past three years or so had paled the adventures of the costumed crime-fighters into insignificance.

War comics still soldiered on but now many of the stories were written and drawn by men who had really seen action. As a result, the over-the-top antics—while not totally absent—were supplanted by a somewhat more realistic approach to war. Still mainly far from true-to-life, they did at least eschew the "fun and games for boys" approach in favor of trying to impart the hardship and tragedies that conflict can visit upon soldiers, seamen, and aviators, especially when fought with mid-20th century weapons of mass destruction.

Much as the later Vietnam War would cause a sea change in attitudes toward war comics, so the advent of the police action that came to be known as the Korean War provided an almighty boost to what was fast becoming a moribund comic book genre. Far more than World War II, it provoked publishers into producing a legion of comics, with series and one-shots aplenty coming from Fawcett, Toby, St. John, Avon, Harvey, Superior, Ajax Farrell, Dell, Quality, and others. Among the many titles launched during the first half of the 1950s were *Soldier Comics*, *Monty Hall of the U.S. Marines*, *Tell it to the Marines*, *U.S. Marines in Action*, *With the Marines on the Battlefronts of the World*, *With the U.S. Paratroops Behind Enemy Lines*, *G.I. Joe*, *Fighting Fronts!*, *United States Fighting Air Force*, *Fighting Undersea Commandos*, *Fighting War Stories*, *Fighting Leathernecks*, *Battle Cry*, *War Battles*, *G.I. Combat*, *Battle Heroes*, *True War Experiences*, and *Yanks in Battle*, to name but a few.

Atlas (now Marvel Comics) entered the fray with myriad titles, among them *Marines in Action*, *Battle*, *Battlefield*, *Young Men on the Battlefield* (formerly *Cowboy Romances*), *Battlefront*, *Battleground*, *War Comics* (unrelated to the Dell title), *Combat Kelly*, *War*

▶
Maurice Whitman, *Fight Comics #82,* **Fiction House, 1952**

▶▶
L. B. Cole, *Captain Flight Comics #7,* **Four Star, 1945**

▶▶▶
Everett Raymond Kinstler, *With the U.S. Paratroops Behind Enemy Lines #4,* **Avon, 1952**

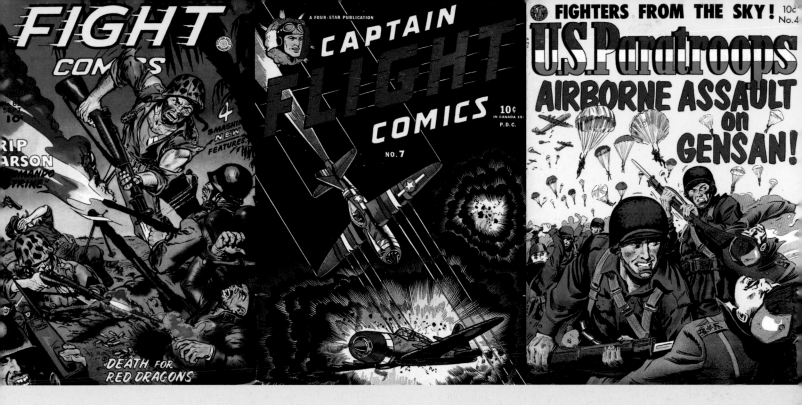

Combat, and Combat Casey, while DC Comics fought back with Star Spangled War Stories, All American Men at War, Our Fighting Forces, Our Army at War, and G.I. Combat, which it acquired from Quality in 1957. But the most prolific of war comics publishers in the 1950s was Charlton, which held on to the crown well into the next decade via a battalion of titles that included some inherited from Fawcett, Toby, and St. John. Among those on the Derby, Connecticut-based publisher's roster were Soldier and Marine Comics (later Fightin' Army), Fightin' Marines, Fightin' Navy (formerly Don Winslow of the Navy), War at Sea, Army War Heroes, and Fightin' Air Force.

Then there was EC Comics. The company published just three titles, but is acknowledged as the supreme champion of war comics in the 1950s. Spearheaded by Harvey Kurtzman, the intensely researched and immaculately drawn Aces High, Frontline Combat, and Two-Fisted Tales took a very down-to-earth approach to the topic. They are regarded as the cream of the crop.

The launch of new titles slowed dramatically through the late 1950s and into the 1960s. Anthologies were still the staple format but recurring characters were coming to the fore, especially at DC, where such war comics veterans as Robert Kanigher, Joe Kubert, and Russ Heath were among the creators introducing

the likes of Sgt. Rock, the Haunted Tank, the Unknown Soldier, Balloon Buster, Johnny Cloud, Captain Storm, and even Enemy Ace. While some of DC's war heroes ultimately graduated to their own comics, for its part Marvel threw its World War II stars straight into the newsstand frontline via the over-the-top Sgt. Fury and His Howling Commandos and the later Combat Kelly and the Deadly Dozen.

But with the specter of the Vietnam War hanging over the nation, the US public's attitude to conflict was changing, and comics began to reflect the new zeitgeist. Kubert, now editing DC's war titles, took to signing off the stories with "make war no more," while Warren launched its staunchly anti-war Blazing Combat—a successor to Kurtzman's EC comics, replete with authentically drawn and researched stories—to much critical acclaim but limited commercial success. Overall the comics industry adopted a more somber tone in its war books, but the genre was losing its appeal.

One by one the titles fell by the wayside until the last of them was gone by the end of the 1980s.

British comics publishers took a more serious approach to war almost from the outset. Sure, there were the outrageous antics of such characters as Captain Hurricane but, in the main, the stories were far less gung-ho and far more grounded in reality than their US counterparts.

Often real life stories of valor and sacrifice were chronicled without any sensationalistic bravado, and the fictional tales frequently featured armed forces personnel getting into scrapes or concerned themselves with class struggles, with ordinary Tommies coping with cowardly officers or bullying NCOs as often as they were fighting "Jerries."

Themed anthologies were rare among British comics—which, unlike their colorful transatlantic cousins, were mainly black and white weeklies rather than monthlies—and war stories sat alongside other two, three, or four-pagers that focused on sports (often soccer, cricket, or athletics), Westerns, or action/adventure. The exceptions were the 64-page digests. Issued monthly beginning in the 1950s, *Air Ace Picture Library*, *War Picture Library*, *War at Sea Picture Library*, *Commando*, *Battle Picture Library*, and other similar pocket-sized comics featured single 60-page stories covering all aspects of warfare in a realistic—albeit bloodless—fashion.

DC Thomson launched *Warlord*, Britain's first weekly title dedicated to war, in 1974, and IPC returned fire with *Battle Picture Weekly* six months later. Both took a more dramatic and downbeat approach to combat than was usual in British comics; the latter featured what has become a benchmark for war comics—Pat Mills and Joe Colquhoun's highly acclaimed World War I saga, *Charley's War*.

As in the US, however, changing tastes led to the demise of virtually all British war comics. With more than 4,000 issues under its belt, DC Thomson's *Commando* soldiers on, but it is the sole survivor.

On the other side of the Atlantic, war comics are now few and far between. Sgt. Rock resurfaces occasionally to continue fighting World War II, while the likes of the Unknown Soldier and the Haunted Tank have received recent makeovers, which have placed them in the midst of 21st century conflicts (in Uganda and Iraq, respectively).

Many consider war an innate part of human nature. While we continue to feel the urge to settle our differences with aggression, it will always be with us. So will war comics, which celebrate war's triumphs and spotlight its tragedies; especially with Joe Sacco and his peers utilizing comics to report on contemporary events with a journalistic eye.

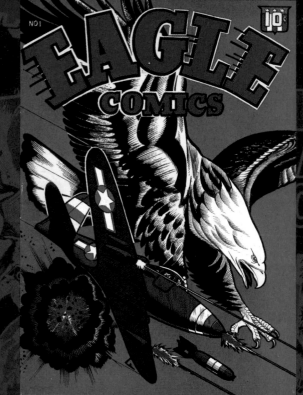

L. B. Cole, *Eagle Comics* #1, Rural Home, 1945

Battle Picture Weekly, IPC, September 1976

By its very nature, this book is not an encyclopedic look at the field. Instead, consider it a primer, an introduction to a comic book genre that has as much to offer as any other, but is often overlooked by the public's constant and overwhelming demand for the superheroes that dominate the medium.

From Spartans and Roman legions, through Medieval knights, to the opening up of America; from pirates and buccaneers, through the Napoleonic Wars, to the catastrophic events of World War I; from the Spanish Civil War, through World War II and the Korean War, to the Vietnam War, and on to today's war against terror and the conflicts in Iraq and Afghanistan, the book you hold in your hand is a potted overview of man's blood-soaked trail from his primitive beginnings to his current "civilized" status.

Mike Conroy
Erith, Kent, UK
December 2008

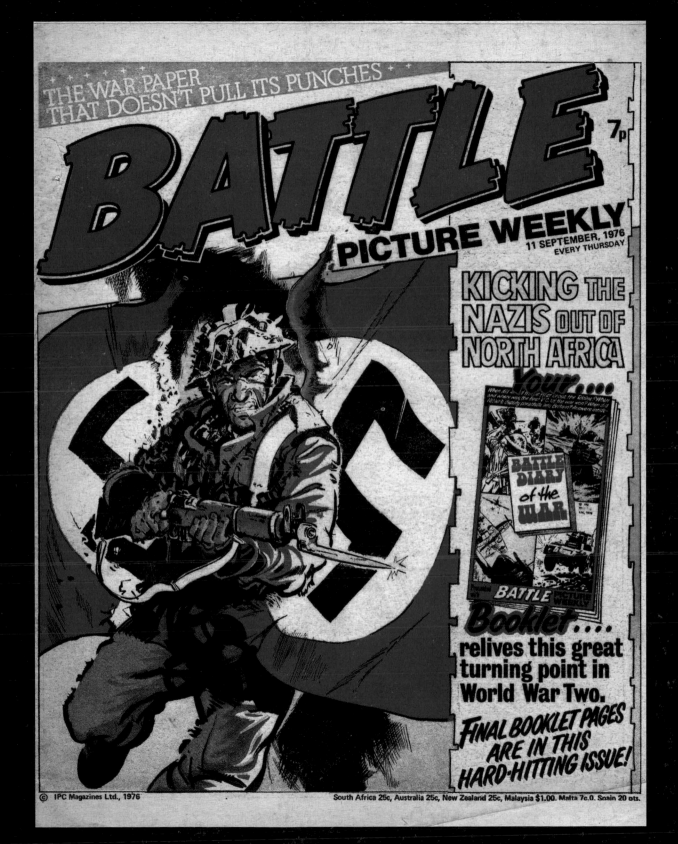

HISTORICAL HOSTILITIES

WHEN DEATH WAS PERSONAL

War, conquest, and mayhem of various kinds are the natural state of man. So advocate assorted philosophers, and a look back through the conflict-strewn history of mankind would suggest they may well have a point.

Certainly the 20th century was blighted by global hostilities, and the huge scale and relatively contemporaneous actions of World War II in particular meant that many of the comic books of the postwar era naturally focused on that particular conflict.

But while the general public had a fascination with the battles against the Axis Powers, writers and artists have certainly not overlooked more historic actions; conflicts where death came by sword, lance, or arrow, and the chances were you would stare into the eyes of those you slaughtered—or, if your god deserted you, the one who took your life.

Foremost among the storytellers who have delved into the time when warriors fought hand-to-hand is Frank Miller, whose *300* (Dark Horse, 1998) was a retelling of the Battle of Thermopylae. Fought in 480 BC, this epic clash saw around 5-6,000 Greeks led by 300 Spartans stand against an invading Persian army said to number approximately a quarter of a million soldiers. The tale—and Miller's telling—proved potent enough to inspire a 2006 movie adaptation, which through extensive use of CGI retained the blood-spattered feel of the comic book.

The encounter was also the subject of *Lion of Sparta*. Drawn by Gerald McCann, this adaptation of 1962's *The 300 Spartans* film was released as Dell's *Movie Classic* #439. Another version of the battle appeared in Warren Publishing's *Blazing Combat* #4 in 1966, in an eight-page strip, *Thermopylae!*, written by Archie Goodwin and drawn by Reed Crandall.

Far more ambitious in its scope is *Age of Bronze*. Launched through Image Comics in 1998, *Age of Bronze* is Eric Shanower's epic retelling of the legend of the Trojan War. Intending his series to run to seven volumes (approximately 70 issues), the writer/artist is working to remain true to all literary traditions, encompassing everything from Homer's *Iliad* to Shakespeare's *Troilus and Cressida*, as well as to the archaeology of the Bronze Age Aegean. Gaining plaudits and praise for its serious-minded and scholarly approach to the period, the series also benefits from believable characterization and clear and compelling artwork.

A truncated version of the Trojan saga also appeared in 1956's *Helen of Troy* (a.k.a. Dell's *Four Color* #684). Drawn by John Buscema, it was an adaptation of the previous year's movie of the same name.

Many other creators have explored beyond the Grecian campaigns, with stories of Roman legions, Viking raiders, and medieval knights appearing in comics as varied as *Classics Illustrated*, *Two-Fisted Tales*, *Weird War Tales*, the starkly titled *War*, and even the World War II-centric *Commando*. Modern warfare may be the 800-pound gorilla in the comic book room, but at least the ancients got a fair share of the action.

◄ A horde of barbarians—the "uncivilized scum" that gave their name to modern-day perpetrators of acts of senseless destruction—sweep along the African coast in a scene from *Pigs of the Roman Empire*. Illustrated by John Severin and Will Elder, the story appeared in EC's *Two-Fisted Tales* #21, May 1951.

►► In the wake of the Persian army's final assault, the arrow-riddled bodies of King Leonides' Spartans litter the battlefield at Thermopylae, in *300*.

►▲ When all else fails... throw something! It's pirate versus Trojan in a dramatic scene from *Sacrifice*, published by Image Comics in 2004, the second book of *Age of Bronze*, Eric Shanower's multi-volume saga of the Trojan War.

► From *300*, Frank Miller's dramatic visuals portray the power of a phalanx of Spartan hoplites bracing themselves for the Persian attack. Miller's strong black and white artwork was viscerally painted by his then-wife, colorist Lynn Varley.

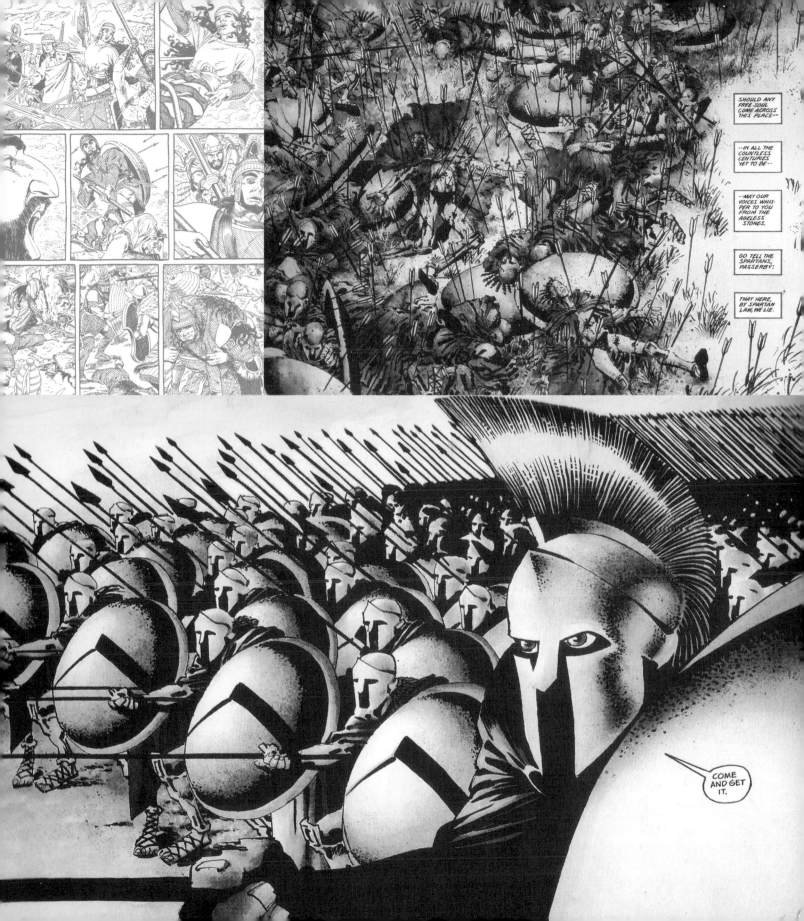

SLINGS AND ARROWS

Written by Aryeh Mahr and published in two volumes by Mahrwood Press in 2005 and 2006, *Nagdila* unfolds the life of Rabbi Shmuel HaNagid. He was a poet, warrior, and philosopher, and among his thoughts on war comes "at first war resembles a beautiful day. We all want to enjoy and achieve. Later it's a raging storm that makes us be bitter and grieve." It's a truism that survives the millennium since he wrote it.

The Jewish Nagid become Grand Vizier of a substantial portion of fragmented 11th century Spain under an Ottoman Sultan, successfully putting down military rebellions fostered by his rivals. Spanish artist Estève Polls produces painted battle scenes in *Nagdila* the likes of which haven't been seen since the glory days of 1950s British boys comics.

Among the highlights of those British boys' stories there was *Wulf the Briton* in *Express Weekly*. Artist Ron Embleton didn't start the series, but when assigned it in 1957 and given the opportunity to paint his pages, his art flourished like never before. Wulf and his band of raiders were engaged in the thankless task of running the Romans out of Britain.

Heros the Spartan ran in UK boys' title *Eagle* from 1962-1965. Abducted from Sparta as a boy, Heros was raised as Roman senator's son, enlisted in the Roman army, and shipped off to Britain. Once there he spent as much time fighting eerie fen denizens as he did putting down rebellions. Written by Tom Tully, it's the meticulous draftsmanship of Frank Bellamy for most of the run that renders the strip memorable today. Other similar historical British strips include Don Lawrence's *Karl the Viking* (*Lion*; 1961-1964) and *Wrath of the Gods* (*Boys World/Eagle*; 1963-1964), and *Black Axe, the Saxon Avenger* by Tom Kerr, which appeared in *Buster* from 1960 to 1965.

Embleton was excellent and Bellamy exceptional, but the master of portraying ancient warfare was Hal Foster in the pages of his lushly drawn *Prince Valiant*. Set in Arthurian times, the story unfolded in US newspapers at the rate of one Sunday page per week over 40 years, with war but a part of a complex saga. Among other conflicts, Valiant was involved in castle sieges, full-blown battles on horseback, naval campaigns, and an early crusade. An episode on the sacking of Rome in the 5th century contained one of

Foster's rare errors, with the Visigoths landing on the Tigris River—actually in Iraq—rather than the Tiber.

The battle between the heavily outnumbered united tribes of Israel and the Philistines has been a favorite in Old Testament adaptations. Don Cameron's 1946 version from the second issue of DC's *Picture Stories from the Bible* set the tone, and more recently David versus Goliath was adapted by Mike Baron and artist Tom Artis (as Tomasina Cawthorn Artis) in *Amazing High Adventure* #5 (Marvel, 1986).

In 1955, EC Comics devoted an entire title to the days of ancient struggles, when death on the battlefield was up close and personal. The stories in the five issues of *Valor* ranged from Roman gladiatorial combat to 18th century revolutionary France, taking in the chivalry of the Middle Ages, 12th century China, and the might of the Incas. Copious research resulted in a wealth of historical detail meticulously rendered by an enthusiastic collection of master artists.

▶▶
Raulo Caceres illustrated the Warren Ellis-written *Crécy*, published in 2007 by Avatar, which depicts one of the most important battles from the Hundred Years' War, where new weapons and tactics marked the beginning of the end of chivalry.

▼
Wally Wood illustrates how archers destroyed the flower of French chivalry and turned the Battle of Agincourt in favor of the English army led by King Henry V; from *Massacre at Agincourt!*, *Two-Fisted Tales* #22, EC, 1951.

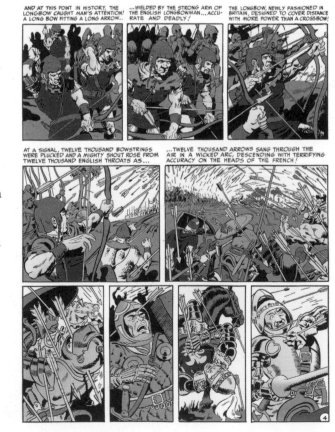

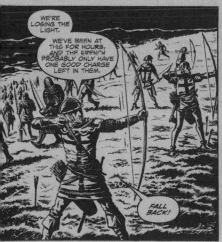

WE'RE LOSING THE LIGHT.

WE'VE BEEN AT THIS FOR HOURS, AND THE FRENCH PROBABLY ONLY HAVE ONE GOOD CHARGE LEFT IN THEM.

FALL BACK!

▲ ▶
At the Battle of Crécy, the outnumbered English army defeated the French through use of the longbow, which, while less technologically advanced than the French crossbows, had greater range.

THIS IS THE STORY OF ENGLAND'S GREATEST BATTLE.

A highly trained but under equipped army invades another country due to that country's perceived threat to home security. The army conducts shock-and-awe raids designed to terrify the populace. This army is soon driven to ground, and vastly outnumbered. The English army has to stand and fight, in Crecy, France. On 26 August 1346, modern warfare changed forever. An original graphic novel from Warren Ellis and his Apparat line of books with artwork by Raulo Caceres.

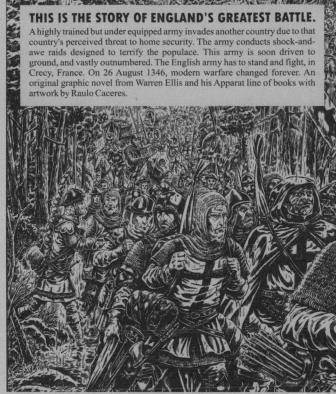

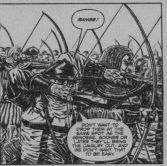

RANGE!

DON'T WANT TO DROP THEM AT THE SAME SPOT AS THE GENOESE. SOONER OR LATER THEY'LL BRING THE CAVALRY OUT, AND WE DON'T WANT THAT TO BE EASY.

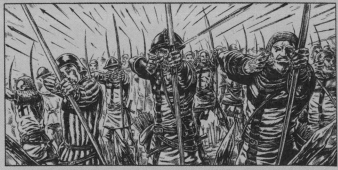

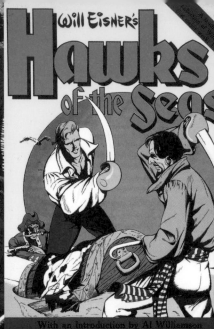

WILL EISNER'S
Hawks
of the Seas

With an Introduction by Al Williamson

▲ Will Eisner's weekly *Hawks of the Seas* (created as Willis B. Rensie) was published all over the world from 1936-1938. This Kitchen Sink collection appeared in 1986; Dark Horse Comics later repackaged the collection in 2003.

◄ Reed Crandall created this fine illustration for issue #27 of *Buccaneers*, published by Quality in 1951.

▼ Working under a variety of pen names (and in various styles), Jack Kirby produced a number of newspaper strips for Lincoln Newspaper Syndicate in the late 1930s, including the swashbuckling *The Black Buccaneer*.

GOOD MORNING DAVY! I HAVE SOME GOOD NEWS FOR YOUR SISTER AND YOU.... I'M LEAVING FOR THE WEST INDIES SOON! I WANT YOU BOTH TO COME WITH ME!

GOSH! I'D LIKE TO GO ALONG!

THIS IS INTERESTING NEWS! LITTLE DAVY'S DREAM OF AN OCEAN VOYAGE HAS COME TRUE AT LAST!

104

I HOPE FAITH AGREES! AN OCEAN VOYAGE WOULD DO YOU TWO A WORLD OF GOOD!

—AND SO MISS FAITH, YOU'D MAKE AN OLD MAN HAPPY IF YOU WOULD TRADE THIS DISMAL INN FOR A BLUE SKY AND BRINY SEAS

IT WOULD BE WONDERFUL, I KNOW. BUT SQUIRE WIGGINS THIS IS ALL SO SUDDEN I-I DON'T KNOW WHAT TO SAY!

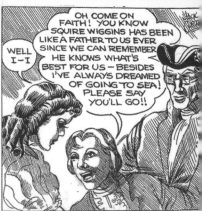

OH COME ON FAITH! YOU KNOW SQUIRE WIGGINS HAS BEEN LIKE A FATHER TO US EVER SINCE WE CAN REMEMBER HE KNOWS WHAT'S BEST FOR US – BESIDES I'VE ALWAYS DREAMED OF GOING TO SEA! PLEASE SAY YOU'LL GO!!

WELL I-I

WAR ON THE HIGH SEAS

War takes many forms, and for centuries it was possible for a hardy crew with a single ship to pillage any other vessels they encountered. Given the larger than life characters, the rollicking adventure, and the ingredients of violence, grog, women, and dubloons, it's surprising how infrequently pirates feature in comics.

Combining their intensive historical research, artistic detail, and cracking good stories, 1954's *Piracy* was seven issues of cutlass waving, eye-patch wearing, cannonball blasting bombast. Unfortunately, the application of Comics Code censorship midway through the run reined in the exuberance when dealing with a subject that united EC's twin obsessions: historical realism and horror. Jack Davis, Wally Wood, and Al Williamson contributed to early issues, but the mainstays were Graham Ingels, Bernie Krigstein, Reed Crandall, and George Evans. Ingels was solid, and Krigstein drifted from the traditional to near abstract stylings, but Crandall and Evans were visibly enthused by the historical material.

Crandall's stories were largely biographical, detailing incidents from the lives of Ben Avery, Blackbeard, and Jean Lafitte, among others, his art heavily influenced by classic illustrators working 60 years previously.

"Because of the trappings needed to create the atmosphere and authenticity," Evans recalled, "*Piracy* was the most difficult to do." His stories concerned naval cruelty, ghastly occurrences at sea, and desperate men in desperate situations.

Piracy was artistically superior, but credit where it's due; the template of mixing biography and adventure had been created by Hillman's *Pirates Comics* in 1950 (and is perpetuated to this day in Richard Becker's self-published *Bloodthirsty Pirate Tales*). The first issue was decently drawn before standards slipped. In the regular features *Alpha the Slave Pirate* battled Romans in 52 AD, while youngster Philip Ashton uncovered rogues at the Spanish court in 1492.

Veteran action comics writer Chuck Dixon was quick to appreciate the current appeal of pirates. *El Cazador* ("The Hunter") was released shortly after the first *Pirates of the Caribbean* movie opened in 2003 and provided Crossgeneration

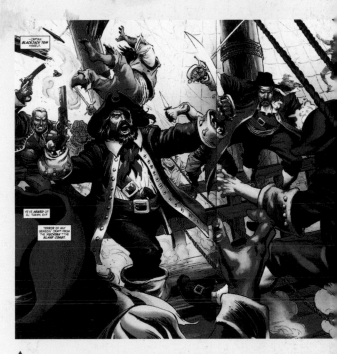

▲
El Cazador's rollicking blend of rogues and buccaneers, with even a lady pirate thrown into the mix, was a hit for Crossgeneration Comics in 2003, drawn by the talented Steve Epting.

Comics with their fastest selling debut issue. A 2002 SLG Publishing six-parter by Ken Knudtsen, *My Monkey's Name is Jennifer*, deserves a mention for attempting a pirate musical in comics and throwing a chimpanzee into the mix, but the best pirate comic of recent years is Christophe Blain's *Isaac the Pirate*, released in two English language volumes by NBM. An artist is captured by pirates and forced to cover their exploits when they discover his talent. He travels the globe, witnessing horror and joy amid a life he never expected.

For pirate action at its grossest, though, S. Clay Wilson is your man. *Captain Pissgums and His Pervert Pirates* appeared in several issues of *Zap Comix* (launched in 1968 by The Print Mint), and even among company used to raising hackles Wilson goes that extra mile, ticking every box on the offensive chart with barely a panel suitable for reproduction in a family book.

THROUGH EUROPE WITH BONEY

For such a pivotal figure, Napoleon's achievements have been given scant regard in English language comics. If nothing else, however, taken together, they display the man's astonishing impact on global affairs. Parents' Magazine Press' wholesome 1942 series *True Comics* served up slices of history to educate and entertain American boys during the 1940s. Artist Willner McArdle detailed the Battle of Waterloo in six pages in issue #2, and 44 issues later its *Cavalcade of England* series briefly covered the Napoleonic Wars. Issue #78 featured Napoleon in their snappily titled *Little Known Facts about Famous People* series, marching his troops across Europe at speed to defeat the unprepared Austrians.

Max Bravo, the Happy Hussar achieved the notable feat of making the Napoleonic campaigns his personal playground. Max was fooled into signing up, but once in the army he outwits Troop-Sergeant-Major Slashtrap, and far from being cannon fodder, rises through the ranks to befriend Napoleon himself. Written by Mike Butterworth, Max ran in Amalgamated Press' *Sun* comic (no relation to the British newspaper) for a credible three years between 1954 and 1957, and in 1961 was revived in Hutton's *Swift* for a further three-year run. One of the most notable of assorted artists was Sergio Tarquino, better known in Italy for his Western strips.

A more downbeat connection between youths and Napoleonic armies is Al Weiss' story in the 1985 second issue of Marvel's *Amazing High Adventures*. In this tale, drunken soldiers take a liberty too many in a gypsy camp. Napoleon himself features in #3,

▼
Best known in Britain for his covers for the *Sexton Blake* novels, Eric Parker illustrated this episode of *Max Bravo*, which originally appeared in *Sun*, although this version, reprinted in *Swift*, boasts much more vivid coloring.

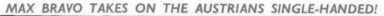

An Officer in the 5th Hussars of the French Army

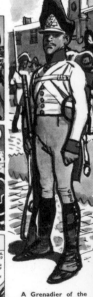
A Grenadier of the Austrian Army fighting the French in Italy

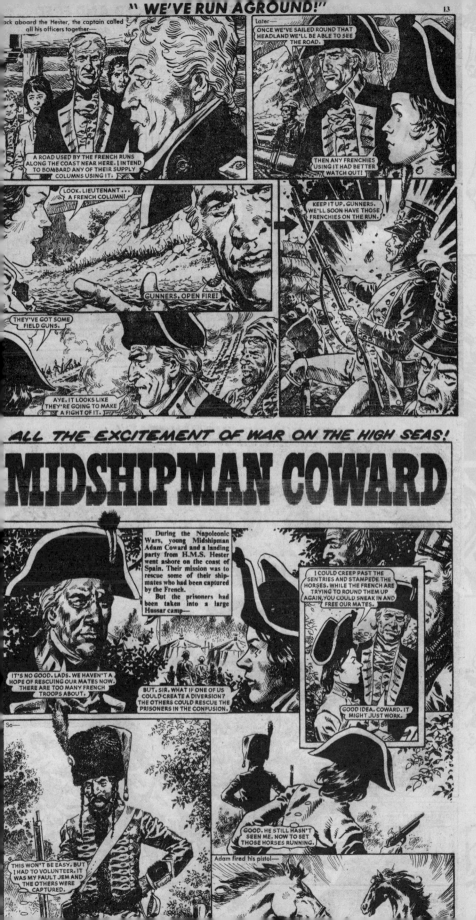

ALL THE EXCITEMENT OF WAR ON THE HIGH SEAS!

MIDSHIPMAN COWARD

personally intervening to quell the superstitions of his troops during their Egyptian campaign.

Not featuring Sherlock Holmes, *Brigadier Gerard* is among Arthur Conan Doyle's lesser-known works, but two of the boastful old soak's stories are adapted in Eureka Productions' *Graphic Classics* series by Antonella Caputo and artist Nick Miller. During the Spanish war of independence, Gerard serves under the French general Massena and ruins the Duke of Wellington's fox hunt, and he later deals with an old revolutionary, now sequestered in a dank castle. Miller's cartooning brings to mind British national treasure Hunt Emerson, and his penchant for historical accuracy would please even Harvey Kurtzman. Speaking of whom…

As with so many historical topics, the gold standard is once again set by EC's densely researched titles of the 1950s. *Frontline Combat* #10 (1953) displays Napoleon's tactical genius in luring the combined Austrian and Russian troops to defeat at Austerlitz. Artist George Evans is every bit the obsessive to match Kurtzman, not balking at drawing accurately costumed armies in detail and in long shot.

Valor also spotlighted the Napoleonic era, starting in its 1955 first issue with the bloody French Revolution, the events of which later permitted Napoleon's coup, and a story revealing one of the few times his generals were outwitted, by a former slave in Haiti. A more traditional era romance with a twist ending appeared in the following issue.

◀ ◀▲
Midshipman Coward ran in the 1980s British comic *Spike*. Featuring detailed art by Buenos Aires-based Enrique Alcatena, the strip followed young Midshipman Adam Coward's adventures in the Napoleonic Wars.

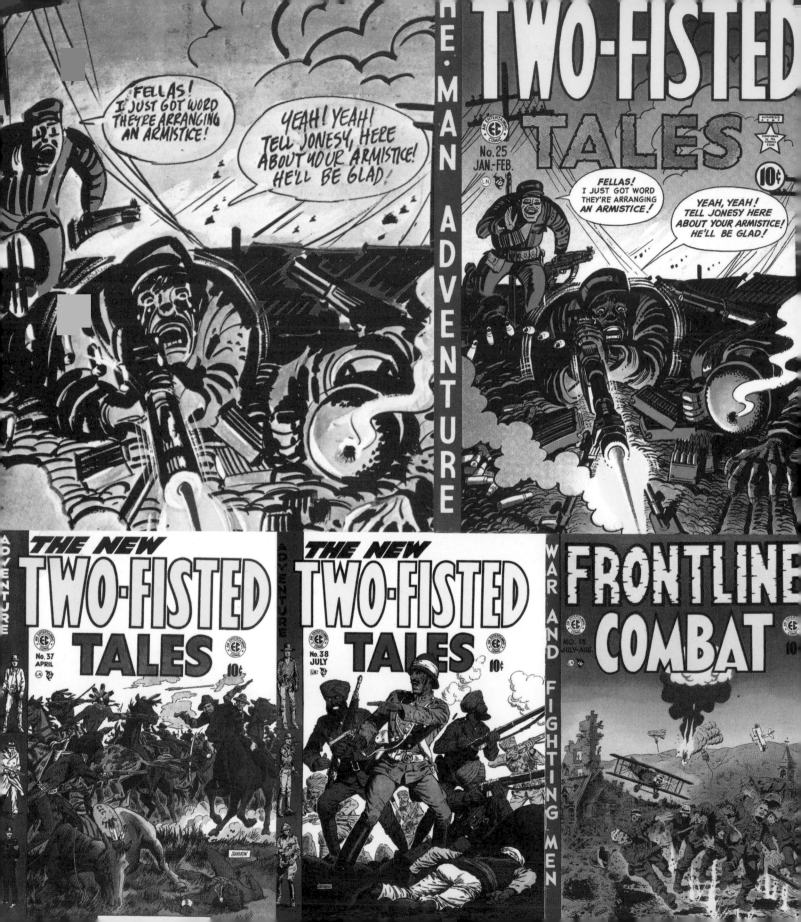

EC'S TWO-FISTED TAKE ON WAR

Ask any knowledgeable comic book fan about EC Comics and the chances are they will wax lyrical about *Tales from the Crypt*, *Vault of Horror*, *Haunt of Fear*, *Weird Science*, *Weird Fantasy*, and other such renowned horror and science fiction titles. But EC also published crime and war comics, and its epic and groundbreaking efforts in the latter genre were the result of the pioneering approach of one man: Harvey Kurtzman.

Primarily a cartoonist, Kurtzman came to focus on editing and writing and, a year after he joined EC, he developed *Two-Fisted Tales*. Initially an adventure comic, it soon became a showcase for war stories. These were drawn from across the ages, covering not just the ubiquitous World War II, but also the American Civil War, the American Revolutionary War, the Roman Empire, as well as stories featuring medieval knights, Spanish Conquistadors, the French Foreign Legion, and more. Many of the strips were based on true tales of conflict that had been scrupulously researched by Kurtzman, a perfectionist who went on to create EC's long-lasting and iconic humor title, *MAD*.

Launched in 1950, *Two-Fisted Tales* is still considered one of the best war—some say *anti*-war—comics ever published. It was joined, in 1951, by a companion title, *Frontline Combat*, which featured Kurtzman's all-time favorite story in the 1952 #4. Published at the height of the Korean War, *Air Burst!* was uniquely told from the perspective of what was, to American readers at the time, the enemy: a North Korean mortar patrol.

Packed with high adventure and historical detail, Kurtzman's war comics featured strips drawn by some of the best artists of the day, including John Severin, Jack Davis, Wally Wood, Alex Toth, George Evans, Joe Kubert, Will Elder, Bernard Krigstein, Russ Heath, and Kurtzman himself.

Frontline Combat ended in 1954; *Two-Fisted Tales* the following year. Both were killed off by dwindling interest in war comics—a reaction to the Korean War. Shortly after *Two-Fisted Tales* bought the farm, EC tried again with *Aces High*, which, like its predecessors, adopted something of an anti-war stance. Lasting just five issues, it featured tales of air combat and frontline service by Allied airmen during the two World Wars, with contributions from Davis, Evans, Krigstein, and Wood, among others.

A decade after *Two-Fisted Tales* died, Warren Publishing launched its magazine-sized *Blazing Combat*. The black and white 1965 series was obviously inspired by *Frontline Combat* and *Two-Fisted Tales*, as publisher Jim Warren was only too willing to admit (see pages 148–149). Kurtzman, then editing Warren's satirical magazine *Help!*, served as consultant on *Blazing Combat*, which was edited by Archie Goodwin, who wrote almost every story in the series' four issues. Like Kurtzman's EC war comics, it also featured an elite roster of artists, including Severin and Wood—both major *Frontline Combat* contributors—as well as such other EC veterans as Evans, Toth, Heath, Reed Crandall, and Joe Orlando.

2

AMERICAN BLOOD, AMERICAN SOIL

A SAVAGE BIRTH

Having achieved independence from Britain (see pages 32–33), the early days of America were far from peaceful. The Native Americans resented the resource-heavy incursion of second generation Europeans; tensions between North and South simmered, leading eventually to Civil War; and Mexico harbored territorial inclinations on what later became United States land.

No comics creator has detailed this period in history as frequently and as well as Jack Jackson. Initially using the pseudonym "Jaxon," the cartoonist focused on Texan history by and large, and, unusually (covers apart), worked exclusively in black and white. Among other achievements, he co-founded the long-running underground comic book publisher Rip-Off Press, and produced what many consider to be the first underground comic in 1964's *God Nose*.

Jackson's approach was to focus on a person or conflict that interested from all sides. He produced graphic biographies of John Wesley Hardin (*Lost Cause: John Wesley Hardin, the Taylor-Sutton Feud, and Reconstruction Texas*; 1998) and Sam Houston (*Indian Lover: Sam Houston and the Cherokees*; 1999), but it's for his stories of small wars that he's best remembered. *The Alamo: An Epic Told from Both Sides* is an authoritative and unsentimental 2002 look at a pivotal piece of US mythology; 1981's *Los Tejanos* covers 40 years of warfare between Mexico and Texas, as experienced by Juan Seguin; and *Comanche Moon* (1979) details the slow decimation of the Comanche tribe.

British artist Ron Embleton was also fascinated by the early frontier days of America, and drew three adventure strips set in the era for British weekly comics. *The Mohawk Trail* closed *Comic Cuts* in 1951 and 1952, and in 1953 he told the story of *Rogers' Rangers*, an independent infantry troop attached to the British army as the French and the British clashed for North American supremacy. This was in *Mickey Mouse Weekly* of all places, where in 1957 Embleton would start *Don O'the Drums*, an even more fondly remembered strip set in the same period and again heavily featuring Rogers' Rangers.

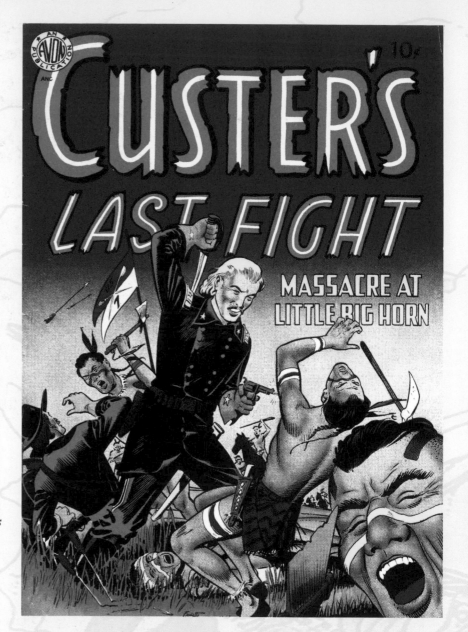

The strained relationship between early American colonists and the indigenous native population is the focal point of *Indian Summer*, a 1983 collaboration between two masters of European comics, Hugo Pratt and Milo Manara. Rich in detail about colony life, the prevailing morality among the colonists, and their attitudes to (what they call) the Indians, is constant fuel to escalating tensions. When the inevitable war arrives, it's short, bloody, and tragic.

▲
The Battle of the Little Bighorn, a.k.a. Custer's Last Stand (or *Custer's Last Fight* as this 1950 Avon comic book has it) has become a symbol of the eventual defeat of the Native Americans, as, despite a famous victory by the Lakota-Northern Cheyenne forces, there was a harsh retribution.

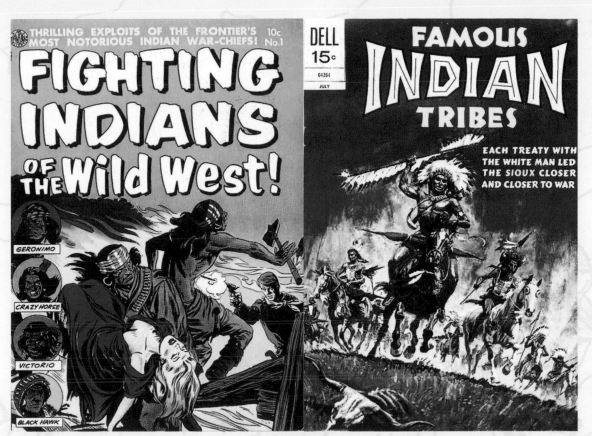

◀ ◀ ◀ Countless comics have taken a more action-oriented look at the Native American plight, with varying degrees of accuracy. These are just two examples, from 1952 (*Fighting Indians of the Wild West!*) and 1972 (*Famous Indian Tribes*).

▼ First published in 1979, *Commanche Moon* tells the story of Quannah, the last chief of the Commanches. Creator Jaxon's abiding preoccupation throughout his work was to relate as truthful an account of American expansionism as possible.

AT LAST THE WARPARTY, ONE OF THE LARGEST EVER FIELDED ON THE SOUTHERN PLAINS, RIDES AGAINST ITS FIRST OBJECTIVE — THE HIDE HUNTERS AT ADOBE WALLS !!

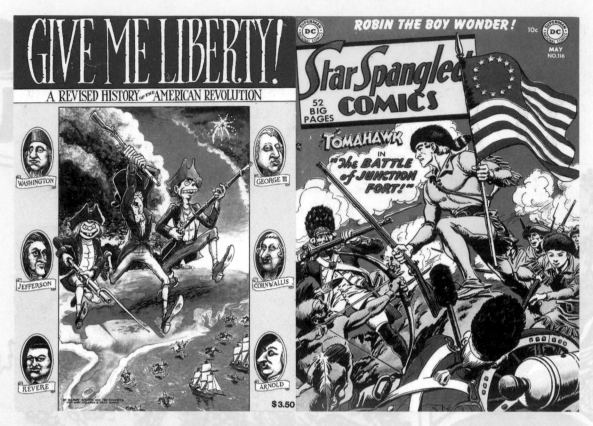

◀◀
A decidedly humorous take on the major events of the American Revolutionary War, Rip-Off Press' *Give Me Liberty!* wasn't subtitled "*A Revised History*" for nothing!

◀
Tom Hawk—the titular *Tomahawk*—served under Washington in the American Revolutionary War in *Star Spangled Comics*, but his adventures became ever more outlandish once he graduated to his own title (see pages 34–35).

▶
As depicted in *Two-Fisted Tales* #28 by Wally Wood, the Battle of Pell's Point on October 18, 1776 saw 4,000 English and Hessian troops meeting stiff resistance from 750 American troops at what is now part of Pelham Bay Park in the Bronx.

As with many war topics, there's little in comics to top the historical research and accuracy of EC's war titles when it comes to the American Revolutionary War (or American War of Independence).

Two-Fisted Tales ran two of them. *Pell's Point* in 1952's #28 detailed a major turning point in the war as Washington's troops escaped Manhattan, finely drawn by Wally Wood. John Severin illustrated a story in the following issue in which a broken and ignored George Washington fails to rouse his troops in what was his lowest point of the revolution.

The American Revolution has produced its share of comic oddities, the oddest of which is Charlton's 1973 adaptation of the Jack Warner-produced film musical *1776*. Illustrated by Tony Tallarico, it concerns the writing of the Declaration of Independence and the struggle to have it ratified by Congress. Sadly, Tallarico and Joe Gill (who adapted the movie) don't match EC quality.

Then there's Rip-Off Press' 1976 one-shot *Give Me Liberty!*, issued for the bicentennial. Gary Hallgren, Willy Murphy, Ted Richards, and Gilbert Shelton—cartoonists better known for their dope-smoking counter-culture characters—turned their wit to history. Covering all the major events in accessible fashion, it should be a standard school text. Larry Gonick's *Cartoon History of the United States* (HarperCollins, 1991) displays similarly irreverent sensibilities in presenting the causes and outcomes of the revolution.

Talking of irreverence, in 1965 Richard Hughes (writing as Shane O'Shea) and artist Ogden Whitney revealed that lollipop-bopping fat little nothing Herbie Popnecker had played his part in freeing what was then the Colonies. In American Comics Group's *Herbie* #8 he has to replace a Paul Revere whose laundry's not arrived, spies among the British as a pizza seller, and inducts animals into the fighting forces, among other less-than-accurate episodes.

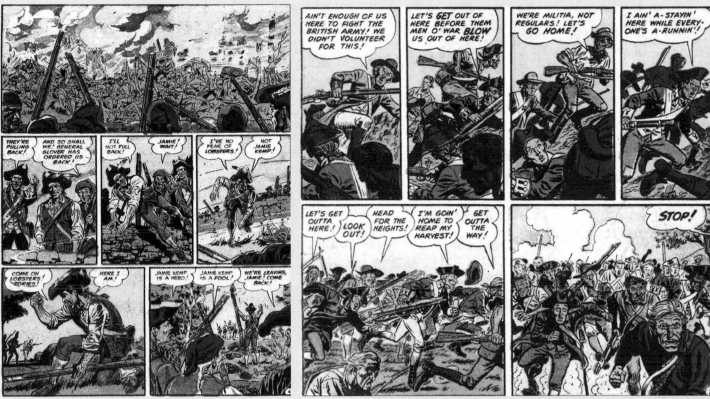

▶▲
George Washington is exasperated to the point of nervous breakdown by his panicking militia in *Two-Fisted Tales* #29, illustrated by John Severin.

▶
In *Herbie* #8, our titular hero has to take messages via George Washington's false teeth. Historical accuracy is obviously not at a premium; Washington's false teeth weren't made of wood.

For historical exactitude at a premium, Learn Well Graphics' 2006 CD-Rom *Causes of the American Revolution* is intended for school classrooms. Richard Keaton and David B. Digby took each important scenario, illustrated it for the comic, then animated the comic for the CD-Rom, providing a less tedious way for students to absorb their history. An earlier educational version was the 1946 second issue of EC's *Picture Stories from American History*. Illustrated by Allen Simon, it covered the pre-revolutionary times to successful independence. But the premier series set in revolutionary times was DC's *Tomahawk*.

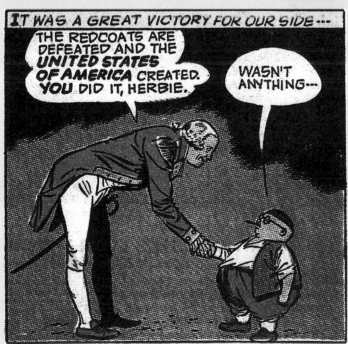

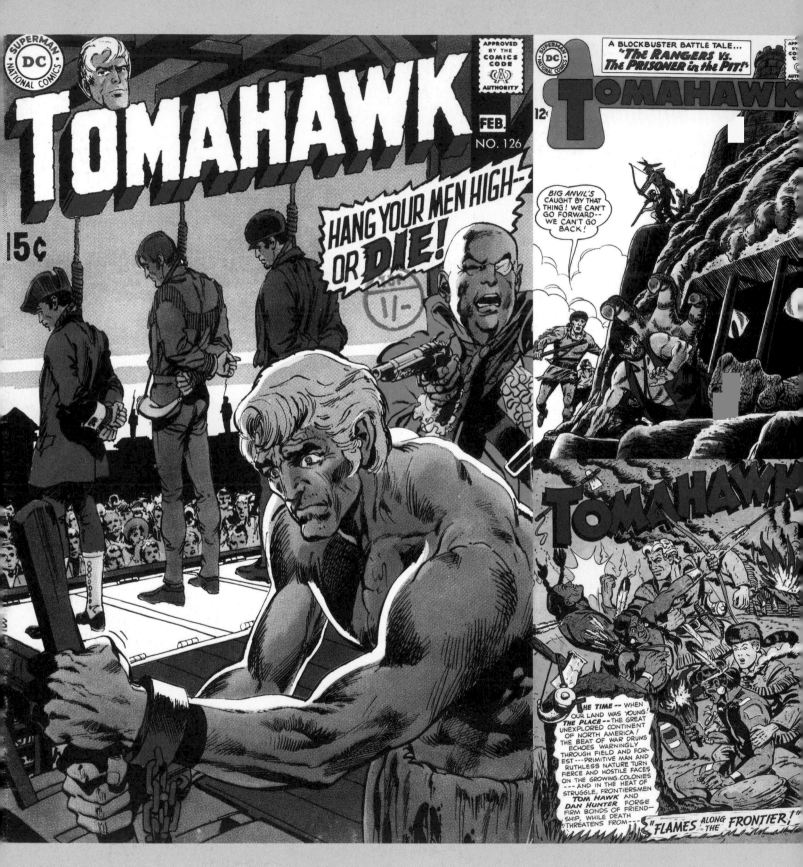

RANGERS AND TRAPPERS

DC Comics' *Tomahawk* title ran from 1950 to 1972, the
character having previously featured in *Star Spangled
Comics* from 1948—a successful run by any standard.

Frontiersman Tom Hawk and his companion
Dan Hunter started off fighting both redcoats and
Native Americans in revolutionary times. Early
issues maintain a vague historical accuracy, but the
emphasis was on providing entertainment for boys,
so by the late 1950s Tomahawk was meeting giant
gorillas (issues #89 and 107), giant spiders (#99), and
dinosaurs (#90). The introduction of a regular gang
of rangers to accompany him restored a modicum of
dignity and revolutionary purpose. Blacksmith Big
Anvil was the strongman, Cannonball the second in
command, Frenchie the athlete, Long Rifle the sure
shot, and Kaintuck Jones the former pacifist. (It's a
wonder the rest came within 20 yards of explosives
expert Stovepipe, given to storing many detonating
substances under his large hat.) Neal Adams covers
on #116-130 still provide an artistic treat.

The independent comics boom of the 1980s
introduced an unlikely hero in the pages of Aardvark-
Vanaheim's *Journey*: Wolverine MacAlistaire, an early
19th century trapper. Written and drawn by Bill
Messner-Loebs, the art was heavily influenced by
Will Eisner, but the writing was like little previously
seen in comics. *Journey's* entire 1983 first issue,
for instance, consists of MacAlistaire being chased
by a bear. MacAlistaire survives on his wits and
knowledge, taking a bed where he finds it, and
using his experience as currency.

A history graduate, Messner-Loebs researched
the period thoroughly, sympathetically portraying
MacAlistaire as in tune with his environment, and
populating the cast with eccentrics. Not the least of
these eccentrics was MacAlistaire himself, described
by fellow artist Matt Wagner as "a unique blend
of Popeye, Daniel Boone, Alastair Cooke, and even
Chuck Jones." MacAlistaire's war experiences come
courtesy of the journey after which the comic is
titled. He accepts a mission to deliver a package, and
along the way arrives at Fort Miami, a remote military
outpost under threat of attack from Tecumseh's
Shawnee braves. An uncompleted follow-up series—
Fantagraphics Books' *Journey: Wardrums*—began to
involve MacAlistaire in the war of 1812.

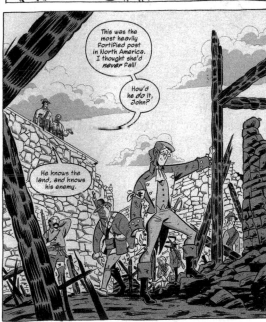

Scott Chantler's 2005 Oni Press three-parter,
Northwest Passage, focuses on a small bay trading
post in what was then known as Rupert's Land in
1755, starting just as the old governor steps down.
Covering much of Canada, it was an area where the
traders mixed freely with the locals, but was also a
territory run by the British and coveted by the French.

HISTORICAL CONFLICTS: THE ALAMO

The symbolic importance of the siege of the Alamo is far greater than its significance as a battle. A badly outnumbered force of Texian defenders held off the army commanded by Mexican President Antonio Lopez de Santa Anna for around 13 days before falling under the Mexicans' final assault on March 6, 1836. That last battle saw the one-time mission fall in just over an hour.

As a military encounter it was rather minor—187 defenders took on 1,800 Mexicans (3,000 more were en route), killing 600 during the various attacks. In describing the battle, Santa Anna said, "It was but a small affair." One of his officers is said to have whispered, "Another victory like this, and we will all go to the devil."

Although the Alamo features widely in American popular culture it was not until the 1950s and the popularity of the Disney TV show *Davy Crockett* that it made its impact on comics. Avon, Dell, and Charlton each published *Crockett* tie-ins in the 1950s, but they rarely mentioned the Alamo—although Dell did publish *Davy Crockett at the Alamo* as the 1955 issue #639 in its *Four Color* series.

Early examples from the 1950s and 1960s, such as *Jim Bowie* and *Classics Illustrated* #129 (1955), presented the siege as heroically inevitable. There was even a mention in *Remember the Alamo*—a story in Marvel Comics' *Two-Gun Kid* #75 (1965)—that privileged unselfish sacrifice as the ultimate motive behind the siege.

By the 1970s, perhaps under the influence of Vietnam, the secessionist rebels in the Mexican territory were reconsidered by creators such as Jaxon (a.k.a. Jack Jackson), who sought to highlight the imperialist ambitions of both sides against the costs borne by the common man. More recently, in the 1990s and 2000s, a more impersonal account of the battle has emerged in comics, as amateur historians use the medium to analyze and explain the events for a modern readership. In the process, they may well have come much closer to the truth, but in so doing have consequently reduced the sense of the heroic.

The Alamo may no longer be the American Thermopylae, and as such may well have lost forever the dramatic power to carry its own comic book narrative.

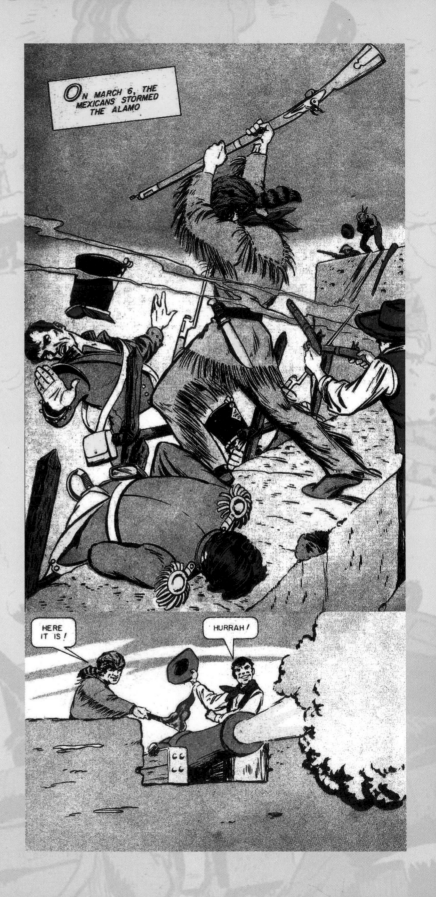

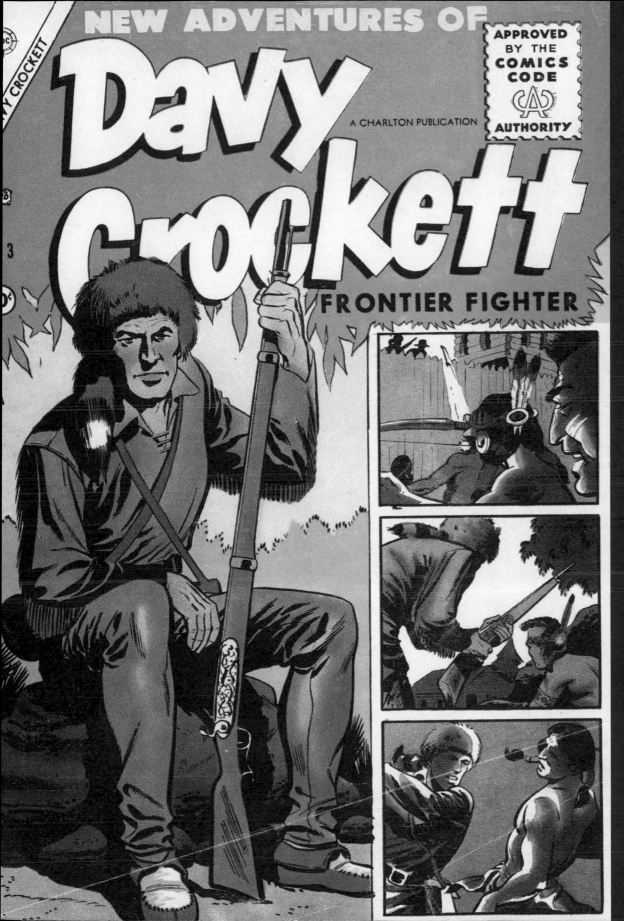

NEW ADVENTURES OF

Davy Crockett

FRONTIER FIGHTER

A CHARLTON PUBLICATION

APPROVED BY THE COMICS CODE AUTHORITY

◄◄
In 1955, at the height of Crockett mania in the US, *Classics Illustrated* #129 provided this sanitized version of Crockett's life. Avoiding the blood and mayhem of the final assault, the artist Lou Cameron presents the frontiersman-cum-Congressman in his buckskins against a heroic sky.

◄
Incredibly, at one time in the 1950s comics readers could find upwards of 15 different Davy Crockett comic books on the stands at any one time, although they rarely mentioned the Alamo, being much more in line with the then-popular Disney TV show. Hot on the heels of Dell came Harvey Comics, then DC Comics, Ace, Avon, ACG, and Charlton, whose *Davy Crockett: Frontier Fighter* is seen here. There was little grit in these tales, however

AMERICAN CIVIL WAR: BROTHER VS. BROTHER

The American Civil War being such a turning point in US history, it's no coincidence that comics have covered few historical topics as often as the War Between the States.

More than 50 years on, the gold standard remain the meticulously researched issues of EC's *Frontline Combat* and *Two-Fisted Tales*, written by Harvey Kurtzman and illustrated by his fine stable of artists. Kurtzman planned to tell the story of the Civil War from start to finish over seven issues. EC Comics published only three, with other significant events covered elsewhere in the runs. As with all his projects, Kurtzman researched in depth, and managed to tell stories of humans amid the carnage. Artists Jack Davis and Wally Wood in particular turned in spectacular pages. Later, considering an age when few comics aspired to anything other than brief entertainment for troops and kids, Kurtzman referred to his war comics by noting, "it was like asking a kid to read *The New York Times*."

Wayne Vansant has worked almost exclusively on comics about military history, and specializes in the Civil War. Allocated entire issues to cover specific battles and campaigns, he produced work on *Antietam*, *Sherman's March Through Atlanta to the Sea*, *Stonewall in the Shenandoah*, *Shiloh*, and *Gettysburg* for Heritage Collection in the 1990s. More recently, he was among assorted creators contributing to a 2007 line of graphic novels for military history publisher, Osprey.

Vansant is also the best of numerous people who've adapted *The Red Badge of Courage*, Stephen Crane's renowned 1895 coming-of-age novel set during the Civil War. Generally, comics have not served the colorful story well, the necessity of reducing a novel to 48 or less illustrated pages diminishing most attempts. Given a full page count, though, Vansant's 2005 version for Puffin succeeds with a sympathetic adaptation of Henry Fleming's experiences.

Four volumes of *Epic Battles of the Civil War* (Marvel, 1998) covered Bull Run, Shiloh, and Antietam, well-illustrated by Nick Choles, Gray Morrow, and Angelo Torres respectively, but it's Civil War buff George Woodbridge's work on Gettysburg that stands out. Best known for his realistic caricatures in *MAD*

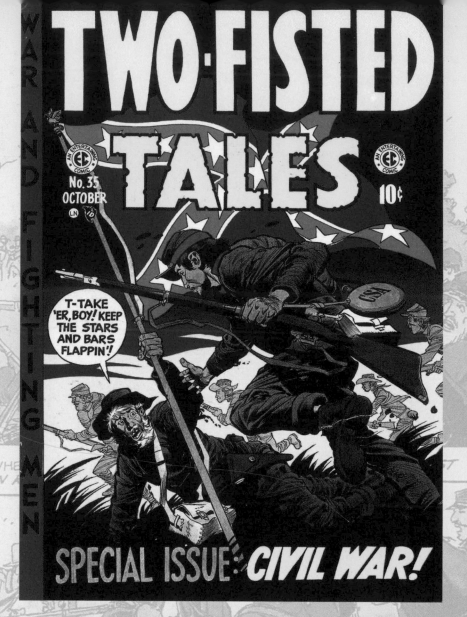

Magazine, he produces authentically detailed book illustrations, which re-enactment societies across the US use as reference.

Heading into 21st century technology, Bentley Boyd has produced numerous web cartoons about the Civil War as teaching aids. Boyd's considerable skill lies in reducing sometimes-complex matters to a form accessible to children, generally in fewer than ten panels. Examples can be found at http://teacherweb.com/CA/CarmenitaMiddleSchool/nyquist/hf3.stm.

Also of note for younger readers is Larry Gonick's *Cartoon History of The United States* (HarperCollins, 1991), where the Civil War, its causes, and its consequences are concisely and eloquently summarized in a mere 24 pages of great cartooning.

▲ EC Comics writer Harvey Kurtzman consulted historian Fletcher Pratt for accuracy on his Civil War tales, and provided reams of reference for his artists. Jack Davis created this memorable cover for *Two-Fisted Tales* #35 in 1953.

▶ *Classics Illustrated* tackled Stephen Crane's *The Red Badge of Courage* in 1952. This vivid painting appeared uncredited on the comic book's cover.

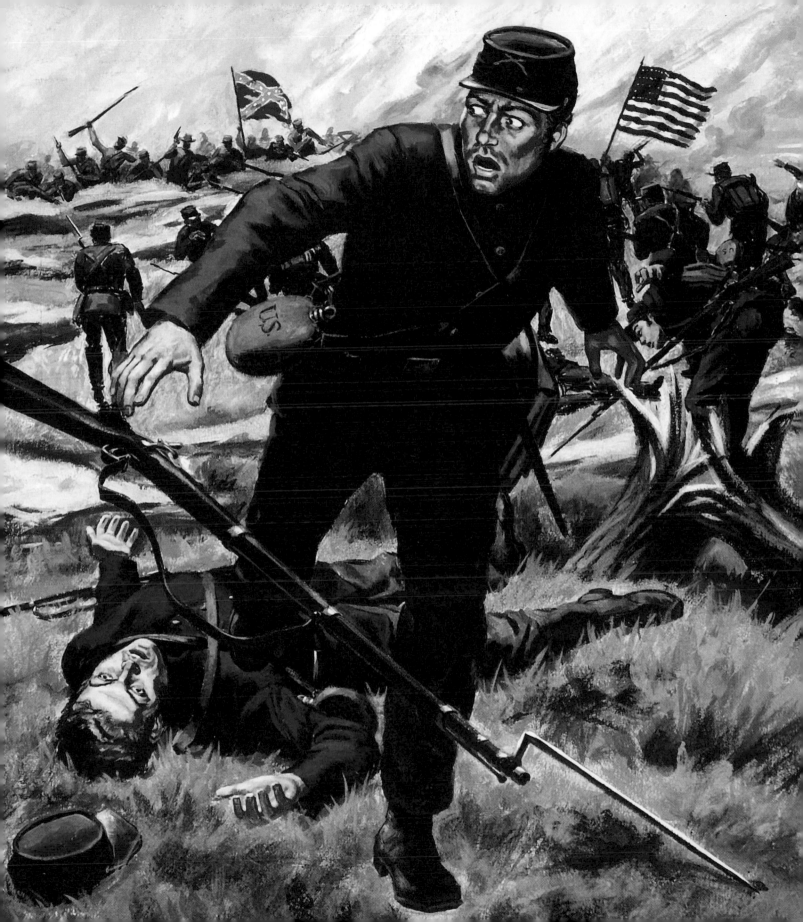

HOW THE WEST WAS WON

With the American frontier finally tamed at the end of the 19th century, and the last states folded into the bosom of the Union, many in this new nation felt something of the American character had been lost. Underpinned by ideals of rugged individualism, the desire to "go west," and a pantheon of legendary characters, both good and bad, the Wild West has an undeniably romantic appeal. That mythical image was seized upon by more civilized society, many of whom yearned to live beneath the stars, fight hostiles, and live free from the constraints of society—a yearning that still finds a very ready audience over a century later.

Even as the war to colonize the frontier was ending, the exploits of gunslingers, outlaws, Indian fighters, and cavalry officers were being romanticized in dime novels and "penny dreadfuls," not just in the US but around the English-speaking world. Comic books, in turn, utilized the ready supply of source material. Coinciding with the increasing popularity of the movie and radio show, four-color tales of the Wild West offered portrayals in a broadly similar manner.

The hero was predominantly white and clean cut; the Indians (or Native Americans to use the more acceptable, modern term) were usually cast as brute savages at worst, clichéd at best. (Revisionism to a more accurate historical portrayal of events lay decades in the future.) As the popularity of comic books increased in the 1930s and 1940s, readers thrilled to the tales of characters that ran the gamut from the fictionalized adventures of historical figures (see pages 42-43), to movie stars, to wholly created Western characters.

The big publishers were keen to get in on the action. *All-Star Western* was DC's Wild West anthology title, published in two portions (1951-1961 and 1970–1972). The series featured the work of such legendary artists as Gil Kane and Alex Toth. Amongst its most popular creations was Jonah Hex, the mutilated ex-Confederate officer turned bounty hunter, who added a gothic element to the Western genre and saw it mutate into the "Weird West"—a combination of horror and supernatural elements and more traditional Western themes.

The Lone Ranger was perhaps the most popular Wild West hero of them all. Beginning on radio in 1933, he graduated, five years later, to a long-running newspaper strip (and the big screen), then to a Dell Comics series that ran for 145 issues from 1948. The Ranger's laconic and trusty sidekick, Tonto (unusual at the time in that he was a Native American), and the Ranger's equally famous horse, Silver, were both given spin-off series.

Dynamite Entertainment revisited the iconic lawman in 2006, with an acclaimed series, although long-standing fans have been critical of the bloodshed depicted, no matter that it represented a more accurate portrayal of the Old West. Such is the nature of revisionist history!

He did not fight alone.

One of his strongest allies was an Anglo named Johnny Bart, who some called The Rawhide Kid.

They met during the time of the Railroad Wars between the mighty Santa Fe and Pacific R.R. and the small Colorado and Texas Line.

Both railroads would arrive in the same valleys, the same passes, and fight to lay their trails of steel. At first, they fought with shovels and pick-axes. Then the Santa Fe and Pacific brought in many gunmen.

The owner of the Colorado and Texas Line called in some friends-- and they included the Rawhide Kid and Pazii. They still tell stories of those times, even now in my final days.

Pazii and Johnny Bart and their friends did not have numbers, but they had courage and cunning and skill. But my story is not about *those* days.

▲
The Apache Kid and the Rawhide Kid, seen here in the 2002 John Ostrander/Leonardo Manco title *Apache Skies*, both debuted in the 1950s at Atlas Comics, and fought together in the Railroad Wars. The Apache Kid was named after the real-life Native American figure, but the similarities end there. For his part, the Rawhide Kid underwent a radical transformation in 2003 when the mini-series *Slap Leather* revealed him to be gay.

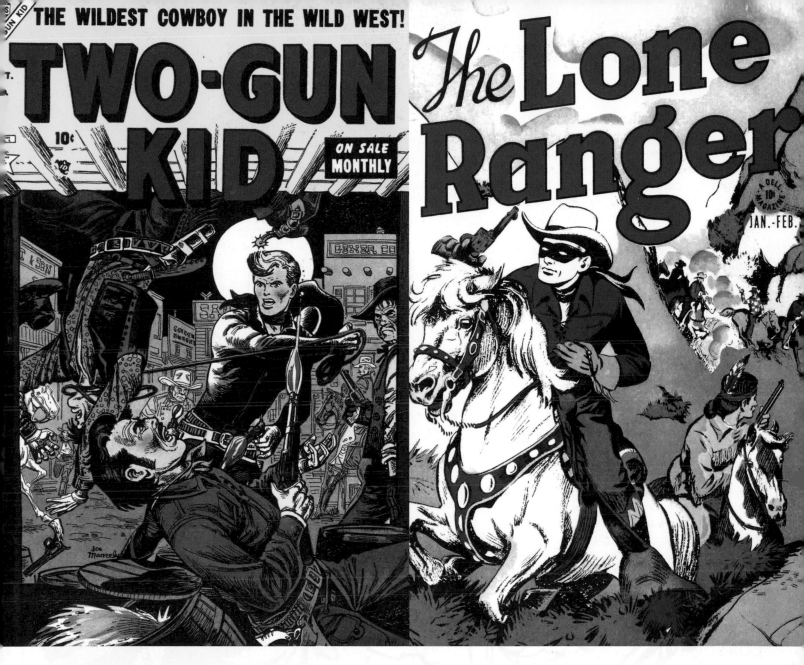

THE WILDEST COWBOY IN THE WILD WEST!

TWO-GUN KID

10¢

ON SALE MONTHLY

The Lone Ranger

A DELL 10¢ MAGAZINE

JAN.-FEB.

▲ Marvel Comics has actually published the adventures of two Two-Gun Kids. The first was Clay Harder, seen here on 1954's *Two-Gun Kid* #17, who was later written out of Marvel continuity in favor of one Matt Liebowicz (alias Matt Hawk), who took over the title in 1962.

▲ Seen here on the cover of his comic book debut in January 1948, the Lone Ranger has enjoyed a lengthy comics career, riding from Dell to Gold Key to Topps Comics, and finally to Dynamite Entertainment in 2006.

WILD WEST HEROES

The lives of the real life gunslingers and soldiers who populated the American West have proved fertile ground for countless comic book stories.

As a frontiersman, Kit Carson's career spanned just about every profession the West had to offer, making him a fitting example of the sort of legendary character who translated easily into comics. A skilled trapper as a young man, he fought Apaches and Navajos, loved an Arapaho woman (killing a fellow suitor over her affections), guided explorers, fought as a scout in the Mexican American and Civil Wars, and became a famous and controversial Indian fighter.

Little wonder, then, that he soon worked his way into popular culture; even in his lifetime, dime novels were appearing about his adventures. In 1931, he became the subject of a daily newspaper strip, *High Lights of History*, by J. Carrol Mansfield. As the popularity of the Western-inspired comic book reached its zenith in the 1940s and 1950s, he featured in a variety of titles.

It's no accident that the most popular real life Western characters in comic books of the 1940s and 1950s were also big names in the movies of the time. Wild Bill Hickok and Jesse James both had series at Avon, while Wyatt Earp enjoyed a 34 issue run at Atlas, and Annie Oakley managed 11 issues at the same publisher. The adventures depicted often bore little relation to real events, however; Atlas' *Wyatt Earp* admitted as much when it stated the comic was based on "the adventures and legends of Wyatt Earp."

Hickok was in many ways the perfect character for comics; many of his exploits were the stuff of legend rather than fact. A lawman in Kansas and Nebraska, Hickock fought for the Union in the Civil War, but it was his later career as a gambler and gunslinger that provided the most material for the dime novels (where he became one of the first "dime novel heroes") and—later, in the 20th century—movies, TV shows, and comic books that recounted his adventures. Fact and fiction blurred towards the end of the Wild West era, leaving a largely romanticized period that bore stark contrast to the harsh realities of the wars of the 20th century.

▲
Christopher Houston "Kit" Carson starred in a variety of US comic books, including his own Avon comic (lasting nine issues; Everett Raymond Kinstler art from #1 seen here), *Classics Illustrated*, *Six Gun Heroes*, and even *Disney Comics Digest*.

▶
Kit Carson's romantic appeal was international. *Cowboy Comics* ran in the UK for 468 issues from April 1950 to September 1962, featuring as many as 350 Kit Carson issues and seven Annuals. This page is from *Kit Carson and the Cheyenne War*, published February 1961.

Billy the Kid managed an impressive run at Charlton, continuing from November 1957 right up to the final issue of the series (#153) in March 1983.

Wild Bill Hickok, Annie Oakley, and Jesse James starred in Charlton's *Cowboy Western* in the 1950s. James fought for the Confederates in the Civil War as part of William Quantrill's Raiders; this issue of *Cowboy Western* from 1955 details a no-doubt fictional episode from the war.

3 WORLD WAR I

ONE OF THEIR BULLETS MUST HAVE HIT MY ENGINE. I'LL HAVE TO TRY TO GLIDE BACK OVER OUR OWN LINES.

HE WILL SOON BE OVER HIS OWN LINES.

MADE IT! BUT THAT WAS TOO CLOSE FOR COMFORT!

Bishop's mascot was a dog called Mig, who would watch all his take-offs and landings.

Bishop was one of the first fighter aces daring enough to attack enemy 'dromes.

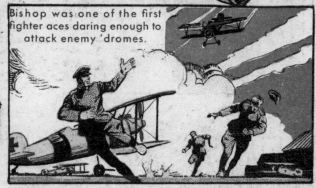

The German pilots never got a chance to take off, and only when he was out of ammunition, did Bishop fly off.

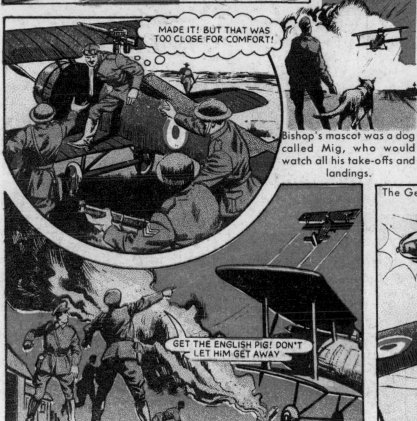

GET THE ENGLISH PIG! DON'T LET HIM GET AWAY

Bishop's score of kills steadily mounted, but his superiors were worried for his safety, and gave him a staff job.

CONGRATULATIONS, BISHOP— YOU'VE BEEN AWARDED THE VICTORIA CROSS! ALSO, YOU'VE BEEN APPOINTED TO A STAFF JOB IN LONDON.

STAFF JOB IN LONDON, EH? STILL I CAN HAVE MY FINAL FLING THIS AFTERNOON.

That afternoon, Bishop shot down a further five German planes. This brought his total of enemy planes destroyed to 72 and made him the top ace of the R.F.C.

In the 1939-45 war, Air Marshal "Billy" Bishop was the dynamic leader who built up Canada's great fighting air force.

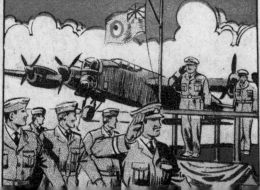

WORLD WAR I POLITICAL CARTOONS

While it's true that there were newspaper cartoons tackling previous conflicts—the Crimean War, for example—it wasn't until World War I broke out in 1914 that political and propaganda cartoons truly came into their own, as a means of boosting morale and furthering the war effort. In an age before television or computers, the only reports that came from the front were via the newspapers, and for the semi-literate much of this was captured in cartoons of the day. The sheer scale and scope of these illustrations was vast on both sides of the barbed wire.

The Germans' and Prussians' appearance made them ripe for caricaturing by French and British cartoonists—with their vast handlebar mustaches, lamb-chop sideburns, and *picklehaube* helmets. Their leader, Kaiser Wilhelm —"Kaiser Bill," as he was known in the cartoons—came under constant attack from the artists' pens and brushes.

Many classic icons were forged in the WWI cartoons, with figures like Uncle Sam, the Russian Bear, the French Cockerel, and the British Lion all firmly planting themselves in the populace's subconscious for decades to come. One of the best-loved British cartoonists was Bruce Bairnsfather, whose creation—the soldier, Old Bill—became a national institution. The walrus mustachioed "Tommy" brought brief comedy relief to those in the trenches, and helped those back home to understand the grim conditions on the front.

Bairnsfather was born into a military family but failed to get into famed military academy Sandhurst, and so joined the Cheshire Regiment. In 1907 he resigned to become an artist, but signed up again in 1914, joining the Royal Warwickshire Regiment and serving with a machine gun unit in France. In 1915 he was hospitalized during the Second Battle of Ypres, suffering from shell shock and hearing damage. While recuperating in England he developed his *Old Bill* series for the *Bystander*—a weekly tabloid—about life in the trenches, featuring a curmudgeonly soldier with trademark mustache and balaclava. Bairnsfather's cartoons were soon collected into two books, *Fragments From France*, and the autobiographical *Bullets & Billets*.

Bill was hugely popular with the troops and helped the *Bystander* achieve massive sales. Bairnsfather even received a promotion and a War Office commission to draw similar cartoons for the Allied forces. After the war, many police officers had similar facial hair to the cartoon soldier, which gave rise to the British police being nicknamed "the Old Bill."

Other key artists who saw active service during WWI included E. H. Shepard, who would later go on to illustrate *Winnie the Pooh*, and William Heath Robinson, who became a war artist with the American Expeditionary Force in France in 1918.

As the "Great War" progressed, the bitter acrimony in the artwork grew, as artists on both sides portrayed the enemy as pigs and hideous man-beasts (sometimes even bayoneting babies). Even after the war, cartoonists from opposing nations continued to fling mud at each other, the Germans accusing a lanky caricature of President Woodrow Wilson of trying to continue the war, and British cartoonist H. M. Bateman mocking the future career of the Kaiser as a music hall comedian, or lecturer on "How I Lost."

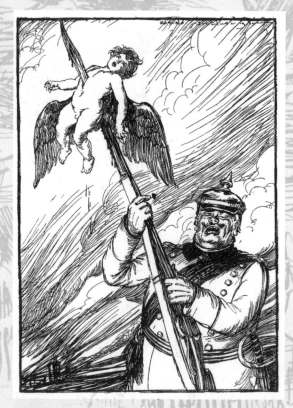

▶ Bruce Bairnsfather's beloved character Old Bill from the Christmas 1915 edition of the *Bystander*. The caption reads, "Well, if you knows of a better 'ole, go to it!"

▶▶ This savage 1917 recruiting poster for the US Army reveals the vitriol reserved for the Germans. The ape's helmet reads "Militarism" and its club has "Kultur" inscribed on it, as it invades America.

◀ ▶ Prolific illustrator Edmund J. Sullivan was driven to draw "hate" cartoons by reports of the atrocities inflicted on Belgian civilians by the German army. Both of these images come from Sullivan's 1915 book, *The Kaiser's Garland*. The illustrator later became president of the Art Workers' Guild and taught at Goldsmith's School of Art.

▶▶ This humorous 1916 postcard, by Donald McGill, has the British Navy preparing a "present" for the Kaiser.

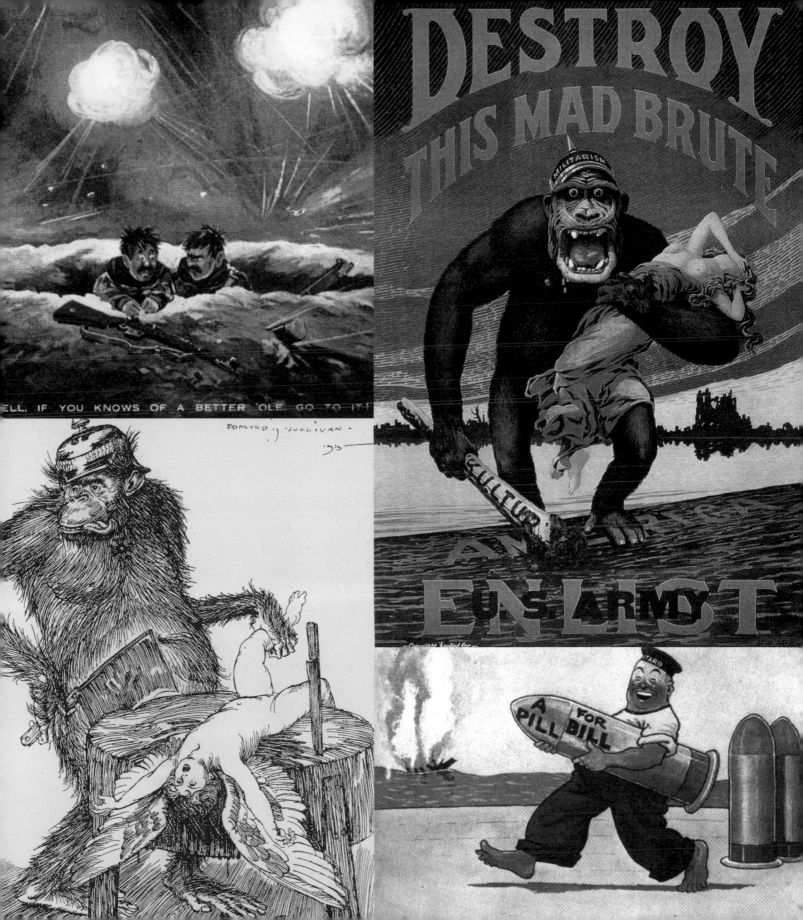

CHARLEY'S WAR

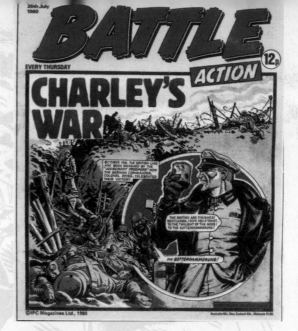

BATTLE Action

EVERY THURSDAY 12p

CHARLEY'S WAR

©IPC Magazines Ltd., 1980

◄ Unlike many war comic strips, *Charley's War* did not attempt to portray the Germans as a faceless, barbaric enemy. Instead, it depicted them as regular people, condemned to involvement in an appalling conflict in which they too believed right was on their side.

▶ In one exquisitely rendered and detailed frame, Joe Colquhoun replicates the appalling conditions and misery of life in the mud and the slaughter on the First World War frontline, where men and animals suffered and died together.

▶ In this frame, Joe Colquhoun—who began drawing the *Battle Picture Weekly* strip in 1978 at the age of 52—skillfully captures the fear as young Charley and his comrades brace themselves for a German attack.

In March 1975, a new war comic hit newsstands across Britain. For its first 199 issues, IPC's *Battle Picture Weekly* was a traditional gung-ho war comic. Strips such as *D-Day Dawson*, *Rat Pack*, and *Day of the Eagle* sat alongside the likes of *Johnny Red*, *Lofty's One-Man Luftwaffe*, and *The Terror Behind the Bamboo Curtain*. (See pages 112–113.) But with issue #200, the mold was broken.

Dated January 6, 1979, #200 debuted a new strip, one that would come to be recognized as one of the greatest stories of war ever recounted in a comic. Written by Pat Mills and drawn by Joe Colquhoun, *Charley's War* followed an idealistic kid, 16-year old Charley Bourne, who lies about his age so he can leave his job at the bus garage and join Kitchener's army. He was just one of the many volunteers who flocked to its ranks, ready to play their patriotic part in the "big push" of summer 1916; the fiasco that was the Battle of the Somme.

Historically accurate, thanks to thorough research by Mills and Colquhoun, the story tracks Charley's fortunes right through the Great War, documenting his experiences on the Somme, Ypres, and the final Advance of 1918. Defiantly anti-war and unflinching in its approach, *Charley's War* revealed—through Charley's eyes, and via his semi-literate letters home—the grim reality of life in the trenches during a conflict that saw the slaughter of a generation of young men. Eschewing jingoism and over-the-top dramatics, in a straightforward manner it spotlighted both heroism and cowardice. It also showcased the effects of gas attacks and tanks on the conduct of

warfare, and highlighted the class attitudes that led to the High Command viewing the lowly infantrymen as mere cannon fodder—lives worth spending in a terrible struggle to gain just a few yards of mud.

As *Battle* editor Dave Hunt put it, "As Pat realized at the time, WWI was an extremely static conflict, and a war of attrition in the trenches certainly wasn't the usual stuff of boys' comics. So Pat's ploy was to give the story a very human touch in the shape of the underage Charley Bourne. The awful conflict would be told through the eyes of a kid who only ever wanted to do his best for King and country, but even more than this, his best for his mum and dad. The postcards home, full of spelling mistakes, were a revelation. Even the visual of the heading, with the 'S' the wrong way round, seemed to capture the very essence of the story and its lead character. Pat never saw Charley as a superhero—that would have been wrong and a slight on all the brave guys who were the cannon fodder during this most terrible of conflicts. Charley was brave without being heroic; Charley was moral without ever knowing why. As each chapter unfurled, as each development of the conflict was uncovered, be it gas, be it the tanks, you knew that you were witnessing a remarkable piece of creative storytelling."

Mills and Colquhoun brought their chronicle of Bourne's First World War experiences to a close with the January 26, 1985 issue of what had become *Battle Action Force*. More than two decades later, *Charley's War* continues to be lauded as the ultimate in war comics storytelling.

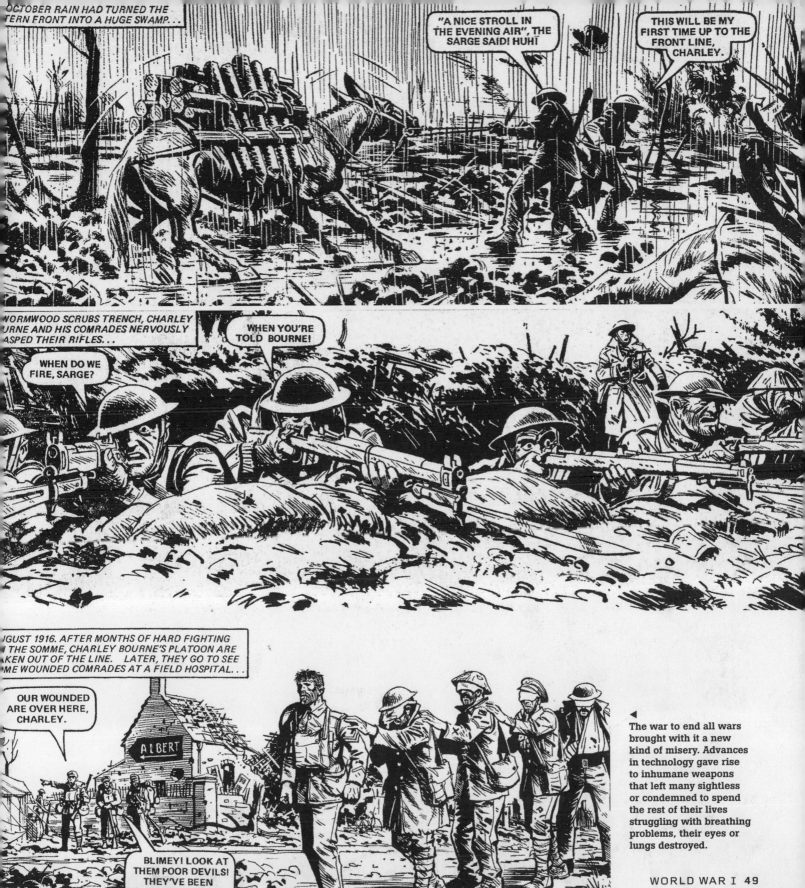

...OCTOBER RAIN HAD TURNED THE ...TERN FRONT INTO A HUGE SWAMP...

"A NICE STROLL IN THE EVENING AIR", THE SARGE SAID! HUH!

THIS WILL BE MY FIRST TIME UP TO THE FRONT LINE, CHARLEY.

...WORMWOOD SCRUBS TRENCH, CHARLEY ...URNE AND HIS COMRADES NERVOUSLY ...ASPED THEIR RIFLES...

WHEN DO WE FIRE, SARGE?

WHEN YOU'RE TOLD BOURNE!

...UGUST 1916. AFTER MONTHS OF HARD FIGHTING ...THE SOMME, CHARLEY BOURNE'S PLATOON ARE ...KEN OUT OF THE LINE. LATER, THEY GO TO SEE ...ME WOUNDED COMRADES AT A FIELD HOSPITAL...

OUR WOUNDED ARE OVER HERE, CHARLEY.

ALBERT

BLIMEY! LOOK AT THEM POOR DEVILS! THEY'VE BEEN BLINDED BY TEAR GAS!

The war to end all wars brought with it a new kind of misery. Advances in technology gave rise to inhumane weapons that left many sightless or condemned to spend the rest of their lives struggling with breathing problems, their eyes or lungs destroyed.

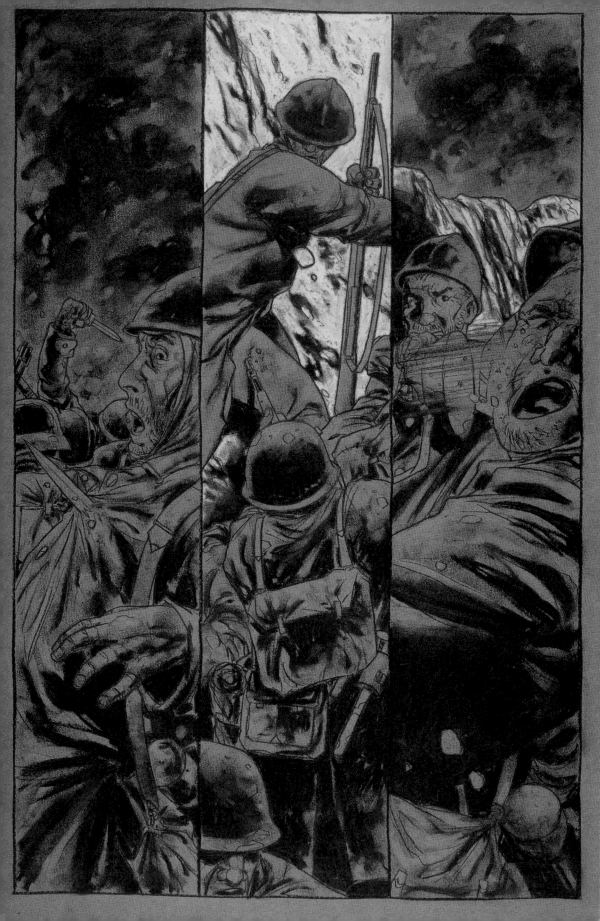

◄
Nearing the climax of
White Death, the Italian
trenches are attacked by
the Austro-Hungarian
forces, leading to vicious
close quarters fighting.
Artist Charlie Adlard
effectively conveys the
desperate nature of
hand-to-hand combat.

▼ ►▼
When the French edition
of *White Death* was
published, Charlie Adlard
created a number of
original illustrations to
be used as limited edition
prints for French book
stores to include with the
graphic novel. Never-
before published, these
are two of the prints.

WHITE DEATH

Inspired by a television documentary estimation that over 60,000 Italian troops died under deliberately triggered avalanches during World War I, writer Robbie Morrison and artist Charlie Adlard produced the greatly underrated and, sadly, little seen, *White Death*.

Published Les Caroonistes Dangereux in 1998, it focused on the 1916 campaign in the Trentino Mountains, a border area between Italy in the south and the Austro-Hungarian Empire to the north. The area is bleak and unforgiving in the winter, with temperatures never rising above freezing.

"Warfare is horrific enough, but the fact that the powers-that-be had effectively turned nature itself into a weapon seemed, to me, even more obscene," recalled Morrison. "I just couldn't shake this idea."

The writer took these events and turned them into a relentlessly grim story about a relentlessly grim situation. Bodies did not decompose in the freezing temperatures, so combatants used the corpses of friends and enemies alike to pack the trenches. Undelivered supplies meant the Italians had no gas masks, so the only manner of dispersing a gas attack

was an avalanche, which was an equal-opportunity destroyer. After a brief, depressing interlude in a whorehouse, the graphic novel details a full-blown grenades and bayonet battle at close quarters. Even injury is no relief as the wounded lie sardine-packed on the floorboards of a large hut.

Acting as the focal point for the story is Pietro Aquasanta, who grew up in an Italian community on the Austro-Hungarian side of the border. Distrusted by his Italian comrades, his task is to set avalanches to destroy the enemy, many of whom are his fellow villagers. Brought up to respect the power of nature, he's reluctant to abuse it, and when nature inevitably responds to the poking and prodding, it results in the destruction of an entire town.

Morrison named his cast from a war memorial in the area, and for his part, Adlard accentuates a harsh environment by drawing with chalk and charcoal on grey paper. There's little relief from the misery, for either the Italian trooper or the reader, but as an evocation of the frustration, misery, and senselessness of war for the ordinary soldier, *White Death* is among the best.

morrison adlard

white death

DEATH FROM ABOVE

Perhaps an odd cultural reversal of the American Western's inordinate popularity in Europe, biplanes fighting World War I in Europe have been a steady feature of US war comics. Issues of EC's *Frontline Combat* and *Two-Fisted Tales* ran several stories retelling the exploits of noted biplane pilots, often drawn by John Severin. They started with the famous German Manfred von Richthofen—the Red Baron, or Red Knight—who was finally shot down after recording 80 kills.

EC eventually devoted an entire (but short-lived) 1955 title to World War I flyers. Severin was occupied elsewhere, but in five issues of *Aces High* Jack Davis, Wally Wood, and Bernard Krigstein mined buckets of dogfight scenarios. The most enthusiastic artist of all, however, was George Evans, who was such a devoted history buff that he could spot errors in EC's meticulously researched war titles. His best story, in #4, concerns a seemingly heartless commanding officer perpetually harangued by his subordinate regarding his casual attitude to sacrificing life.

Marvel Comics' own Great War pilot returns once a decade, most recently in Garth Ennis and artist Howard Chaykin's *War is Hell: The First Flight of the Phantom Eagle* in 2008. First flying the French skies in *Marvel Super Heroes* #16 back in 1968, the Phantom Eagle's name was appropriated from a long-defunct Fawcett comics character. In his origin story—courtesy of the Gary Friedrich/Herb Trimpe writer/artist team—he was Karl Kaufman, American son of German immigrant parents, who became the scourge of his forefathers' nation. Kaufman remained masked in order that his parents—now back in Germany—would not suffer reprisals.

Over the course of a sporadic career, he would encounter a time-drifting Incredible Hulk, and form part of a World War I-era prototype superteam. When eventually strafed by German ace Hermann von Reitberger, he became true to his moniker, and haunted his killer for decades.

Another World War I pilot with a peculiarly prolonged afterlife was Baron Emmelmann, who was skilled enough to be a member of Von Richthofen's squadron. When his plane was shot down and sank into a swamp, Emmelmann's grip on life was so tenacious that the spark that remained festered for decades, drawing in vegetation and molding it into a shambling body that finally emerged into World

◀▼
From *Aces High* #3, this Jack Davis sequence is brilliantly orchestrated, as German and British biplanes wheel and swoop in a deadly dogfight.

▶ ▶▼
Wally Wood fills the air with biplanes in these densely-packed panels from *Aces High* #1 and 4.

▶▼
Two British pilots in their brightly-colored biplanes celebrate a kill, in this George Evans panel from *Aces High* #4.

▼
Another George Evans illustration, this time for *Aces High* #1, contrasting the sleek lines of then-contemporary jet fighters with the rather more rickety biplanes of World War I.

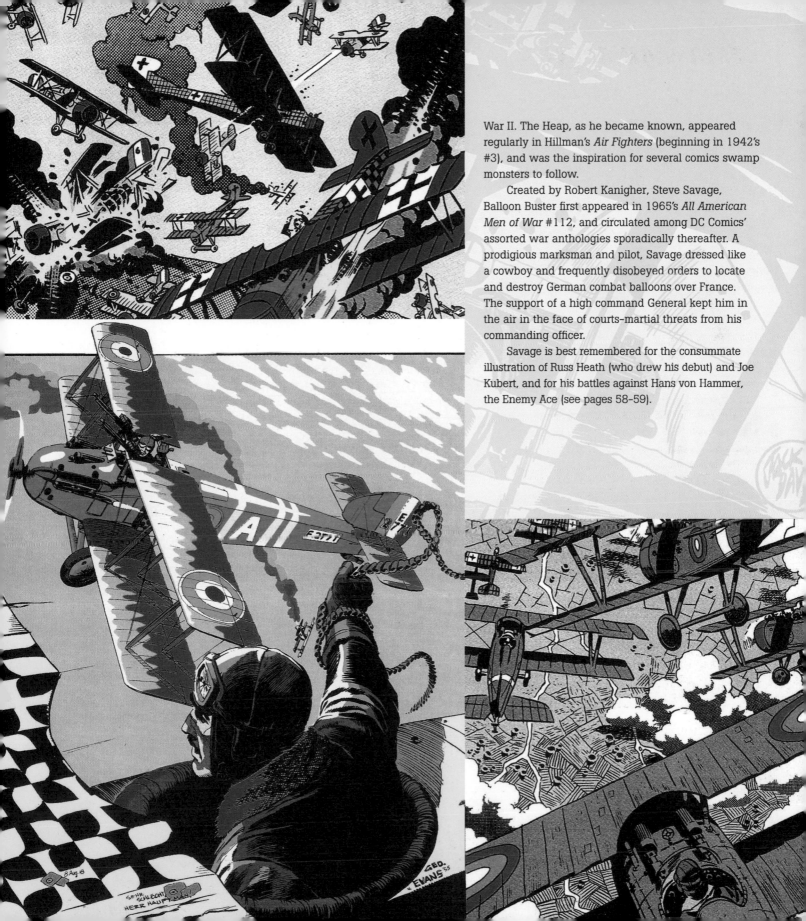

War II. The Heap, as he became known, appeared regularly in Hillman's *Air Fighters* (beginning in 1942's #3), and was the inspiration for several comics swamp monsters to follow.

Created by Robert Kanigher, Steve Savage, Balloon Buster first appeared in 1965's *All American Men of War* #112, and circulated among DC Comics' assorted war anthologies sporadically thereafter. A prodigious marksman and pilot, Savage dressed like a cowboy and frequently disobeyed orders to locate and destroy German combat balloons over France. The support of a high command General kept him in the air in the face of courts-martial threats from his commanding officer.

Savage is best remembered for the consummate illustration of Russ Heath (who drew his debut) and Joe Kubert, and for his battles against Hans von Hammer, the Enemy Ace (see pages 58–59).

TO THE VICTOR

Across three decades and more than 1,600 issues, British publisher DC Thomson used the front and back covers of *The Victor* to spotlight the medal-winning heroism of British and Commonwealth troops.

Like most comics of the time, the focus of the weekly's *True Story* two-pagers was the Second World War, although it would occasionally stray from that conflict into other actions. One example was the story of how—on the North West Frontier—Private Ginge Letts of the Northamptonshire Regiment won the Distinguished Conduct Medal for taking a ridge occupied by Pathan tribesmen on September 9, 1937.

But such diversionary excursions were comparatively rare. When it wasn't detailing World War II exploits, the series' secondary focus was usually World War I, although it wasn't until 1963 (two years after its *True Stories* feature premiered) that *The Victor* began to showcase the medal-winning exploits of Great War heroes.

One of the first WWI stories was *Ace of Aces*, which spotlighted Canadian flying ace "Billy" Bishop. Already the holder of the Distinguished Flying Cross (for scoring 25 victories in 12 days), he was awarded the Victoria Cross after single-handedly attacking a German aerodrome near Vimy Ridge on June 2, 1917. By the time the war ended, Bishop was able to claim 72 victories; only Manfred von Richthofen (80), Rene Fonck (75), and Mick Mannock (73) had better records. After the war, Bishop became the first Canadian Air Marshall, and throughout the Second World War was director of the Royal Canadian Air Force. His World War I exploits were also the subject of an Archie

Goodwin/Alex Toth six-pager in 1966's *Blazing Combat* #2.

The End of the E15 followed swiftly after *Ace of Aces*. It told the tragic tale of the destruction of HMS E15 by British troops. The Royal Navy submarine had run aground on April 17, 1915, under the guns of the Turkish forces, and many lives were lost trying to keep it out of enemy hands. Lieutenant Commander Eric Robinson led the final assault on the craft. He would have undoubtedly earned the Victoria Cross had he not already been recommended for the award following earlier exploits on the Gallipoli peninsula.

Next came the story of another medal won in the air. *Insall's Epic Patrol* told how on November 7, 1915, G. S. M. Insall, a 21-year old Second Lieutenant in the 11 Squadron, Royal Flying Corps, forced an enemy aircraft to crash land near Achiet, France. When the German fliers looked set to continue their attack from the ground, Insall dove to 500 ft. and his gunner opened fire, forcing the Germans to flee. After dropping an incendiary bomb on the crashed German aircraft, he flew through heavy fire at 2,000 ft. over enemy trenches. Insall's petrol tank was hit, but he managed to bring his plane back inside Allied lines for an emergency landing. He was awarded the Victoria Cross for his actions.

Amazingly, DC Thomson's anonymous writers and artists were able to cram details of these and many other often complex incidents into just two pages. They continued spotlighting winners of medals during the First (and Second) World War in *The Victor* on a weekly basis until 1991.

▶ The Indian Army had many famous cavalry regiments, and even into WWI Indian horsemen took part in old-style cavalry battles. This *Victor* cover story depicts one such battle in March 1915, as the 33rd Queen Victoria's Own Light Cavalry clashed with a hostile Arab force.

▼ *Victor*'s "real life" WWI cover stories were particularly effective when recounting episodes of aerial derring-do, as these three examples from 1963 (*Ace of Aces* and *Insall's Epic Patrol*) and 1966 (*Duel Over London*) show.

▶▼ As depicted in *The End of the E15*, the British sailors who undertook the potentially suicidal mission to destroy the E15 were all volunteers. They all received Distinguished Service Medals.

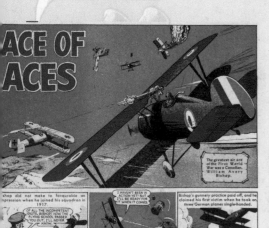

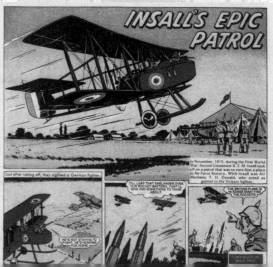

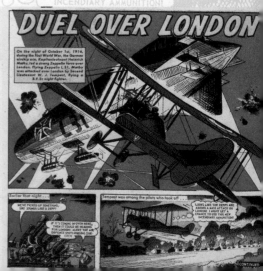

THE VICTOR

EVERY MONDAY
Price 3p
No. 583
Apr. 22nd
1972

WARRIORS OF THE SAHIB

In the old Indian Army were many famous cavalry regiments, and even up to the First World War these Indian horsemen, Warriors of the Sahib, took part in old-style cavalry battles. In March 1915, the 33rd Queen Victoria's Own Light Cavalry was patrolling the area of Shaiba in the Persian Gulf when warriors worthy of their mettle appeared on the skyline...

Captain Willoughby died of his wounds. Santa Singh, Bisham Singh and Buda Singh were awarded the Indian Order of Merit for their courage.

NEXT WEEK—"An Eventful Night!"—the story of a hectic patrol of the Welsh Guards!

Printed and Published in Great Britain by D. C. THOMSON & CO., LTD., 12 Fetter Lane, Fleet Street, London, EC4A 1BL.
© D. C. THOMSON & CO., LTD., 1972.

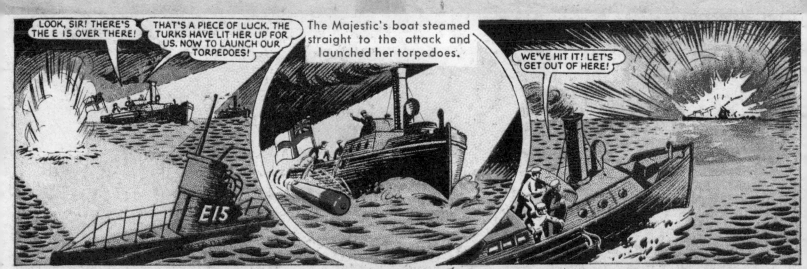

The Majestic's boat steamed straight to the attack and launched her torpedoes.

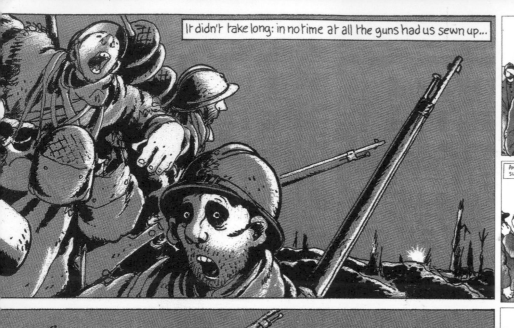

It didn't take long: in no time at all the guns had us sewn up...

And you, Tommy, you were sent as an ally from neighbouring England, but I'm sure you'll live to regret it.

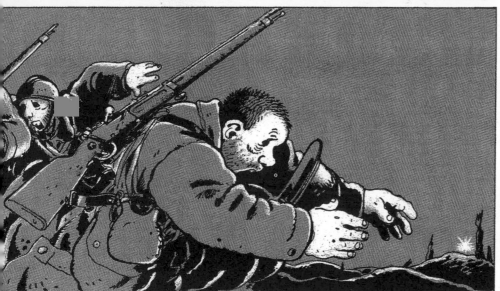

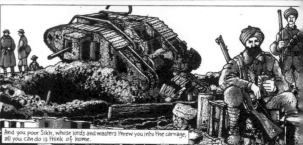

And you poor Sikh, whose lords and masters threw you into the carnage, all you can do is think of home.

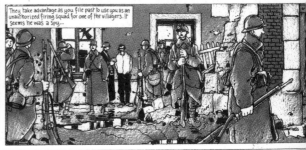

They take advantage as you file past to use you as an unauthorized firing squad for one of the villagers. It seems he was a spy...

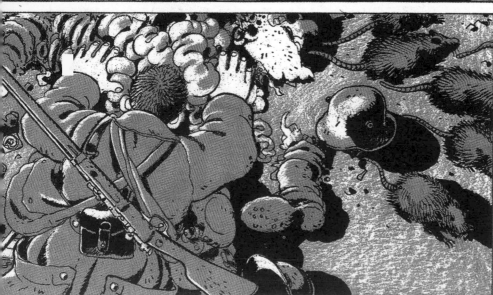

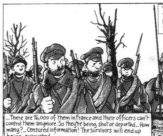

The Russians are leaving. They don't want to fight anymore. There on the line in the middle of France they've hung a banner saying 'DOWN WITH WAR'. The Tzar has abdicated and they want to go home because of the Revolution.

...There are 16,000 of them in France and their officers can't control them anymore. So they're being shot or deported...How many?... Censured information! The survivors will end up being evacuated.

Here come the Yanks... they took their time... The Vietnamese look on with great curiosity.

JACQUES TARDI'S TRENCH WARFARE

◄

In a neat parallel of *Charley's War*, here the French troops watch a column of blinded British soldiers walk past.

◄◄

The desperation and danger of trench warfare is brought vividly to life by Tardi, the hollow eyes of the soldiers effectively communicating the visceral sense of fear.

Better known outside France for his series of *Adèle Blanc-Sec* mysteries or *Nestor Burma* crime stories, the most memorable and affecting achievement of Jacques Tardi's career has been his horrific depiction of the trenches and No Man's Land during the Great War.

The *Blanc-Sec* stories encompass the period without explicitly dealing in warfare, and searching for a greater truth, Tardi would investigate World War I conflicts time and again for over a decade, punctuating his graphic novels with short stories about World War I.

Tardi's starting point were the recollections of his grandfather, a conscripted foot soldier who witnessed the horrors first hand, and from there he researched the documented remembrances of French soldiers enveloped by the conflict. It's an approach that ensures Tardi's depictions focus on the reactions and experiences of ordinary people, and that the foundations of his stories are consequences, not decisions. His lead characters are men whose hopes extend no further than wishing to survive a few more hours.

Due to the constraints imposed by British and American publishers working for defined markets, no artist producing English language comics has ever achieved the overtly graphic realism offered by Tardi. In one story alone, a soldier remains seated outside his trench hut with half his face blown away. An explosion propels the remains of a horse into a tree. Intestines seep from the stomachs of bayoneted troops, and the corpses of two butchered military policemen hang from meat hooks.

Tardi's lumpy black and white artwork accentuates a wasteland populated by hollow-eyed soldiers wandering amid the meticulously detailed mud, grime, and devastation. Tardi is no jingoistic patriot. His sympathies extend equally among the foot soldiers of all participating nations, and he notes the French army included battalions from the then-occupied territories of Senegal and Vietnam.

In 1997 Tardi would return to World War I by adapting Didier Daeninckx's novel *Varlot Soldat* ("Varlot, Soldier"), using only two panels per page. Varlot survived the Great War to become a private detective, but remains haunted by what he lived through.

Sadly few of Tardi's war stories are available in English. The second series of Canada's *Drawn and Quarterly* anthology translated three stories in 1994 and 1995, but for the full complement the French book *C'Etait la Guerre des Tranches* ("It Was Trench Warfare") is required. For the really dedicated, it forms part of the University of Sheffield's French course.

Two German hussars, obviously on inspection duty, turned up in the afternoon.

◄◄

Based on the recollections of his grandfather, Tardi paints a compelling picture of the multinational nature of the front line, with Russians, Americans, and even Indian Sikhs present.

◄

A quiet moment from *C'Etait la Guerre des Tranches*, as two light cavalrymen pick their way through a deserted, partly-destroyed French village.

THE HAMMER OF HELL

Always prepared to push the contemporary envelope, writer Robert Kanigher almost burst through it when he and artist Joe Kubert introduced Baron Hans von Hammer to American comic book readers.

The move was a particularly brave one, as war comics were still very traditional and jingoistic in 1965 when the character debuted in *Our Army at War* #151—and Von Hammer was German. Furthermore, the stories of the World War I fighter pilot better known as Enemy Ace were told from the German point of view; he was very much the hero of his strip. Describing the fighter ace—also known as the Hammer of Hell—Kanigher said, "Von Hammer is tall, lean, haunted, neurotic, a loner, a hunter and the hunted. When he was wounded and in a hospital, he kissed a nurse and she said it felt like a kiss from the angel of death, making him feel more alone than ever."

Writing to Richard A. Peterson, Department of Sociology and Anthropology at Vanderbilt University, First Comics co-founder Mike Gold declared, "At DC, Kanigher and Kubert cooked up a truly innovative feature called *Enemy Ace*, a World War I German air ace feeding off the Red Baron mythology. This was a psychological comic, probing into the German (Von Hammer) and his attitude to war and killing. The air battles were presented with great honor and valor… *Enemy Ace* was, in my opinion, the continuity war comic at its peak, featuring the most spectacular work by Bob Kanigher and Joe Kubert…"

To which Kanigher's response was, "Completely missing the point, in my biography in *The World Encyclopedia of Comics*, the biographer wrote that Enemy Ace was a *good* guy on the *wrong* side. Ye Gods! I wrote the series from the *German* point of view. To a German, the British, the French, and the Americans were the enemy."

To make Von Hammer more acceptable to US readers, the writer emphasized the German's devotion to duty, as well as the fact that, on a personal level, the pilot very much disliked sending honorable men to their graves. Enemy Ace made two more appearances in *Our Army at War* (in issues #153 and 155) before getting a shot at his own series via *Showcase*. He featured in 1965's #57 and 58, but sales obviously did not warrant an *Enemy Ace* title as it would be another two and a half years before he would fly again.

Beginning with 1968's #138, Von Hammer took over the lead slot in *Star Spangled War Stories*. Relegated to the back in 1970 (#151), he remained in the comic until 1972's #161, returning two years later (in #181) for a three-parter involving Lieutenant Steve Savage, a.k.a. Balloon Buster (see pages 52-53). A year after his stint in *Star Spangled War Stories* ended, he returned for ten issues of *Men of War*, beginning with the title's 1977 first issue and ending in 1979 with #20. In 1981 came a handful of issues of *Unknown Soldier*, after which sightings of Von Hammer were few and far between until 1990, when George Pratt produced *Enemy Ace: War Idyll*, a graphic novel that told of Von Hammer's meeting with a Vietnam veteran/investigative reporter, and how each helped the other to lay his particular wartime ghosts to rest. It concluded with the World War I veteran's death in a sanitarium in 1969 at the age of 73.

Von Hammer's next major appearance was in Tim Truman's *Guns of the Dragon*, an out of chronology 1998 six-parter set in 1929. Along with several other DC heroes, he ends up on Dragon (later Dinosaur) Island, the setting for DC's *War that Time Forgot* (see pages 82-83). He subsequently returned to Germany, as revealed in 2001's two-issue *Enemy Ace: War in Heaven*. Written by Garth Ennis and drawn by Christian Alamy and Chris Weston (#1) and Russ Heath (#2), the two-issue series followed the fighter pilot as he led a Luftwaffe squadron on the Russian Front, only to end up surrendering to an American unit led by Sgt. Rock (see pages 78-79).

▶
Russ Heath art from 2001's *Enemy Ace: War in Heaven*, Von Hammer's final flight to date.

▼ ▶▼
Hans von Hammer's life and character were loosely based on Rittmeister Manfred von Richthofen, a.k.a. the Red Baron. Artist Joe Kubert depicted the Enemy Ace as a melancholy man, seldom smiling, as seen here in *Our Army at War* #151 and *Showcase* #57.

▶▶
More than 40 years on from his debut it's hard to tell whether DC Comics were nervous about featuring Von Hammer on the cover for his first appearance, or felt the enigmatic flaming question mark would enhance sales. Given the potentially provocative nature of the Kanigher/Kubert creation, it's easy to surmise the former prompted the final decision, although the less than popular World War I setting probably also played a part.

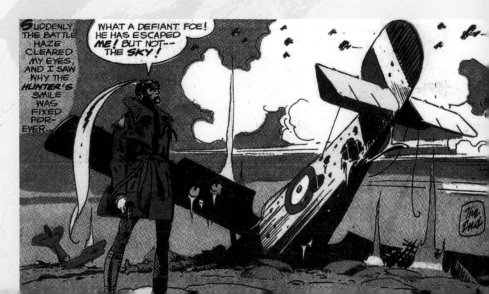

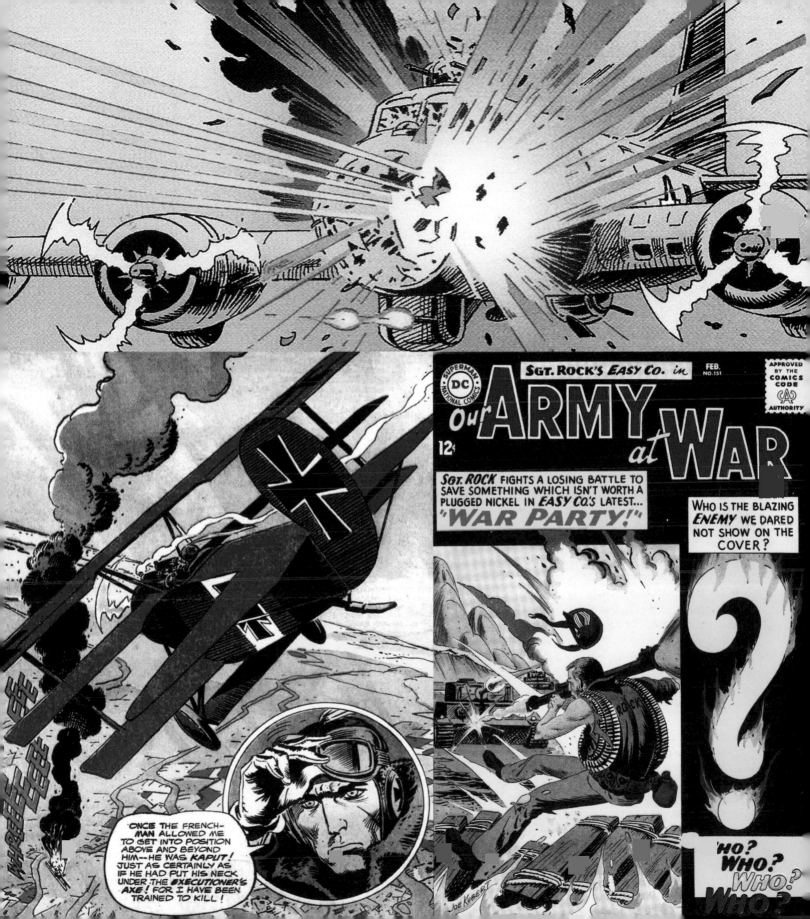

4 WORLD WAR II

CARTOONISTS GO TO WAR

Having been some of the first to point out the dangers of Adolf Hitler's regime to the US public, Jewish comic book creators also played their part on the battlefields of Europe and the steamy South Pacific. Indeed, there were very few of the Golden Age artists who didn't see military service in some form or another throughout World War II.

Will Eisner, creator of *The Spirit* and father of the modern graphic novel, was drafted in early 1942. "The Army gave me a six-month delay because I was working on [*The Spirit*]," the artist recalled in an interview in 2001. "I was kind of eager to be part of it…On the other hand, this was a year after I had started *The Spirit*, which represented a whole new career for me. And I knew that if I went into the Army this whole thing would kind of fall apart on me. So, I was torn between the two feelings. One was the eagerness to go and sign up. On the other hand, the loss of a possible career."

This was a familiar feeling for many cartoonists, and when war was announced, the creators of Captain America—writer Joe Simon and artist Jack Kirby—started working flat out to create a backlog of material for their comic books before they were drafted. Simon joined the Coast Guard in 1943 and spent most of the war creating Military comics in Washington, DC, but Kirby was conscripted into the 11th Infantry, under General George Patton, and eventually saw active service in Europe. He almost lost two feet to frostbite, and was awarded a Combat Infantry Badge and a bronze battle star, and his experiences—as for many—were life changing, seeping into his later comics work.

Meanwhile, Eisner was revolutionizing the army's training manuals. After basic training, the camp newspaper editor asked Eisner to contribute artwork, cartoons, and other work. Eisner went on to revamp the *Army Motors* magazine, using comics as a training tool, before starting *PS Magazine*, intended for training US troops.

Other cartoonists who served in the war included Sam Glanzman and Jack Davis, both of whom joined the Navy. Davis worked on the *Navy News*, where he created the character Boondocker. Fellow future EC artist Wally Wood was underage, but still managed to enlist in the military during WWII, serving in the Merchant Marine and later as a paratrooper. Bill Everett (creator of the Sub-Mariner) and Carl Burgos (creator of the Human Torch) were both drafted, while some, like the patriotic young Stan Lee, enlisted.

Nick Cardy worked at the Eisner-Iger Studio, alongside many other legends; he was drafted into the 66th Infantry Division as a tank driver. Bill Ward's popular *Torchy* was conceived during his four-year tenure in the US Army while stationed at Brooklyn's Fort Hamilton during WWII. The blonde bombshell was soon syndicated to other army newspapers worldwide, before gaining her own comic book when Ward returned to civilian life. And gag cartoonist and *Archie* artist Dan DeCarlo was shipped to the UK, where, as part of the cartographic team, he helped plan the D-Day landings.

Joe Kubert just missed out on serving in WWII, but when the Korean War started he was drafted into the infantry. "I was stationed at Fort Dix for a year…Most of the guys in my outfit went directly to Korea, but for one reason or another I was shipped to Germany," recalled the fortunate comics creator. "I recall getting letters from some of the guys and they told me about 50% of the guys were casualties within the first week of going to Korea…I had a brother-in-law who was in Korea, and he froze a couple of toes off. It was, like all wars, a horrible situation."

Underground cartoonist Don Lomax was drafted into the Vietnam War and turned his experiences into the unflinching series, *Vietnam War Journal*. Writer Doug Murray did the same with his Comics Code-approved series *The 'Nam*, with fellow Vietnam vet, Larry Hama, as his editor.

▲
Stan Lee was the youngest editor in the comics business when World War II broke out. He enlisted, and spent the war scripting training films, posters, and even turning training manuals into comics. After the war, Lee of course returned to comics, eventually bringing the Marvel Universe we know today to life. This panel from *Stan Lee Meets the Thing*, 2006.

◄ ◄◄ ◄▼
Will Eisner's 1991 autobiographical graphic novel *To the Heart of the Storm* follows a young man riding a troop train during World War II and recalling his life.

◄◄
Cartoonist Dick Ayers served in the Army Air Corps, where he published his first comic strip, *Radio Ray*, in the *Army Radio Post* in 1942. After the war he had a successful run on many Marvel titles, including *Sgt. Fury*. This page is from his auobiographical *Dick Ayers Story*, published by Century Comics.

SUPERHERO PROPAGANDA

Throughout World War II the funny books fueled patriotic fervor. Superhero comic books regularly presented Axis leaders Hitler, Mussolini, and Tojo as figures of ridicule.

When Fawcett's Captain Marvel foiled their plans—in 1942's *Captain Marvel Adventures* #12 by Otto Binder and artist C. C. Beck—they bickered among themselves in the knockabout manner of the Three Stooges. In Tojo's case, and that of most Japanese represented in 1940s comics, there was the added level of offensively exaggerated racial characteristics. He was generally colored bright yellow, and portrayed as a myopic, slavering fiend, who, when not possessed of the most prominent front teeth this side of Bugs Bunny, was given fangs. Praise must go, therefore, to Irv Novick, artist in *Zip Comics* #26, for his restrained 1942 portrayal of Tojo and other Japanese, as Steel Sterling flies the Pacific to interrupt Tojo's broadcast to the nation.

For caricaturists and comic book artists, Hitler was easily mocked with his Chaplinesque mustache and floppy fringe parting. Countless superheroes queued up to sock his jaw during World War II, most prominently the original (Lev Gleason) Daredevil. His 1941 first issue was actually titled *Daredevil Battles Hitler*. He teamed up in separate stories with other Gleason-published characters Speed King, Lance Hale, Cloud Curtis, Pirate Prince, and Dickie Dean, Boy Inventor, bopping Hitler several times and foiling his plans several more.

In the years since, Hitler has remained ubiquitous. A robot Hitler fought the JLA in 1973's *Justice League of America* #108 by Len Wein and Dick Dillin, while, a decade earlier, the Fantastic Four unmasked the bile-spewing Hatemonger to discover Hitler had survived the bunker after all, as revealed by Stan Lee and Jack Kirby in *Fantastic Four* #21.

The propaganda cut both ways. In 1940 *Look* magazine commissioned Superman's creators Jerry Siegel and Joe Shuster to produce a two page strip about how Superman would end the war. It was prominent enough to attract the attention of Nazi Propaganda Minister Josef Goebbels. In Nazi newspaper *Das Schwarze Korps* ("The Black Battalion") he unpleasantly called Siegel "an intellectually and physically circumcised chap," and noted, "The inventive Israelite named this pleasant guy with an overdeveloped body and underdeveloped mind 'Superman.'"

Beyond spreading patriotic propaganda via ridiculing enemy leaders, the comics of the 1940s regularly featured their heroes asking readers to reduce waste, invest, or save. Captain America exhorted the audience to join his Sentinels of Liberty and save paper.

The Beck/Pete Costanza art team gave the cover of 1942's *Captain Marvel Adventures* #15 over entirely to a contest where the prize was war bonds. Advertisers sponsored such pages. In the same year's *Uncle Sam Quarterly* #4 (Quality Comics) the Tootsie Roll of Honor spotlighted kids who helped the war effort while promoting the Tootsie Roll brand of tooth decay. And decades of ads on the back of comics exhorting kids to sell seeds for prizes began in the 1940s, promoting seeds for Victory Gardens.

▶
Published in 1941, *Daredevil* #1 features possibly the only photographic appearance of Hitler on a comic book cover. Artist Bob Wood depicts the dictator being attacked by Daredevil and his pals.

▶▶
Throughout the war, *Captain America Comics* often contained adverts featuring Cap urging readers to join the Sentinels of Liberty, "America's fastest growing patriotic organization." For just ten cents, members would receive an official badge, a membership card…and regular requests to save paper!

◀
Post-World War II, Hitler's presence could still be felt in comic books, as in this Jack Kirby panel from 1963's *Fantastic Four* #21.

▶
H. G. Peter provided the dynamic cover for the January 1943 issue of *Sensation Comics*, featuring Wonder Woman tossing bowling balls at the bowling pin-mounted heads of Hitler, Tojo, and Mussolini.

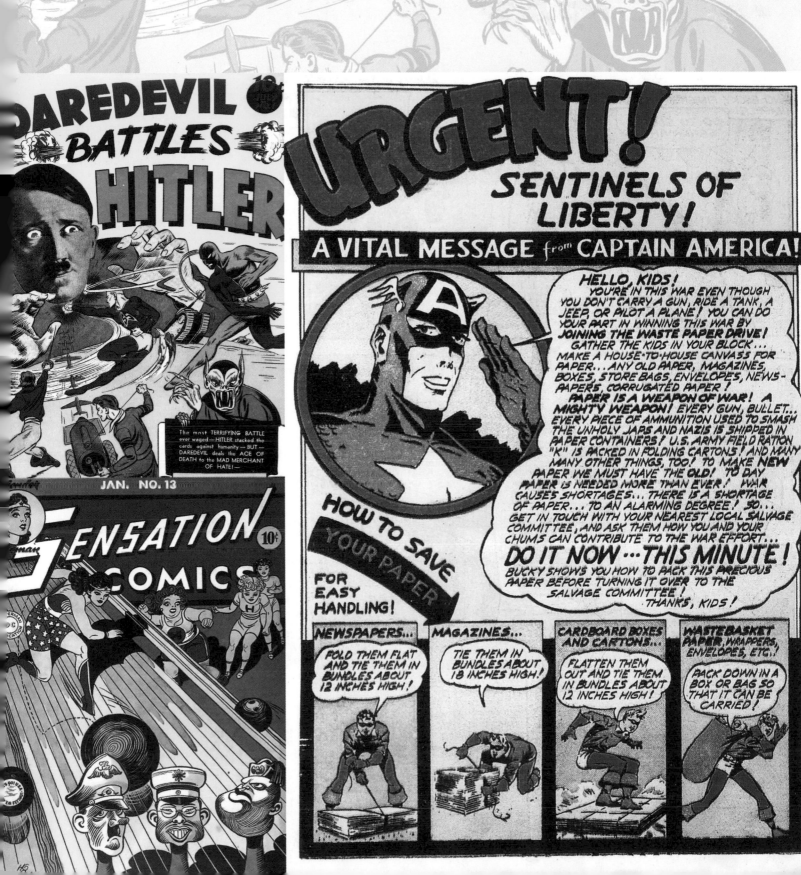

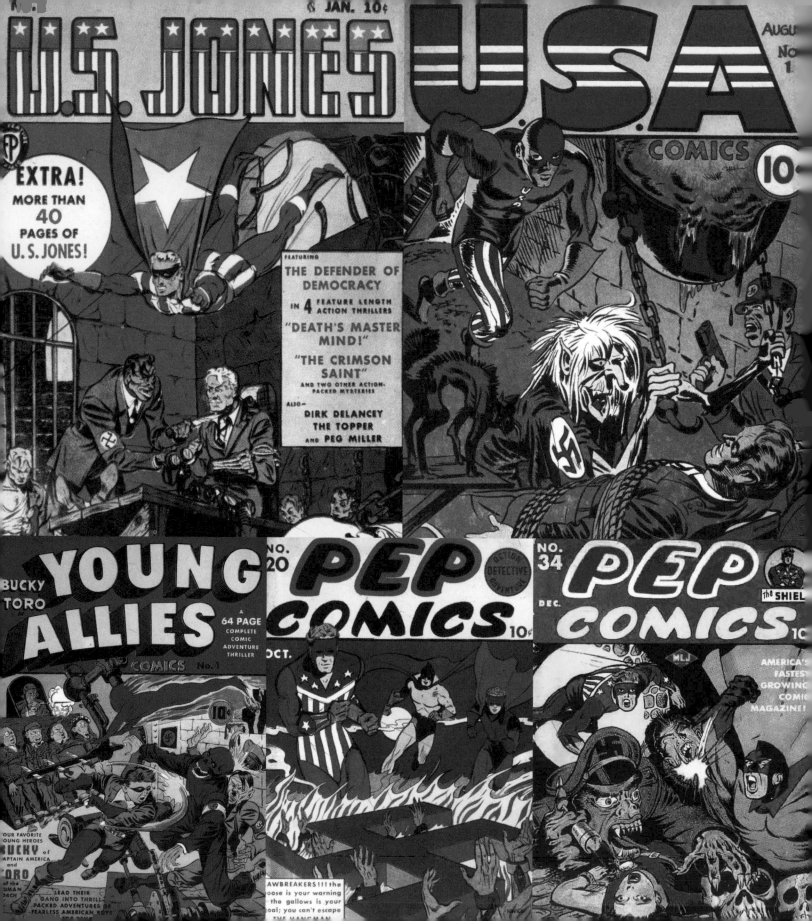

SUPERHEROES GO TO WAR

World War II was a bonanza for comic book publishers. Comics featuring superheroes fulfilling the wishes of every soldier were lapped up in their millions by G.I.s. Almost every publisher took their lead from Timely's Captain America, wrapping a character in the red, white, and blue of the US flag and dispatching them to patriotic duty.

On the cover of his 1941 first issue, Captain America delivered a right hook to Hitler's jaw, and along with kid sidekick Bucky, he rooted out fifth columnists, war racketeers, and ended the nefarious plans of the villainous Red Skull. The Shield (introduced in MLJ's *Pep Comics* #1, 1940) had been the initial flag-wrapped patriot in comics, but he lacked the talents of creators Joe Simon and Jack Kirby. Under them Cap was a kinetic blur of action, and Kirby would later claim Cap made Timely as a publisher: "The entire line went up 50% because of it." For his part, Simon titled a chapter of his recollections *Captain America: Our Answer to Hitler*.

Timely knew a good thing when they saw it, and made sure that the Sub-Mariner and the Human Torch pounded Nazis and battered Japanese. It didn't take long for other publishers to follow suit. DC transformed Mr. America into the Americommando, then introduced the Star-Spangled Kid, while elsewhere there were the Spirit of '76, the Fighting Yank, Commando Yank, Miss Victory, Minuteman, and Flagman. Timely even introduced their own Captain America clone, the Patriot. The best of them was Uncle Sam. First seen in the 1940 premiere issue of Quality's *National Comics*, the super-strong embodiment of the American spirit emerged from the mists of history in the country's hour of need.

While superheroes were wish-fulfillment fodder for G.I.s, kid gangs provided the same service for children. Again, Simon and Kirby were responsible for the best: *Boy Commandos*, starting in 1942's *Detective Comics* #64 and running there for seven years, alongside 36 issues of their own title. Having grown up in a tough neighborhood, Kirby identified with scrappy kids doing their bit. Daring fighter pilots were also a popular standby, with Sky Wolf, Captain Flight, Captain Aero, Captain Midnight, and Captain X of the Royal Air Force, among others.

Two features stood out. Airboy—first seen in the 1942 second issue of Hillman's *Air Fighters Comics*—was a teenage flying prodigy with a distinctive bat-shaped plane who flew out of a Californian monastery into 11 years of comics, long outlasting the war. Introduced in 1941 in *Military Comics* #1, Quality's Polish Blackhawk led a multinational airborne squadron named after him, all wearing a distinctive military uniform (see pages 72–73). He didn't create the strip, but its success was in no small part due to artist Reed Crandall's virtuosity.

Decades later writer and history buff Roy Thomas would create two successful series setting superheroes in World War II. *The Invaders* (1975) starred Timely's 1940s heroes, and for much of its run featured the cinematic action art of Frank Robbins. Six years later, in *All Star Squadron*, the writer united most of DC's 1940s heroes. Thomas even solved the dilemma of why all-powerful superheroes didn't end WWII in minutes. *All Star Squadron* #4 revealed how Hitler's possession of the Spear of Destiny created mystical barriers around Axis territory. These transformed any hero vulnerable to magic into a Nazi. So now you know.

◄◄
Lasting just two issues, *U.S. Jones* was published between November 1941 and January 1942 by Fox Comics. Little is now remembered about this short-lived hero.

◄
Kicking off in August 1941 from publisher Timely Comics, the debut issue of *USA Comics* spotlighted the Defender on the cover—as drawn by Jack Kirby and Joe Simon—who battled Nazis until the end of the war, when he was shot dead by a mobster.

◄ ◄◄
Published by MLJ Magazines (later to become Archie Comics) from January 1940, *Pep Comics* starred the first patriotic superhero, the Shield, created by writer Harry Shorten and artist Irv Novick.

◄◄◄
Debuting in the summer of 1941, the *Young Allies* were a group of superhero sidekicks and other spirited youngsters, gathered together by Bucky (Captain America's partner) and Toro (the original Human Torch's pal) to set an example for the youth of America in the days leading up to the country joining World War II. Cover art by Jack Kirby.

LIFE DURING WARTIME

The experiences of ordinary people during World War II have provided plenty of material for several excellent graphic novels.

Writer James Robinson's first published comics work was 1989's *London's Dark*. Elegantly illustrated by Paul Johnson, the Titan-published title is set in the British capital during the blackout. ARP warden Jack Brookes investigates a murder involving black marketeers in a city bombed every night, yet with a population displaying a stoic spirit that enables them to make do and survive in extreme conditions. Along the way, Jack discovers love as well as the culprits, and there's a whiff of the supernatural.

Autumn, written by Colin Clayton and Chris Dows, is set in the same period, also with supernatural elements, as a serial killer carries out his grisly work confident he'll remain undetected amid the carnage caused by the constant bombing. There's a certain irony in German artist Horus drawing this 1995 Caliber series.

Published by Jonathan Cape in 1999, Raymond Briggs' loving memoir to his parents, *Ethel & Ernest: A True Story* has large sections dealing with his childhood during World War II. With their son evacuated to the country, away from bombs, Ethel and Ernest construct Anderson shelters and modify the kitchen table to become a safe sleeping area. A milkman by trade, Ernest serves as a volunteer fireman and is a witness to carnage that finally penetrates his relentlessly optimistic chin-up persona.

Wartime France under Nazi occupation is the setting for two connected and excellently illustrated stories by French writer/artist Jean-Pierre Gibrat. In *Le Sursis* ("The Reprieve"), Julien returns home to hide from the Germans. Only able to roam during darkness, he can't reveal himself to his girlfriend, Cécilef. When they do reunite, Julien starts taking greater risks that lead to his capture. *Le Vol du Corbeau* ("Flight of the Raven") concerns Jeanne, anonymously betrayed to the police. She escapes in the company of housebreaker Francois, who conceals her on his family's barge, where she starts a new life. Both combine love and tragedy, adventure and tension; sadly, neither is available in English.

Translated into five English-language volumes, *Adolf* was originally serialized in Japan's *Shukan*

Bunshen between 1983 and 1985 as *Adorufu ni Tsugu* ("Tell Adolf"). It's a characteristically quirky story from manga master Osamu Tezuka, beginning with two German boys named Adolf growing up in Japan in the years immediately preceding World War II, and playing out over a decade. When war arrives, the one-time playmates are set on the path to separate destinies. Adolf Kauffmann, half German and half Japanese, is sent to a German public school and Hitler Youth indoctrination, while the Jewish Adolf Kamil remains in Japan and becomes privy to a secret about the far more famous German Adolf. At over 1,000 pages, Tezuka supplies a love story, a thriller, and a pontification on upbringing and destiny that's compulsive reading.

LONDON'S DARK

2ᴅ

A TALE OF
LOVE & WAR,
LIFE, DEATH
(& AFTERLIFE).

BY
JAMES ROBINSON
& PAUL JOHNSON

Raymond Briggs' mother and father, the titular *Ethel and Ernest*, discuss newspaper reports about Hitler in the run up to the war, in *Ethel & Ernest: A True Story*.

Paul Johnson's cover for the 1991 World War II "Home Front" graphic novel *London's Dark* employs a "distressed" design and includes the price in pre-decimalized money for period effect.

In *London's Dark*, the lead character, Jack, is an Air Raid Precautions warden. ARP wardens were charged with patrolling the streets to make sure no lights were visible to Luftwaffe bombers.

As shown here in *London's Dark*, when the air raid sirens sounded during the Blitz, Londoners would often seek shelter in the Undergound (or "Tube") tunnels.

RACISM: JAPANAZIS

As World War II raged, cartoonists used every weapon in their art box to help win the hearts and minds of the US public and get them to join in the war effort. While many utilized their new and existing superheroes as positive role models—succeeding where real life soldiers couldn't—some cartoonists turned to a more pernicious form of propaganda. Many started playing up racial stereotypes of the enemy.

It didn't take long for comic book artists to start portraying Germans as thick-set, heavy browed, near-Neanderthal thugs. These Cro-Magnon henchmen were loutish, brutal, and stupid, and subsequently easily outwitted. Conversely the Nazi leaders and scientists were small, weasely characters, possibly based on Joseph Goebbels' (Hitler's propaganda minister) appearance.

As the war progressed these caricatures of the Nazis grew more pronounced, until scientists were being portrayed as sub-human creatures with lizard tongues, razor sharp teeth, a deathly green pallor, and barley discernable human features. Even the language used in the comics had racist overtones, with the Germans often referred to as "Ratzis."

After Pearl Harbor in 1941, US artists' ire unsurprisingly turned on the Japanese. Oriental stereotypes weren't new in comics—ever since the late 1800s there had been insidious caricatures of Chinese, Koreans, and Japanese in US newspaper strips—but after war was declared these caricatures increased ten-fold. Most Japanese soldiers were depicted as buck-toothed, myopic morons and sadists wearing Coke-bottle glasses. Their skin was portrayed as being yellow, a color associated with cowardice, and often the enemy would be seen terrorizing innocent civilians or helpless victims, until confronted with real soldiers, at which point the Japanese would flee in terror.

The cover to *Air Fighters Comics* #6 (March 1943) took this racism to new extremes, featuring the lead character, Airboy, swooping down in his plane and machine-gunning a bunch of rats with Japanese human heads. Graphic—even by today's standards—the cover showed bullets pumping into the scattering human/rat hybrids, with blood flying everywhere. This brutal depiction of enemy soldiers as vermin reveals how high emotions were running after Pearl Harbor, and ironically uses the same iconography that the Nazis used to describe the Jews in Germany.

Amazingly, these kinds of racial stereotypes continued in both British and US war comics, right through the Korean War and even as late as the 1970s and 1980s.

▶ ▶ ▶
Debuting in the second issue of Hillman's *Air Fighters Comics* (November 1941), Airboy's adventures often featured racial caricatures, as on these Bob Fuje covers for issues #6 and 8.

▶ ▶ ▶
Standard stereotypes for Japanese soldiers were pronounced front teeth and exaggerated squints. Here, on this Alex Schomburg cover for #12, the Fighting Yank vanquishes a platoon of identikit Japanese soldiers, and ties up a similarly caricatured Hirohito for good measure.

▶
Bucky, Toro, and friends weren't above laying into stereotyped Japanese soldiers, as this Alex Schomburg cover from March 1944 demonstrates.

▶ ▶
Al Avison portrays Shock Gibson battling a Nazi scientist who is practically a full-fledged lizard on this 1941 cover for *Speed Comics* #14—the second ever comic book to be published by Harvey Comics, who took over the series from Brookwood.

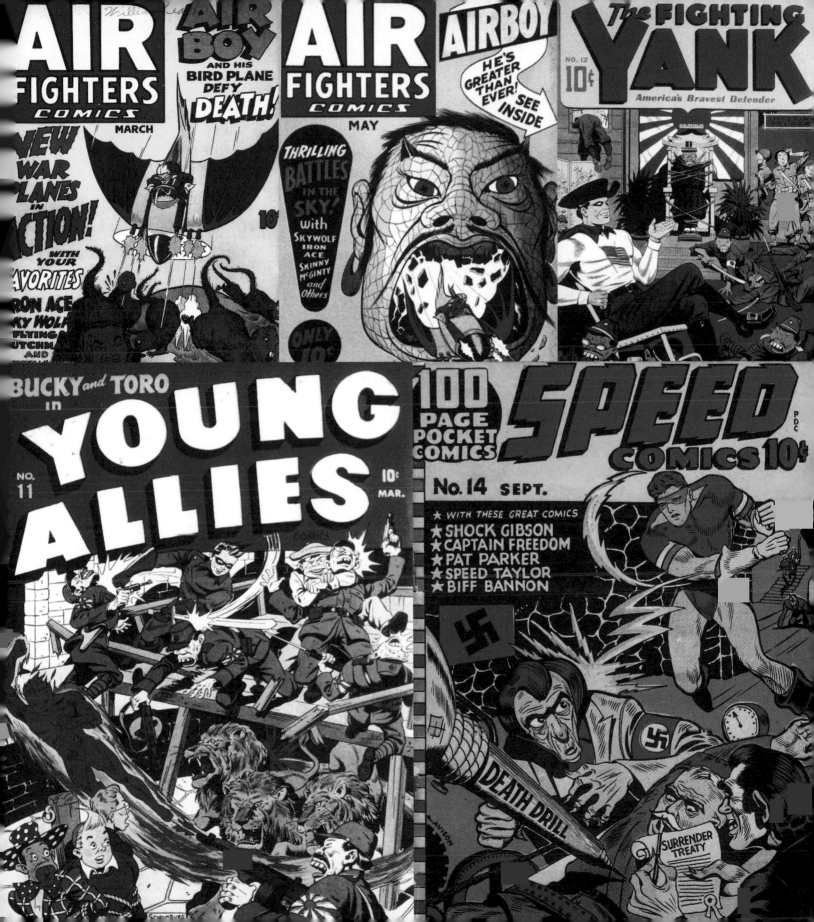

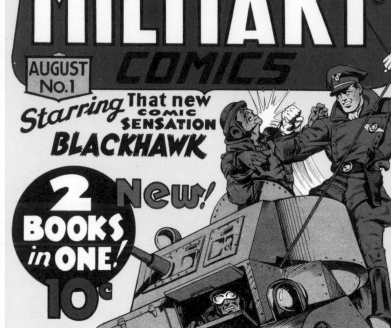

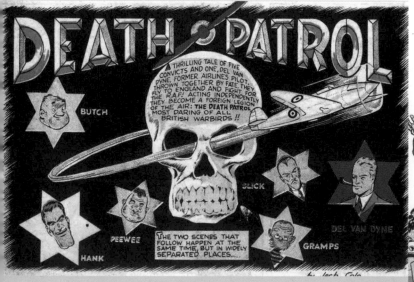

OF BLACKHAWKS AND DEATH PATROLS

G.I. Combat publisher Quality Comics' first major foray into the war zone came with the 1941 first issue of *Military Comics*, which carried a tagline: "Stories of the Army and Navy."

Divided into two sections—one for each of those branches of the armed forces—the title is best remembered for introducing the Polish airman known as Blackhawk to the world. Cover featured on all 102 issues of the series (which, with World War II at an end, was re-titled *Modern Comics* with #43), the flying ace and his multinational Blackhawk Squadron were eventually acquired by DC Comics, which kept the *Blackhawk* comic Quality launched in 1944 going until 1977's #251.

Created by Will (*The Spirit*) Eisner with input from Chuck Cuidera (who drew their first adventure) and others, the Blackhawks battled Nazis initially. Post World War II, when they ran out of fascists to fight, the fighting fliers took to combating Commies and various would-be world conquerors.

Intriguingly, although the front half of *Military Comics* was supposedly devoted to the Army, not only did *Blackhawk* lead off the section, but right behind it came another series about fliers. Drawn by Bob Powell (credited as Bud Ernest), *Loops and Banks of the Red Dragon Squadron* followed the antics of two freelance airman in China. Klaus Nordling's semi-humorous *Shot and Shell* also maintained a flying theme.

Even the other two "Army" strips only loosely fit the definition. The Fred Guardineer-illustrated *Blue Tracer* centers on an American engineer who built the titular hi-tech vehicle. In it he travels the world fighting the Axis. Then there is *Archie Atkins, Desert Scout*, a series whose creators' names are lost in the mists of time. It was replete with Arabs, Legionnaires, and the like, as well as Germans.

Sailing on to the Navy section, the lead strip was the John Stewart-drawn *Yankee Eagle*, which tells of Naval Secret Service operative Jerry Noble and his sidekick…an eagle named Sam. Then came Jack Cole's *Death Patrol*. Predating *The Dirty Dozen* movie by over 25 years, the *Plastic Man* creator's series focuses on five escaped convicts—initially a forger, a safe cracker, a pickpocket, a cattle rustler, and a con artist—who band together to fight the Nazis.

Like *Death Patrol*, *Miss America*—drawn by Ed Wexler—actually has nothing to do with the Navy. Neither can the strip's heroine be described as being of a military bent. Instead the superhero-like lady in question is a young reporter gifted with magical powers by the Statue of Liberty!

Rounding out the first issue was *Q-Boat*. Illustrated by Henry Kiefer, it told of the Albatross, a four-masted schooner equipped with modern and advanced engines and weapons, including a plane.

Every culture, every civilization has been proud to laud its heroes and celebrate their valor. The US comic book industry was more than happy to play its part in the celebration of US fighting men, with *True Comics* leading the way.

The anthology premiered in 1941 from the aptly named True Comics, Inc. This was an imprint of Parents' Magazine Press and, as such, was committed to providing worthy, wholesome material with an educational bent rather than simple four-color entertainment. The first issue led off with a biography of then British Prime Minister, Winston Churchill (culminating in his "I have nothing to offer you but blood, toil, tears, and sweat" speech). Among other strips, it also included a history of fighting aircraft, the first in an ongoing series on famous frontier fighters, the story behind the discovery of a cure for yellow fever, and a biography of South American liberator Simon Bolivar. Featured in addition was a retelling of the battle of Marathon and of the subsequent long-distance run that gave its name to the famous race.

Later issues followed a similar template but, as war loomed for the US, the content took on a more militaristic slant. Initially it spotlighted contemporary bigwigs, among them US Army Chief General George C. Marshall; Rear Admiral John H. Towers; US Navy Chief Harold R. Stark; US Marine Chief Major General Commandant Thomas Holcomb; and General Douglas MacArthur, as well as New Zealand's General Bernard C. Freyberg and French General Charles de Gaulle. Later, the focus gradually shifted to the men (and women) on the frontline. Jingoistic tales of courage from every theater of war became commonplace, with even the bravery of the Shadow Army—the men and women of the Office of Strategic Services—and the Russian allies not going neglected.

Brimful with patriotic fervor, *True Comics* lasted 84 issues until 1950. While the war stories became infrequent toward the end, they did not cease entirely; one of the last told of General Lucius D. Clay, Military Governor of the US Occupation Zone in Germany and "father" of the Berlin Airlift.

Three different comic books have featured stories about Congressional Medal of Honor winners, all titled *Medal of Honor*. The first was published by A. S. Curtis in 1946, while another *Medal of Honor* series kicked off in the back of DC's *Star Spangled War Stories* #160 in 1964. Written and drawn by Norman Maurer, it consisted of just a dozen sporadically-published strips, most of which ran in *Our Army at War*. A third *Medal of Honor* series was published by Dark Horse in 1994.

Of the many one-off stories chronicling the derring-do of true-life war heroes, *Movie Comics* #10123-409 is worth an honorable mention in dispatches. The 1964 Dell comic tells the story of John F. Kennedy's exploits in the Pacific. It is, however, an adaptation of *PT-109*, the 1963 movie starring Cliff Robertson as the future president.

▼ ▶

The 1994 Dark Horse four-part (plus one-off special) *Medal of Honor* mini-series featured stories of winners of the Congressional Medal of Honor—as did an earlier, similarly titled one-shot. Published by A.S. Curtis in 1946, this 36-pager crammed in 15 tales of valor.

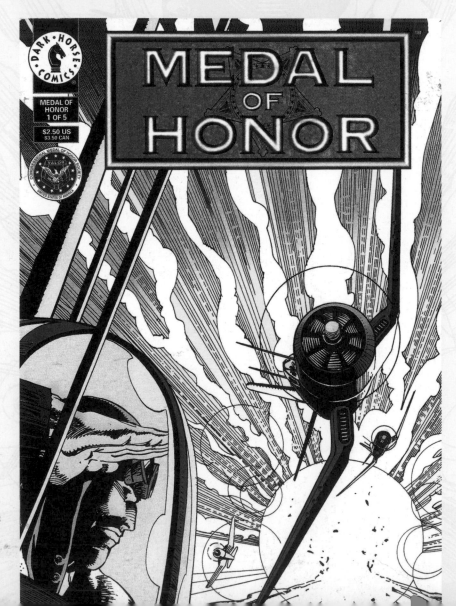

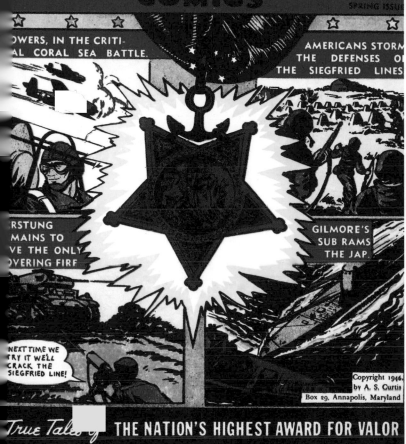

In later issues of the *True Comics* series, stories began to appear of the British Commandos, the Fighting Seabees (a.k.a. the Construction Battalions of the US Navy), Merrill's Marauders, and other renowned fighting units, as well as tales of individual heroism.

A typical tale from *True Comics* #25, this page contains the iconic moment when Marines planted the US flag on Mount Surabachi on February 23, 1945.

BEHIND ENEMY LINES

When working on war comics, most writers and artists tended to concentrate on the sound and fury of all-out action, whether it be on land, sea, or in the air. Some, however, took it upon themselves to highlight the dangerous exploits of the brave souls who waged a guerrilla war on the enemy that occupied their homelands.

One of the first comic book resistance fighters was Monsieur X, who made his one and only appearance in a nine-page *Secret War News* story in Quality's *Military Comics* #6. Created by Al McWilliams, he was a domino mask-wearing Frenchman, who left a Zorro-like "X" wherever he terrorized the Nazis.

Introduced at the same time was Lieutenant John Watkins. First seen in 1942 in a Ben Thompson-illustrated 10-pager in the eighth (and final) issue of Timely's *Daring Mystery Comics*, this British quasi-superhero led an underground resistance group—the V Battalion—deep into the heart of Nazi-controlled Europe. Like his French counterpart, he also had a Zorro influence; his calling card was a large red "V" daubed on the chests of Nazi officials he had first relieved of their shirts!

▶▲

The Marksman was in reality Baron Povalsky, a Polish aristocrat whose family castle became headquarters for the German occupation forces. Infiltrating their ranks as Major Hurtz—the troops' commanding officer—he used his archery skills against the invaders.

▶▶

Mademoiselle Marie continued to appear sporadically over the years following her 1959 debut. A 2008 ret-con (retroactive continuity) revealed "Mademoiselle Marie" to be a codename that dates back to at least the French Revolution.

▶ ▶▶

Named after The Tomb of the Unknown Soldier at Arlington National Cemetery, Virginia, and intended to symbolize the nameless soldiers that have fought throughout America's wars, the Unknown Soldier is the "man who no one knows—but—is known by everyone!" DC's mature readers imprint Vertigo again returned to the character in 2008, with an ongoing series by Joshua Dysart and Alberto Ponticelli.

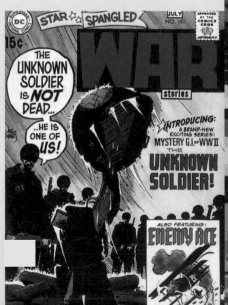

MADEMOISELLE MARIE

V made only one other appearance (in *Comedy Comics* #9) but was soon replaced by the even more superhero-like Marksman, who surfaced in 1942 at Quality Comics in a seven-page story drawn by Ed Cronin in *Smash Comics* #33. Battling the Nazis almost to the end of the war (actually 1945's *Smash Comics* #58), four issues after his debut he crossed paths with the Three Shadows: a Czech, an Austrian, and a Pole, who escaped from a concentration camp and joined the underground.

More in keeping with reality was Mademoiselle Marie, who became a major legendary figure in the DC Universe's version of the French resistance movement. Created by Bob (*Sgt. Rock*) Kanigher and artist Jerry Grandenetti, she first appeared in 1959's *Star Spangled War Stories* #84 in a series that ran to eight issues.

Another important member of DC's French underground was Chat Noir (Black Cat), a.k.a. Steve Robinson. Created by legendary *Sgt. Rock* artist Joe Kubert and unique in that he was African American, this leader in the resistance movement was first seen in 1970's *Star Spangled War Stories* #151, the issue that also introduced his frequent ally, the Unknown Soldier. He died—gunned down by Nazi soldiers—on April 20, 1945 (as depicted in 1972's *Unknown Soldier* #268, the last issue of the series).

The Unknown Soldier was created by *Sgt. Rock*'s Joe Kubert, who introduced him in 1970's *Star Spangled War Stories* #151. The heavily bandaged hero (occasionally referred to as the Immortal G.I.) was a master of disguise, a severely disfigured intelligence operative whose run in *Star Spangled War Stories*—which was re-titled *The Unknown Soldier* with 1977's #205—continued until the series ended in 1982. In keeping with changing attitudes toward war, in 1988 Jim Owsley and artist Phil Gascoine produced an *Unknown Soldier* 12-parter that depicted the titular hero as literally immortal and more cynical about the United States than the clearly patriotic original. That series was ignored when *War Stories'* Garth Ennis and artist Kilian Plunkett teamed up for a 1997 *Unknown Soldier* four-parter. Published by Vertigo, DC's mature readers imprint, this told of a CIA agent investigating the Soldier's post-war activities while the Soldier searched for his own replacement.

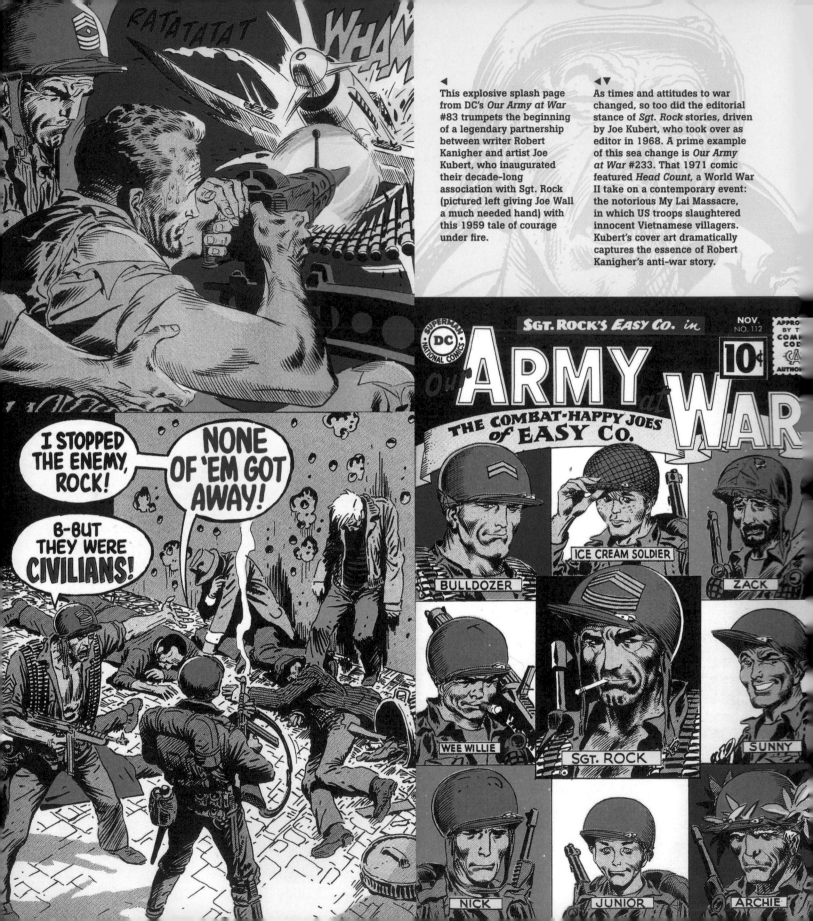

◄ This explosive splash page from DC's *Our Army at War* #83 trumpets the beginning of a legendary partnership between writer Robert Kanigher and artist Joe Kubert, who inaugurated their decade-long association with Sgt. Rock (pictured left giving Joe Wall a much needed hand) with this 1959 tale of courage under fire.

◄◄ As times and attitudes to war changed, so too did the editorial stance of *Sgt. Rock* stories, driven by Joe Kubert, who took over as editor in 1968. A prime example of this sea change is *Our Army at War* #233. That 1971 comic featured *Head Count*, a World War II take on a contemporary event: the notorious My Lai Massacre, in which US troops slaughtered innocent Vietnamese villagers. Kubert's cover art dramatically captures the essence of Robert Kanigher's anti-war story.

SGT. ROCK

Throughout the 1940s and 1950s, the vast majority of war comics were anthologies offering isolated glimpses of conflict in various theaters, and spotlighting an ever-changing cast of combatants from different eras. But World War II in particular became a comic book battleground for some high-profile regulars. The first of these was the star of Ziff-Davis's *G.I. Joe* (1950-1957, see pages 132-133), but others soon followed. Among them were Marvel's gung-ho *Sgt. Fury and his Howling Commandos* (see pages 80-81), while, in Britain, the outrageous and outlandish Captain Hurricane became the lead feature in *Valiant* (see pages 114-115). Standing head and shoulders above them all, however, was a particularly gritty DC war hero: Sgt. Rock.

Rock was introduced in a six-page strip in 1959's *Our Army at War* #81, entitled *The Rock of Easy Co!*, written by Bob Haney and with art by Ross Andru and Mike Esposito. Haney collaborated with artist Mort Drucker on a second six-pager in the following issue, but it was when Robert Kanigher and artist Joe Kubert got together for *The Rock and the Wall* in #83 that the legend of Sgt. Rock truly began to take form. World War II may only have lasted six years, but thanks to the foundations laid down by Kanigher and Kubert, Rock and "the combat-happy Joes of Easy Company" have been fighting for almost 50 years—and the war's not over for them yet.

Visually, Rock personified his name; he was a granite-faced Titan, an indomitable and seemingly invincible infantryman who, through sheer force of will, always won the day. As a rookie private, Frank Rock's first taste of war came on the bloody French beaches of D-Day, but he soon rose to the rank of sergeant, overseeing the colorful G.I.s of Easy Company. Among his motley platoon were the colossal, Gatling gun-wielding Bulldozer, the Indian brave Little Sure Shot, the hillbilly Wild Man, Zack, Ice Cream Soldier, and (literally) hundreds more.

At the end of the 1960s, Kubert became the comic's editor and immediately introduced a strong anti-war theme, each episode ending with the phrase, "Make war no more."

Throughout its long existence, *Sgt. Rock* was graced with inventive scripts from Kanigher and terrific art, first from Kubert, and then the talented Russ Heath, followed by John Severin, Frank Redondo, and many others. Rock himself became a mainstay of DC Comics' line, with *Our Army at War* being re-titled *Sgt. Rock* with 1977's #302.

As victory followed victory, Rock's war heroics merited countless promotions but he always refused, claiming that his place was with his men. In interviews and letter columns, Kanigher stated that Rock could have no life beyond the war, and that he was to die on the last day of the war.

The writer himself passed away in 2002, without ever writing that final Rock story. But even after the death of his main writer and his title's cancellation in 1988, Rock lives on. His most recent appearances include a deluxe 2003 hardcover, written by Brian Azzarello (*100 Bullets*). *Sgt. Rock: Between Hell and a Hard Place* was drawn by Kubert, who also produced 2006's *Sgt. Rock: The Prophecy* mini-series.

With his 50th anniversary looming, the legend still refuses to die, and Billy Tucci wrote and drew another six-parter, *Sgt. Rock: The Lost Battalion*, in 2008.

◄ Surrounded by the Easy Company regulars, the chiseled features of Sgt. Rock take center point in Joe Kubert's art for the cover to *Our Army at War* #112 (1961).

▼ Original art for a double-page splash by Doug Wildey for *Our Army at War* #285 (1975).

HOWLING COMMANDOS AND HAUNTED TANKS

The sheer volume of US war comics led to publishers looking for gimmicks to separate their titles from the main body. In some cases this was merely a matter of keeping one foot grounded in reality, while still treating combat with an over-the-top-exuberance. Marvel unleashed a prime example in 1963 with the first issue of *Sgt. Fury and His Howling Commandos*.

Written by Stan Lee and penciled by Jack Kirby—the artist hailed as the King of Comics—the series sent a mixed bag of troops off to wreak havoc on the Nazis. The unit—which was American, despite the Commandos being a uniquely British regiment—would not have been out of place in a World War II version of *The Magnificent Seven*, although 1967's *The Dirty Dozen*—sans the condemned convicts angle—might offer a better analogy.

Led by the irascible, cigar-smokin' Fury, its ranks initially consisted of a former circus strongman (Fury's second-in-command), a trumpet-playing African American (unusual, as US units did not integrate until after the war), a good ol' boy from Kentucky, an Italian-American actor, and a New York Jew. There was also a young Ivy Leaguer, who died in #8; his replacement was a foppish Englishman.

To all intents and purposes, Lee, Kirby, and their successors depicted the Howlers as non-powered superheroes, even saddling them with their own Nazi counterparts in the shape of Baron von Strucker and his Blitzkrieg Squad. They didn't so much go on missions as get up to Axis-humiliating antics, continuing to fight World War II through 167 slam-bang issues (although many of the later ones were reprint) until 1981.

Even closer in spirit to *The Dirty Dozen* was *Sgt. Stryker's Death Squad*. Debuting in 1975 and running through all three issues of Atlas/Seaboard's *Savage Combat Tales*, Stryker's motley crew consisted of four condemned US Army prisoners: an Asian judo expert, a circus acrobat, a behemoth pro wrestler, and a gangster. Story-wise, the series—which was written by *Blazing Combat's* Archie Goodwin and drawn by Al McWilliams—evoked *Sgt. Fury*, but that's hardly surprising as the short-lived Atlas had been set up by publisher Martin Goodman to clone the essence of Marvel, the company he had sold to Cadence Industries in 1968 and left four years later.

DC Comics chose a more subdued gimmick when it launched the *The Haunted Tank* strip in 1961's *G.I. Combat* #87. Created by Robert (*Sgt. Rock*) Kanigher and artist Russ Heath, the series followed the crew of a Light Tank M3 Stuart commanded by Lieutenant Jeb Stuart (initially Jeb Stuart Smith), guided by the ghost of 19th century Confederate General J. E. B. Stuart, who in turn has been sent by the spirit of Alexander the Great to act as guardian over his two namesakes (i.e. the soldier and the tank). DC's longest-running war series after *Sgt. Rock*, *The Haunted Tank* finally ran out of juice in 1987 when *G.I. Combat* was cancelled with issue #288.

First appearing in 1967's *Army War Heroes* #22 was the Iron Corporal. Introduced by Willi Franz—who wrote two other Charlton war strips, *The Lonely War of Captain Willy Schultz* and *The Devil's Brigade*—and drawn by Sam Glanzman, the series' eponymous star was a US corporal whose ribs had been replaced with an iron cage. The corporal, who fought with the Australian army in the Pacific, had a very short career, appearing in just four issues.

► With Al McWilliams on art duties, at the start of *Savage Combat Tales'* short 1975 run, Sgt. Stryker witnesses his battalion decimated by the Nazis, leaving just four men under his command, who, through sheer bad luck, turn out to be criminals. Luckily they're also the best killers in the army.

►► *Sgt. Fury* issue #64's *The Peacemonger!* storyline (cover by Dick Ayers) continued from *Captain Savage and His Leatherneck Raiders* #11 (see pages 100-101).

►► Jack Kirby's splash page for 1963's *Sgt. Fury* #1 introduces the Howlers in bombastic fashion.

► As seen in *G.I. Combat* #93, Russ Heath depicts the titular Light Tank M3, with the ghost of the Confederate General J. E. B. Stuart looming overhead. A new *Haunted Tank* mini-series launched in 2008 from Vertigo, set during the second US/Iraq war.

►► Issue #13 of *Sgt. Fury* (December 1964) saw the Howlers teaming up with *Captain America* (as drawn by Jack Kirby).

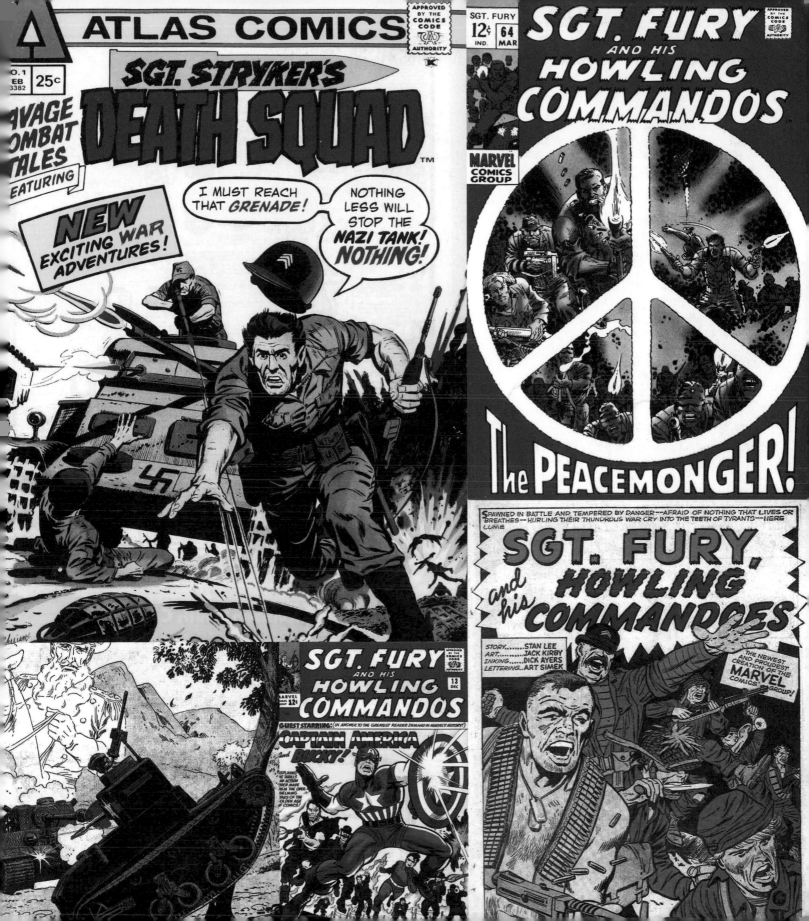

WEIRD WAR STORIES

As if extracting drama and action from tales of troops battling an enemy armed with tanks, flamethrowers, and every other kind of 1940s killing machine wasn't enough, in 1960 DC Comics decided to up the ante by taking a step away from reality, dispatching ordinary G.I.s into the comic book equivalent of the Twilight Zone.

Introduced in *Star Spangled War Stories* #90 and visualized by Ross Andru and Mike Esposito, Dinosaur Island—a remote, uncharted Pacific island—was the site for the Robert Kanigher-written *The War that Time Forgot*, which ran until 1968 (#137). Far more than any other comics publisher, DC had a proclivity for dropping wacky, weird, surreal, and downright bizarre elements into World War II settings. Alongside the Creature Commandos, for example, even DC's own *Haunted Tank* (see pages 80–81) began to look comparatively realistic. First seen in 1980's *Weird War Tales* #93 and led by a normal human, the quartet—the result of experiments by the mysterious Project M—consisted of avatars of classic monster archetypes; a vampire, a werewolf, and Medusa, as well as a rebuilt man substituting for Frankenstein's Monster. Created by J. M. DeMatteis and artist Pat Broderick, the Creature Commandos spent some time on Dinosaur Island, as did another Kanigher/Andru/Esposito creation, G.I. Robot. The first in a series of similarly named mechanical fighting men, he made his debut in 1962's *Star Spangled War Stories* #101.

As for the title that introduced the Creature Commandos, *Weird War Tales* was an anthology with distinctly supernatural overtones. Hosted by Death—depicted as a skeleton whose fashion sense was limited to wearing military uniforms from different eras—it ran 124 issues from 1971 to 1983. During those 12 years, its pages featured robot soldiers, Nazi apes, dinosaurs, ghosts, the undead, and other paranormal characters in stories from the past to the future.

While the Creature Commandos were the last of DC's outlandish WWII concepts to appear, and would undoubtedly win the award for being the most bizarre troops to take part in that conflict, they only just beat Viking Commando into second place. First seen in a George Evans-drawn 18-pager in 1979's *All Out War* #1, Valoric was yet another character dreamed up by Kanigher, who also created the *The Haunted Tank* and had much to do with the success of *Sgt. Rock*. A Norseman taken before his time by an erring Valkyrie, Valoric was returned to Earth post-D-Day by Odin's command. There he was to fight the modern equivalent of the Huns until he finally met his end, but his comic died before he did...DC cancelled *All Out War* after only six issues.

G.I. ROBOT

◄
Nicknamed Joe, the original *G.I. Robot* was merely the first in a long line. He was followed by the Robert Kanigher/Joe Kubert-created Mac in *Star Spangled War Stories* #125 (February 1966), and then J.A.K.E. 1 (seen here), who first appeared in *Weird War Tales* #101 (July 1981), again written by Kanigher, but drawn this time by Pepe Morino Casaras. Other G.I. Robots were to follow...

▶ ▶▼
Each episode of *The War That Time Forgot* in DC's *Star Spangled War Stories* featured a fresh band of US servicemen, who would stumble upon Dinosaur Island and its menagerie of monstrous residents, among them the seemingly ubiquitous tyrannosaurus rex.

▶▶ ▶▼▼
Joe Kubert provided the cover for the debut issue of *Weird War Tales* (1971), while this original Joe Staton artwork for *Weird War Tales* #108 (1982) features the Creature Commandos taking on Hitler himself.

▶▶▶
George Evans contributed the art for the cover of *Weird War Tales* #17 (1973), showing the title's host, Death, snatching biplanes from the sky.

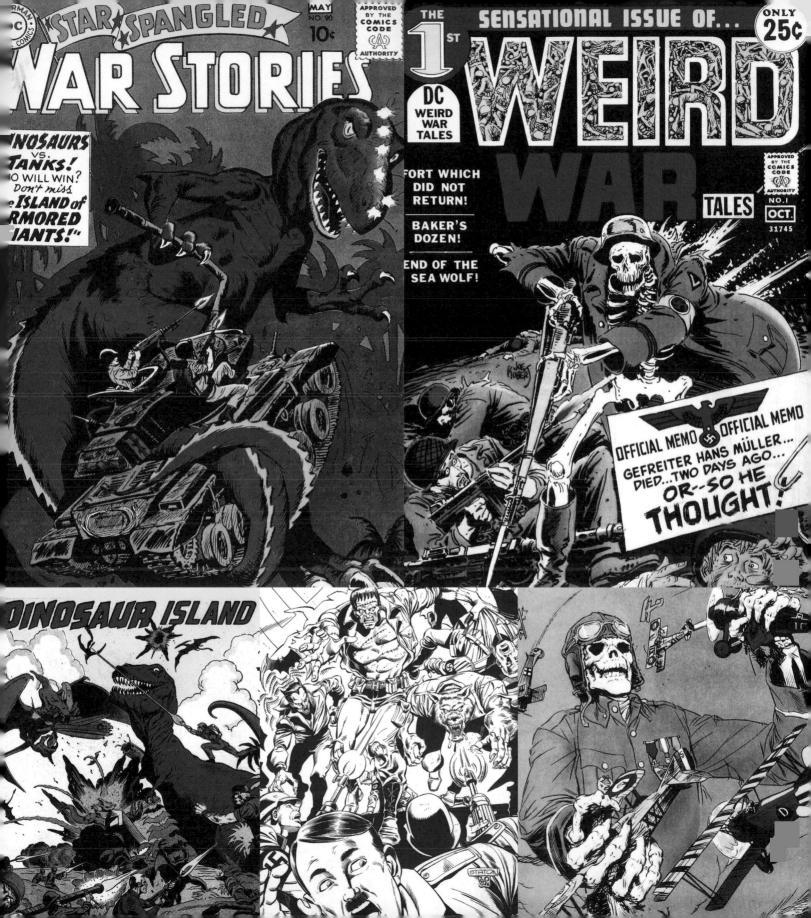

GARTH ENNIS' WAR COMICS

Growing up in 1970s Belfast, Garth Ennis had little time for the armed conflict fracturing his city. Instead he immersed himself in the action-packed war comics found on the local newsstand. 25 years later, his enthusiasm undiminished and now established as a top-selling comics writer, Ennis' cachet provided him with the opportunity to write war comics for US publishers, for whom he almost single-handedly perpetuated and reinvigorated a dying genre.

Between 2001 and 2003, in eight 64-page DC/Vertigo *War Story* one-shots (collected as two volumes of *War Stories*), Ennis channeled the World War II comics of his youth, delivering exciting true-to-life adventure based on real missions. What makes these superior comics is that he brought his own ideas to the table. As well as researching in detail, and applying a conscience and context to the work, he wasn't afraid to deal with a topic in an unconventional manner.

Condors, his Spanish Civil War story, illustrated by Spanish artist Carlos Ezquerra (perhaps best known for *Judge Dredd* and *Strontium Dog* in *2000 AD*), consists largely of four men from different countries, all fighting on different sides, sitting in a bomb crater explaining why they're involved, encompassing the terror of Guernica along the way. *Johann's Tiger* (drawn by Chris Weston and Gary Erskine) details the horrors experienced by a German tank crew retreating from the Russian front. *Archangel* (Erskine again) focuses on the preposterous and desperate notion of protecting shipping convoys from bombers by launching a fighter plane from on board a ship without having anywhere for it to land.

By and large, Ennis' lead characters, not all of whom deserve the "heroes" label, are men led by desperate circumstance and the awareness they could become a casualty any day.

In *D-Day Dodgers* (John Higgins), the situation for troops fighting for their lives in Italy worsens when they receive news from London in the form of a speech that designates them shirkers because they're not part of the highly publicized French campaign. *The Reivers* (Cam Kennedy) examines the type of man participating in desert raids among the squads who formed the SAS. At least the soldiers in *Screaming Eagles* (Dave Gibbons) have the opportunity for a few days of sybaritic luxury away from the action in a German castle.

David Lloyd illustrates the two bleakest stories; *Nightingale*—set in the claustrophobic confines of a convoy ship heading for Russia—and *J for Jenny*, which focuses on the controversial blanket bombing of Germany's industrial region.

Ennis and Ezquerra were also able to refry the more ludicrous aspects of British war comics with 2000's *Adventures in the Rifle Brigade*, a Vertigo three-parter best described as "Carry On Dirty Dozen." Smutty innuendo, national stereotyping, and ramped-up exaggeration are the order of the day as a bunch of incompetents are first parachuted into Berlin, then—in 2001's three-issue sequel, *Operation Bollock*—dispatched on a propaganda mission to capture Hitler's missing testicle.

More recently, Ennis revived a childhood hero for DC's WildStorm imprint. In 2006's five-issue *Battler Britton*, the writer sent IPC's "Fighting Ace of Land, Sea, and Air" and his fellow fighter pilots into Rommel's desert campaign, and a fractious alliance with the US pilots already there.

Ennis—whose 2004 Avatar six-parter, the Jacen Burrows-illustrated *303*, is set in a war-ravaged Afghanistan (see pages 158-159)—is currently writing *Battlefields* for Dynamite Entertainment, a trilogy of three-issue World War II stories.

▶

D-Day Dodgers **takes its title from a speech made by Lady Astor (and later denied by her) in the British Parliament. In fact nearly 100,000 Allied soldiers were killed in Italy, and the devastating closing stages of this story consist of 11 full-page illustrations by John Higgins of the characters lying dead on the battlefield.**

Illustrated by Dave Gibbons, *Screaming Eagles* follows the remnants of Easy Company as they commandeer a country house in Germany. The relatively quiet tale is interspersed with full-page panels of the characters' comrades meeting their ends in the various campaigns since D-Day.

Colin Wilson's action-packed art for 2006's *Battler Britton* recalled Battler's 1950s glory days (see pages 124–125). Ennis' portrayal of the fighter pilot was of a brave and noble man performing miracles of flight.

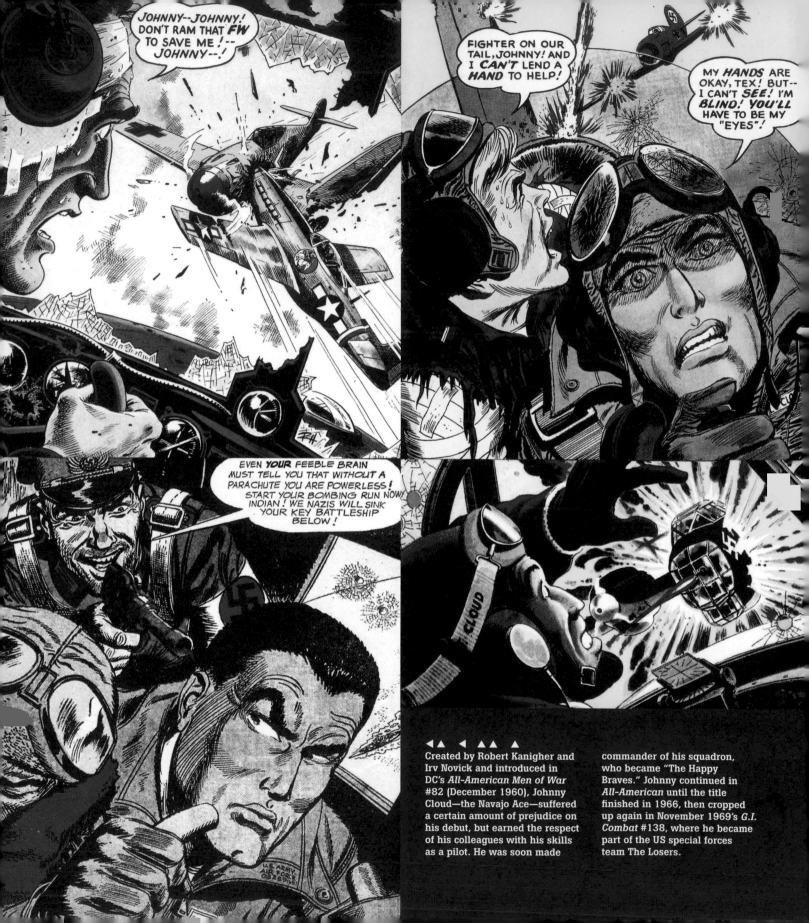

Created by Robert Kanigher and Irv Novick and introduced in DC's *All-American Men of War* #82 (December 1960), Johnny Cloud—the Navajo Ace—suffered a certain amount of prejudice on his debut, but earned the respect of his colleagues with his skills as a pilot. He was soon made commander of his squadron, who became "The Happy Braves." Johnny continued in *All-American* until the title finished in 1966, then cropped up again in November 1969's *G.I. Combat* #138, where he became part of the US special forces team The Losers.

BREAKING THE MOLD

If, by some incredible twist of fate, future historians were to research World War II purely through those American comic books that were published between the 1950s and the 1970s, they may be left with a somewhat simplistic perspective on events. They would deduce that the war was fought purely by heroic white males with God and justice on the side of the Allies, while any German or Japanese characters were irredeemably vile and evil creatures.

The reality, of course, couldn't have been more different. Good and evil could be found on both sides and the stereotypical white male soldier was a myth perpetuated by both political forces and social attitudes of the time. The plight of the ethnic minorities in the US was particularly offensive. African Americans desperate to serve their country were dealt with as if second class citizens in war as much as they were in civilian life at the time.

Kept in segregated units, African Americans were mainly assigned the most menial of duties; digging ditches, cleaning latrines, and burying the dead. At USO concerts they were even made to sit behind German prisoners of war. Despite this, many African American soldiers served with distinction, but their heroism was rarely acknowledged or medals awarded. Even when over 2,000 African American soldiers answered General Eisenhower's call for volunteers to replace white soldiers killed at the Battle of the Bulge, their only reward was to be transferred back to their labor units once hostilities ceased. Their white comrades got to go home or were given more dignified assignments.

This appalling hypocrisy didn't begin to be recognized until some 30 years later, and American war comics before that time largely reflected the perceived attitudes of wartime. Things began to slowly change in 1959 when Sgt. Rock first appeared in DC Comics' *Our Army at War* #83. His squad, Easy Company, contained an African American ex-heavyweight boxing champion named Jackie Johnson. Ignoring the fact that there were no integrated army squads until after the war, Johnson is notable as one of the first non-stereotypical African American characters in US comic books.

Four years later Marvel Comics launched *Sgt. Fury and His Howling Commandos*, featuring Gabriel "Gabe" Jones as a key member of Fury's team. It could be argued that both African American soldiers were created more as a reaction to the growing civil rights movement in the US at the time than as an accurate portrayal of events in World War II.

Accurate representation didn't really occur until some 14 years later in 1977, when DC Comics published *Men of War* #1, featuring Gravedigger. Created by David Michelinie and artist Ed Davis, Gravedigger was a far more realistic representation of the African American soldier's war experience than anything that had gone before.

Ulysses Hazard was a victim to polio as a child as well as a constant target to bullies. Driven to overcome his physical impairments he built his body to a peak of condition. At the outbreak of WWII he enlisted in the US Army, but because of the color of his skin he was assigned to permanent grave digging duty—hence his nickname. Eventually, however, he won round the top brass and they designated him as a one-man commando unit, codenamed "Gravedigger," and pointed him at the Nazis.

Though Jackie Johnson and Gabe Jones still didn't accurately represent the plight of their African American comrades in WWII, they did pave the way for Gravedigger and others to "break the mold" of how war comic books treated their race in the future.

▶

As seen in *Men of War*, frustrated that he was he was barred from frontline action, Ulysses Hazard, a.k.a. Gravedigger, managed to take his grievances to Washington, where he stormed the Pentagon. He was able to convince the Joint Chiefs that not only was he fully capable of combat duty, but he had developed special abilities that would be invaluable to the Allied offensive.

CONSEQUENCES: THE HOLOCAUST

Given the horror of the Holocaust and the general view that comics trivialize any topic, it's no surprise that few comics have touched on the subject. But of those that have been published, two stories are considered among the greatest English language comics: *Master Race* and *Maus*.

Master Race saw print less than a decade after the Holocaust. On receiving the script in March 1954 artist Bernard Krigstein told his wife, "I'm doing something very, very special, something that's never been done before." He pleaded for more than EC Comics' standard six pages, and transformed Al Feldstein's already brilliant script, about a concentration camp guard haunted by a former charge, into a claustrophobic masterpiece.

Ironically, Krigstein's perfectionist nature meant the story missed its original publication slot and instead appeared in the 1955 launch issue of a new title, *Impact*, shining a greater spotlight on an event that was still not widespread knowledge.

Art Spiegelman's father had survived the Holocaust, and the stories he told his son were the topic of *Maus*, a three-page strip featured in the one and only issue of Apex Novelties' *Funny Aminals* in 1972. (It was reprinted three years later by Marvel in *Comix Book* #2.) Spiegelman later interviewed his father more extensively about the deeper horrors the elder man had witnessed and experienced; these interviews would form the basis of an extended, serialized *Maus*, which appeared in Spiegelman's own *RAW* magazine and was subsequently collected in two volumes in the 1980s that would win a Pulitzer Prize.

Distancing events by transforming all protagonists into animals, Spiegelman portrayed Jews as mice and Germans as cats and didn't flinch from detailing the most harrowing of occurrences. Nor did he flinch from portraying how the consequences shaped his upbringing, making *Maus* a very uncomfortable read and one of the few graphic novels to achieve mainstream literary acceptance.

The passage of time has seen the Holocaust more frequently addressed in comics, to the point where even a Wolverine story has been set in a World War II era concentration camp (the Mark Millar-scripted *Wolverine* Vol. 3 #32, Marvel, 2005), and part of supervillain Magneto's motivation is surviving

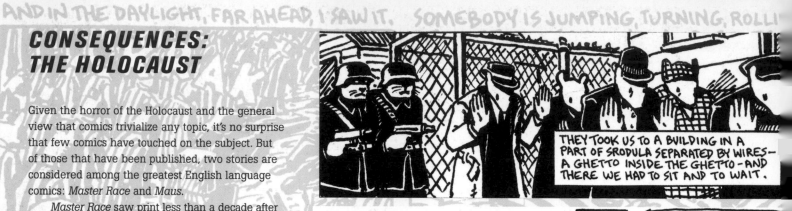

THEY TOOK US TO A BUILDING IN A PART OF SRODULA SEPARATED BY WIRES—A GHETTO INSIDE THE GHETTO—AND THERE WE HAD TO SIT AND TO WAIT.

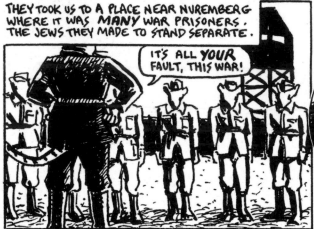

THEY TOOK US TO A PLACE NEAR NUREMBERG WHERE IT WAS MANY WAR PRISONERS. THE JEWS THEY MADE TO STAND SEPARATE.

IT'S ALL YOUR FAULT, THIS WAR!

WE SHOULD HANG YOU RIGHT HERE ON THIS SPOT!

OF COURSE, NOBODY OF US SAID A WORD.

Auschwitz. Miriam Katin's *We Are On Our Own* relates the persecution endured by her Jewish mother in Nazi-occupied Budapest. She fled the city in 1944, and the book details how she survived and ensured her daughter's survival. Will Eisner's *The Plot* gives the historical background used by many to justify anti-Semitism, and Dave Sim's *Judenhass* presents appalling anti-Semitic quotes from historical figures accompanied by explicit imagery of Holocaust atrocities.

German society has only recently begun to address the crimes of previous generations, and Klaus Kordon's evocative wartime novel *Der Erste Frühling* ("The First Spring") has been adapted for comics by artist Christoph Heuer. Himself arrested and imprisoned by the East German Stasi, Kordon has a Buchenwald survivor detail his horrific experiences.

Dutch creator Eric Heuvel's *De Ontdekking* (published in English as *A Family Secret*) dealt with the wartime persecution of Jews as part of the wider picture, and his 2008 book *The Search* goes into greater detail. Both are published by The Anne Frank House and aimed at educating children, and so are illustrated in a clear line style reminiscent of *Tintin*.

▲ ▲
Prior to being sent to Auschwitz, like many Jews in the surrounding area Art Spiegelman's father, Vladek, was imprisoned at the Srodula Ghetto.

▲
Spiegelman's casting of the persecuted Jews as mice is a highly effective way of showing their helplessness at the hands of the Nazis, cast as cats.

▶
Literally meaning "Jew hatred," Dave Sim's harrowing *Judenhass* was an attempt by the artist to bring fresh eyes to the problem of anti-Semitism. Neil Gaiman called it "an astonishing piece of work. Painful and real and unflinching."

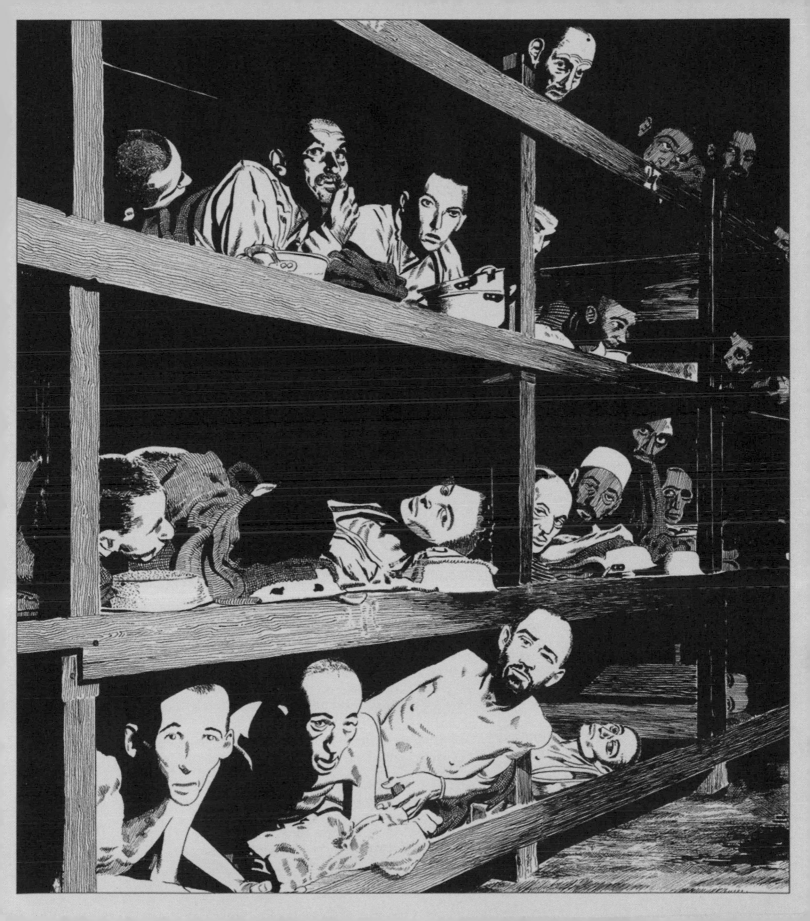

SEMPER FI

Jarhead...gyrene...leatherneck...Devil Dog...Call them what you will, but the US Marine Corps is an elite fighting force that has carved its place not only in US history but in the annals of comic book publishing as well. Titles featuring men from other branches of the armed forces abound, but there have been more than 20 comics devoted to the men of the US Marine Corps in general.

One of the first was *Leatherneck the Marine*. Published in 1943 by Samuel E. Lowe & Co., four by five inch *Mighty Midget Comic* featured the titular hero in an eight-pager—reprinted from the 1940 first (and only) issue of United Features Syndicate's *Okay Comics*—set in Tibet.

Hitting the stands around the same time was the aptly titled *United States Marines*. A typical war comic, the Magazine Enterprises title told fairly generic World War II stories across its four issues. ME revived the title for a further four-issue run in 1952, shifting the action to Korea for the duration.

A year prior to the resurrection of *United States Marines*, Toby—which also published another four issues of that Magazine Enterprises comic—launched *Monty Hall of the U.S. Marines*. Running to 11 issues, it featured Hall and his sidekicks Tex and Canarsie getting into all sorts of scrapes; on the front line, on leave, and even back in the US. Hall and co. went on to appear in both issues of *With the Marines on the Battlefronts of the World*. Toby launched that title in 1953 and included a ten-pager featuring movie star John Wayne in its inaugural issue.

Hall, Tex, and Canarsie also turned up in 1954's *Tell it to the Marines* #8. That series, which Toby had premiered two years earlier, lasted 15 issues until 1955, and was but one of several generated in reaction to the Korean War. Among its counterparts were *Fightin' Marines* (originally published by St. John and subsequently acquired by Charlton, which also produced *Soldier and Marine Comics*) and Toby's *U.S. Marines in Action* and *Fighting Leathernecks*, running alongside *Tell it to the Marines*.

Charlton kept *Fightin' Marines* going for an impressive 163 issues until 1984, and added nine issues of *Marines Attack* and 18 of *Marine War Heroes* (both beginning in 1964). Apart from that, the Marines were out of the comic book war until 1988, when

◄ Spike and Bat were regular cover stars on Toby's *Tell it to the Marines*, although one wonders how they managed to stay so chatty in the midst of combat.

◄ Russ Heath provided the striking art for the 1954 debut issue of Atlas' *Marines in Battle*, which racked up 25 issues between August 1954 and September 1958.

Marvel—which (as Atlas) had made a strong impact with 1954's *Marines in Battle* and the following year's correspondingly titled *Marines in Action*—premiered *Semper Fi.*

Titled after the Corps slogan (an abbreviation of the Latin "Semper Fidelis," which translates as "Always Faithful"), the series was launched off the back of *The 'Nam* (see pages 140–141). But despite contributions from such artistic war comics veterans as John Severin, Sam Glanzman, and Wayne Vansant, the series (subtitled *Tales of the Marine Corps*) bought the farm after only nine issues, a victim, no doubt, of changing attitudes.

▲
The cover art for *Fightin' Marines* #5 (St. John, 1952) was created by Matt Baker, best known for his work on *Phantom Lady*, and one of the comics medium's first known African American artists, active from the 1930s Golden Age.

THE CRUEL SEA

When focusing on naval combat in their war comics, US publishers covered all types of vessel, from PT boats and landing craft to giant battleships and aircraft carriers. The stories spotlighted every kind of seaman, including (to quote from the tagline on the cover to Key Publications' *Navy Patrol* #1) gobs (a US navy colloquialism for sailors), marines, frogmen, and Seabees (Construction Battalions).

While the bulk of dedicated-to-the-navy titles only surfaced in the wake of the Korean War, there were a couple that washed in off the back of World War II. One of the first was pulp magazine publisher Street & Smith's *Army and Navy Comics*, which lasted just five issues. That 1941 series was, however, a humor series, so that probably puts *Navy Heroes* in the vanguard.

That said, predating that 1945 Almanac Publishing one-shot by more than a decade was a newspaper strip that became a source of comic book reprints as early as 1937. Created by World War I veteran Frank V. Martinek, the Bell Syndicate's *Don Winslow, U.S.N.* debuted on March 5, 1934. Conceived primarily to boost recruitment for the US Navy, the initial adventures of the lieutenant commander in Naval Intelligence also involved art director Leon Beroth and Carl Hammond, who provided layouts and research.

In 1943 Fawcett picked up the license to the naval hero, who had proved successful enough to branch out into Big Little Books, novels, and on to radio. Rather than reprints, the *Captain Marvel* publisher's *Don Winslow of the Navy* featured new material. It lasted 69 issues until 1954, when it was acquired by Charlton. There it ran another four issues before the title was changed to *Fightin' Navy* with 1955's #74.

Under Charlton the re-titled comic book steamed on for another 52 issues until 1966, with a 1983 revival bringing the numbering up to 133. Alongside *Fightin' Navy*, the company had added *War at Sea* (1957) and *Navy War Heroes* (1964), as well as 1968's *Attack at Sea* one-shot. Aside from the contributions of Sam Glanzman (see pages 94–95) and other such creators, all were fairly generic. Given the long-range nature of most sea battles, they tended to concentrate on the personal actions of gunnery crews, pilots, and landing craft personnel.

STARRING: "BATTLESHIP" BURKE!

Much the same can be said of titles put out by Charlton's fleet of competitors. Among them were *Navy Task Force* and the aforementioned *Navy Patrol* (two short-lived series launched by Key in 1954 and 1955, respectively); Stanmor Publications' 1954 one-shot; and a small wave of titles from Atlas (Marvel as was); *Navy Combat* (1955) and *Navy Tales* (1957), plus 1954's *Navy Action*, which became the somewhat tongue-in-cheek *Sailor Sweeney* for three issues in the middle of its 18-issue run.

One oddity was Stoke Walesby's *Navy History and Tradition*. Premiering in 1958 and lasting only seven issues, the series was more of a history lesson than a conventional war comic.

Sadly, and yet ironically bringing the war-at-sea comic book genre full circle, the last navy-related series to launch was another humor title. Premiering in 1972, Harvey Publications' *Sad Sack Navy, Gobs 'n' Gals* sank after eight issues.

◄◄◄ ◄◄
Although Charlton published a great many interchangeable sea combat titles in the 1950s and 1960s, the occasional piece of art stands out. The art at top right graced *War at Sea* #26 (1958) by "Nicholas Alascia"— actually two artists; Charles Nicholas and Vince Alascia—while the uncredited piece at top left is from 1960's *Fightin' Navy* #95.

◄
This original artwork for *Navy Combat* #6 (Atlas, 1956) was drawn by Joe Maneely, and stars "Battleship" Burke, Chief Petty Officer of an unnamed destroyer.

◄ ◄◄
Merwil were the first company to reprint the *Don Winslow* naval comic strip in 1937, combining it with new prose stories. Later, in 1943, Winslow met Captain Marvel on the cover to Fawcett's *Don Winslow of the Navy* #1.

SAM GLANZMAN: WAR AT SEA

A mainstay artist for Charlton's war comics of the 1960s, Sam Glanzman applied a knowledge of service beyond most of his contemporaries.

Glanzman had signed up for World War II naval duty at 18, and spent the next three years in the Pacific aboard the U.S.S. Stevens. "When I joined up I wanted a ship, and by God I got one," he later recalled. His experiences fed his stories for years. At DC Comics in the 1970s, Jack Kirby sensationalized his wartime experiences in typically exuberant style in the pages of *Our Fighting Forces*. In comparison, over 50 installments of Glanzman's more restrained *U.S.S. Stevens* strip appeared intermittently throughout DC's war comics, predominantly in *Our Army at War*. Glanzman also drew the occasional *War Diary* strip for that title, based on the actual letters he'd sent home in the 1940s. In the 1980s, however, Glanzman had the opportunity to recount his stories in truer fashion. He delivered two Marvel graphic novels of his wartime experiences titled *A Sailor's Story*. Previously his *U.S.S. Stevens* tales had been restricted by the need to provide a story first and foremost. This material was strictly autobiographical.

The first volume in 1987 started with Glanzman's longing to sign up after Pearl Harbor, and ran through his tour of duty until his 1946 discharge and return home. To jog his memory for 1989's second volume—subtitled *Winds, Dreams, and Dragons*—the artist obtained copies of the battleship's wartime logs, and was also aided by bumping into an old shipmate, now a train conductor, when traveling to Marvel to talk about the books. Glanzman used the bare bones of the travel logs to contrast his recollections of what actually occurred on the dates noted.

Over two volumes all navy life is present. There are the cramped conditions, the tedium, the storms, the joy of shore leave, and the horror of combat, along with a wealth of practical tips as ordinary folk adapted to life at sea. Glanzman even located cartoons produced for mates during his service, adding to the scrapbook feel.

Rarely less than an exemplary artist, Glanzman's war stories have earned him a place in comics history, although later in life he came to feel he'd been stereotyped as an artist. "I can draw something besides war," he claimed in 1998.

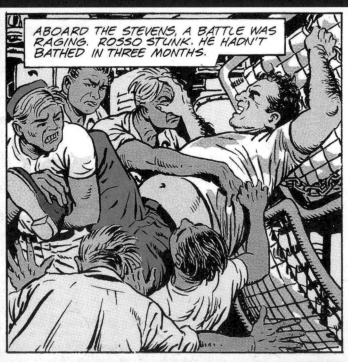

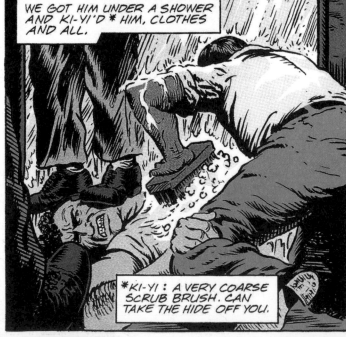

MARVEL® GRAPHIC NOVEL

US $5.95
CAN $6.95

A SAILOR'S STORY ™

★ ★ ★ ★

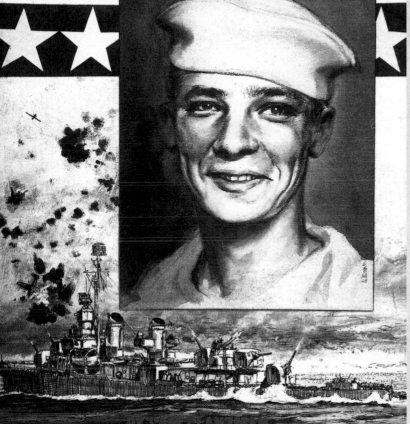

BY SAM GLANZMAN

Even in the midst of this sky filled with explosive destruction, *TATSUNO'S* physical self reacted instinctively...as his mind pulled him *ELSE-WHERE...*

Once more, he was at another place...in a happier time...

Ponderous *SUMO* wrestlers tumbled with elephantine agility...the great eastern temple of *NARA* appeared...and his own fishing village glowed blood-red under a setting sun...

But—it was *NOT* the sunset! Now *TATSUNO'S* plane was wreathed in flame—plunging down...down...

FATHER... MOTHER...

WHERE ARE YOU?

3

WHEN HIS FLOAT PLANE WASN'T ALOFT, SGT. STONE ALSO HAD A SHIPBOARD G.Q. STATION... AT 1500 "FLYBOY" WAS STILL IN THE SHOWER...

ALL HANDS MAN YOUR BATTLE STATIONS FOR G.Q. ALERT!!

"FLYBOY" HOOKED UP HIS LITTLE 30 CAL. AIRCRAFT GUN AN' REAL SERIOUS LIKE GOT BEHIND IT AS IF IT WERE A 16 INCHER. HA! THAT PEA-SHOOTER WOULD BE ABOUT AS MUCH USE AS A SLING SHOT.

◄▲ ◄◄ ◄

Published in two volumes in 1987 and 1989 (cover of the first volume seen here), Glanzman's autobiographical *A Sailor's Story* provides revealing snapshots of life at sea during World War II. In these examples from the second volume, Glanzman details sailors giving a shipmate an impromptu (and unwanted) shower, and shows another crewman rushing to his post wearing just a towel.

▲

First seen in *Our Army at War* #235 (DC, 1971), the four-page *U.S.S. Stevens* story *Kamikaze* centers on Tatsuno Sakigawa, a Japanese kamikaze pilot flying toward the Allied fleet off Okinawa. Glanzman offers a motive for the pilot beyond that of the Samurai code of chivalry; the deaths of Sakigawa's family as a result of the incendiary bombs dropped on Japanese cities.

◄ *Navy Tales* was a short-lived Atlas title, with just four issues published from January 1957 to June 1958. This original Bill Everett artwork for #1, with its "split screen" approach, is characteristic of Everett's aptitude for sea-based artwork; the writer-artist was the creator of Marvel's Sub-Mariner character.

► Joe Maneely's cover for *Navy Combat* #1 (Atlas, 1955) spotlights "Torpedo" Taylor, who was head of the torpedo room on the U.S.S. Barracuda. Taylor ran through 18 issues of the title.

ABOVE US THE WAVES

Part of the appeal of a comic book lies in its capacity to visualize dynamic action sequences that, at one time, were beyond the capability and budget of the movies. Locating a story under the sea tends to put a dampener on proceedings and it's perhaps for this reason as much as any other that sub-aqua superheroes are few and far between, and that—despite their longevity—the top two aquatic characters (DC Comics' Aquaman and Marvel Comics' Namor the Sub-Mariner) have failed to truly establish themselves as major draws.

It's probably the same rationale that pretty much sidelined submarine warfare on the comic book racks. While there were occasional stories of submariners in the war anthologies (particularly *Navy Combat*, *Navy Tales*, and others dedicated to the war at sea), there was only one title spotlighting the brave sailors who fought their war in the ocean depths, cooped up for days on end in a claustrophobic vessel, their enemy the pressure of the deep as much as the ships they hunted, and which in turn hunted them.

All that said, Charlton's *Submarine Attack*, which launched in 1958, lasted for a sterling eight years. Picking up its numbering from the less-than-militaristic *Speed Demons*, it ran for 44 issues (#11-54), and featured stories with such titles as *Deep and Deadly*, *Duel at 40 Fathoms*, *Find and Recover U.S.S. Arrowfish*, *Sunken Fortress*, *The Log of the U-238*, and *U-Boat Master*, and frequent submarine from artists Sam Glanzman (see pages 94-95) and Charles Nicholas—actually Charles Wojtkoski, creator of Fox Comics' *Blue Beetle*—among others.

But there were others who fought beneath the waves, and Avon Periodicals' aptly titled but short-lived *Fighting Undersea Commandos* showcased the exploits of US Navy frogmen. The 1952 title, which ran just five issues, was drawn in the main by Louis Ravielli, who also contributed to *Battle* and other such Atlas (now Marvel) war comics.

That same year Hillman Periodicals released *Frogman Comics* but, while naval divers did feature, the title was an adventure comic rather than a war book. It had more in common with DC's later *Sea Devils*. Like Dell's 1952 series, *The Frogmen*, its stars were simply, well, frogmen.

HISTORICAL CONFLICTS: PEARL HARBOR

Until 1941 the war on the other side of the Atlantic was watched carefully by the US. Having been through one World War and a Depression, the nation had embarked on a period of isolationism. However, World War II rudely kicked down America's door and forced the nation's hand at 8.30 in the morning of Friday, December 7, 1941.

The US Navy's Pacific Fleet was based at Pearl Harbor in the Hawaiian Islands when the Japanese fleet launched an unprovoked, surprise attack. Over 2,400 people were killed and 1,178 injured, and the US Navy was decimated, with nine ships sunk and a further 21 severely damaged.

Just as with 9/11, most people of that generation remember exactly where they first heard about the attack, including *Sgt. Rock* artist Joe Kubert: "I recall that rather vividly. I was about 15 and was already working as a cartoonist. I was in my home, in my bedroom, it was on Sunday morning. I was drawing pictures, as I was already a pro cartoonist for comic books. I don't think I really understood the significance of what was happening when the news came over that Pearl Harbor was bombed."

At the same time Will Eisner "was sitting in my studio eating a roast beef sandwich which my mother prepared for me. I was working on *The Spirit*. I was really shook up listening to it…because I realized that this was gonna be it. I'd be drafted." Bizarrely, Eisner's studio team of writer Gil Fox and artist Lou Fine had "predicted" the attack in *National Comics* #18, published by Quality a whole month before, in November 1941. The story featured US iconic superhero, Uncle Sam, fighting off a *German* attack on the Hawaiian island.

The terrible assault changed comics completely. Until then, superheroes chiefly roughed up Nazis in Europe, but the first Timely (Marvel's forefather) comic to come out after Pearl Harbor was *Captain America* #13 (April 1942), which featured Cap beating a demonized Japanese general and bellowing, "You started it! Now—we'll finish it!" The cover, by Al Avison, was a deliberate echo of Jack Kirby's first issue, which had the super soldier punching Hitler's lights out. After this, US comic books' predominate villains became the grotesque caricatures of Japanese soldiers fighting the US Forces in the South Pacific.

A year on from the attack, the propaganda one-shot *Remember Pearl Harbor* was released by Street & Smith (publishers of *Doc Savage* comics), which had a different Uncle Sam on the cover, rolling up his sleeves and heading for Japan for retribution. Pearl Harbor would feature in numerous comics over the next 60 years, but two in particular stand out. Tying

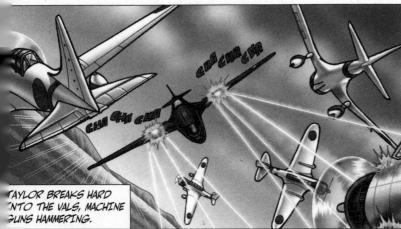

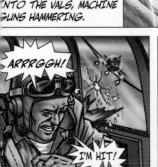

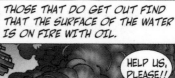

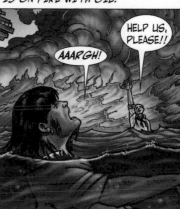

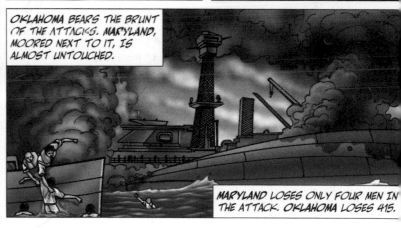

in with the 60th anniversary of the attack, Ted Noruma's *Pearl Harbor: The Comic Book 1941*—a graphic novel collection of his earlier comics—was published by Antarctic Press in 2001, and details the tragedy in depth. *Attack on Pearl Harbor: Day of Infamy*, by Steve White and artists Gary Erskine and Jerrold Spahn, took its subtitle from President Roosevelt's famous quote. Published by Osprey in 2007, the graphic novel packs in facts, but consequently loses some of the human element.

▲ ◀▲ ◀◀▲
Attack on Pearl Harbor: Day of Infamy offers a blow-by-blow account of the attack, focusing on the real life participants and events of Pearl Harbor.

HELL IN THE PACIFIC

The best US Pacific war comics appeared 20 years after World War II.

Captain Savage served his time helping out Marvel's Sgt. Fury on several occasions before spinning into his own 1968 title. Shifting his service to the Marines, Savage led the Leatherneck Raiders, who mysteriously morphed into the Battlefield Raiders after eight issues of sock 'em in the face action. Given that the Raiders consisted of Frenchy LaRoque, Yakkety Yates, Blarney Stone, and Jay Little Bear, shorthand characterization wasn't restricted to the enemy. Savage lasted 19 issues, a respectable run during increasingly superhero obsessed times.

Captain Storm lasted even longer; 18 issues of his own title, then a decade among The Losers in assorted DC war titles.

"Skipper, your leg's been blasted," cries a marine on the cover of Storm's 1964 first issue. "It's only wood! I'll get another," replies Storm, firing his machine gun at a plane seemingly only yards away. Similar close encounters would grace five further covers, so few bodily orifices remained unclenched when Storm was around. *Moby Dick* parallels abounded as Storm lost his leg and his crew to a Japanese commander, spurring his vengeful career patrolling the Pacific. Storm later united with other servicemen who'd lost their units and series, and who consequently christened themselves The Losers (introduced in 1970's *Our Fighting Forces* #123). His comrades Gunner and Sarge were, respectively, among the youngest and oldest serving Marines, and pilot Johnny Cloud was known as the Navajo Ace (see pages 86-87).

And then there was Jap-Buster Johnson. Where to start? These days the bigoted overtones of the moniker alone wouldn't pass muster, but with the US at war with Japan, *USA Comics* served up what's by current standards outrageously offensive patriotic entertainment. Never given a first name (unless "Jap-Buster" was on his birth certificate), fighter pilot Johnson's avenging career began when his sailor buddy was killed in a Japanese air attack. Racial epithets abounded as Johnson set about his business, single-handedly dealing with entire destroyer crews—once by dumping a box of dynamite down a ship's funnel from the window of his fighter plane—and

rooting out Japanese sympathizers in the Navy. Among his far from politically correct escapades he painted his face to disguise himself as a big-lipped native, and identified a disguised Japanese by his inability to pronounce "lollipops" correctly.

Offensive he may have been, but he caught the tenor of the times, and Johnson's career—which began in the 1942 sixth issue of Timely's (now Marvel) *USA Comics*— spanned four years.

▲ ▶▲ ▶
Dick Ayers on art duties for issues #1 and 7 of *Captain Savage*, and the captain's first appearance in *Sgt. Fury* #10 (1964).

▶▶ ▶▶▲
Irv Novick's cover for *Captain Storm* #1, and Joe Kubert art from #12.

CONSEQUENCES: BAREFOOT GEN

It would be somewhat unfair to say the least to expect many laughs from a story displaying in gruesome detail the effects of dropping the atomic bomb on Hiroshima. Of how people died from the blast, their injuries, or disease, and how the survivors mistreated each other before the arrival of US soldiers, some of whom used their position to rape and abuse. But humor is an integral factor in the international success of Keiji Nakazawa's *Barefoot Gen*, or *Hadashi no Gen* (to give it its original Japanese title).

Nakazawa himself survived Hiroshima, and waited years to tell his story to the world. He was astute enough to realize that unremitting misery and finger-pointing would quickly lose an audience, so despite losing his father, brother, and sister during the initial bombing of Hiroshima, the mangaka's story mixes shorter good-natured chapters with the horrors.

Gen—a character based on Nakazawa himself—displays an irrepressible optimism despite the desperate nature of his existence, harsh lessons in the workings of the world, and all his hair falling out…although it would re-grow. He schemes to raise money for his family, rails against injustice, hypocrisy and dishonesty, and despite the surroundings, in many ways experiences a freedom that would not be possible under other circumstances.

Horrific imagery abounds, however. Gen's mother gives birth in the street in the immediate aftermath of the bomb, amid the wounded with their flesh peeling from their bodies. Gangsters exploit orphans in their turf wars. Children are prepared to kill each other over a bowl of rice.

Published in Japan in *Monthly Shonen Jump, I Saw It* (*Ore wa Mita*) is Nakazawa's 1972 precursor

▼
Scenes from Nakazawa's *Barefoot Gen*; Gen imagines his family is still alive, tries to help his pregnant mother, and sees the mushroom cloud rising above the city.

▶▼
A year prior to *Barefoot Gen*'s debut in *Weekly Shonen Jump* in 1973, Nakazawa's autobiographical precursor, *I Saw It*, ran in *Monthly Shonen Jump*, telling the true story of his experiences at Hiroshima.

▶
***Barefoot Gen* shows the full horror of Hiroshima.**

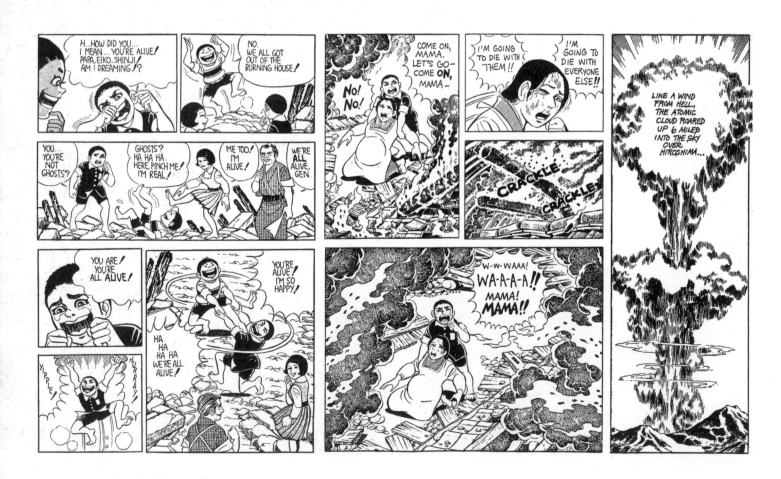

to *Barefoot Gen*. In it he relates how his mother's bones had been so weakened by radiation they did not survive cremation. That he illustrates all this in his broad cartooning style in no way diminishes the effect.

Barefoot Gen first appeared as an aborted serialization that began in Shueisha's *Shukan Shonen Jampu* (*Weekly Shonen Jump*) in June 1973. Following its initial cancellation, it moved through various other magazines until it spanned ten volumes. In Japan it has been adapted as a three-part live-action film (1976–1980), animated (1983), transferred to TV (2007), and even transformed into opera.

Project Gen, a volunteer foundation dedicated to spreading Nakazawa's work as widely as possible around the world in the hope that the horror will never be repeated, has so far translated six of the ten volumes of his opus into English.

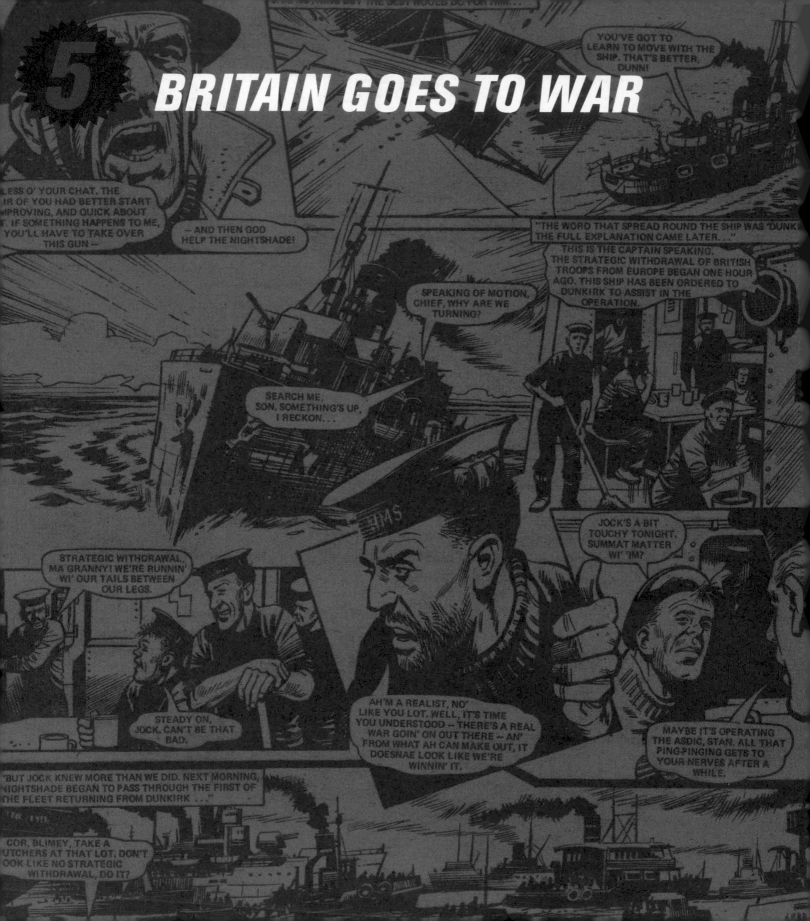

WHO DO YOU THINK YOU ARE KIDDING, MR. HITLER?

The day war broke out, British comic books had already been fighting on the humor front for quite some time…

There was no mistaking that the antics of *Jester's* comical detectives Basil and Bert and their battle against the tyrannical Dick Tater were nothing but a thinly disguised attack on what was happening in Europe in 1938. As soon as war was declared, Tater, his spy, Herr Pinn, and soldiers, the Stormtaters, showed their true selves: 'Ateful Adolf, General Snoring, and Dr. Gobbles suffered a weekly kick in the pants or dunk in a pond from our alliterative heroes.

Humor was how Britain dealt with the dark days of war, whether it was laughing at the absurd antics of *Addie and Hermy, the Nasty Nazis* in *The Dandy* or the preposterous and pompous *Musso the Wop—He's a Big-a-da Flop* in *The Beano*. The DC Thomson weeklies wheeled out their big guns in the fight against the Nazis, with Lord Snooty and his pals downing a German plane with a kite, Pansy Potter attacking a U-Boat with a tin-opener, and Desperate Dan punching Hitler all the way back to Germany.

Not that the humor was all one way. With *Colonel Blimp*, cartoonist David Low caricatured the British military officer as plump and walrus-mustached, jingoistic, loudly opinionated, and unable to move with the times. He was loved and loathed in equal measures by the establishment and accused of damaging morale by those whom Blimp resembled.

A morale-booster of another kind came in the curvaceous shape of *Jane* in the *Daily Mirror*. It took only a week for the former flapper of the 1930s to reflect the new wartime footing, with Jane and her friends contemplating joining up, building an air raid shelter, and (since this was a humor strip) picking up her camera instead of her gas mask. Followed daily by over two million readers, Jane was notable for finally "giving her all" for the boys and appearing fully nude during the war years.

In the years between the wars, most comics targeted a very young audience, with older children served by story papers filled with text stories and serials. Here there was an endless parade of war heroes; in boys' papers especially, air aces in the tradition of Biggles (created by Capt. W. E. Johns in 1932) and secret agents were very popular. The impending war saw the *Rover's Master Spy*, Tiger Wallace, infiltrate the German High Command in the DC Thomson title as early as May 1939 and, in Amalgamated Press' *Champion*, air ace Rockfist Rogan transitioned the two wars by simply swapping his old-fashioned First World War bi-plane for a sleek spitfire with the words "Same old enemy, but different aircraft."

The post-war comics grew out of this story paper tradition and, in 1952, Fleetway's newly launched *Lion* featured the adventures of *The Lone Commandos* volunteering to blow up a German radar station in German-occupied France. Stories about the Royal Navy, British Navy frogmen, and a platoon of tales about the war in Europe and the North African deserts followed that series in rapid succession. Even more heroic characters, such as Battler Britton and Paddy Payne, would soon replace these relatively short-lived comic strips.

MUSSO THE WOP
HE'S A BIG-A-DA FLOP

BASIL AND BERT, OUR VERY PRIVATE DETECTIVES.

1. Basil and Bert, the famous detectives, were in Dictatorland doing a spot of Secret Service work. They suddenly spotted 'Ateful Adolf and General Snoring.

2. "Quick! Hide!" whispered Basil. "Here comes the Nasty Dictator!" The prize detectives dodged into a near-by tailor's shop and made a noise like moths.

3. "Look at this lovely bit of cloth," said General Snoring, picking up Basil's coat. "I'll cut a piece off and use it for patching." He pulled out an overgrown penknife and gave a swipe.

4. "Oi! You leave my coat-tails alone!" yelled our monocled 'tec, dodging neatly aside. Old Snoring was so surprised, his sword chopped a chair in half. "Three chairs, I mean, cheers!" cackled Bas, leaping away.

5. "'Tis Baseel!" yelled the Nasty Dictator. "After him, Hermann!" Bert was standing near by disguised as a dummy. "Don't point, Adolf!" he murmured. "It's bad manners!"

6. "I like zat sound almost as much as I like myself," grinned 'Ateful Adolf, as Bert gave Snoring a hearty thump with his boot.

WAR IN A DIGEST

The pocket picture library was an invention born of necessity. When, in 1950, Edward Holmes had an idea to reuse artwork for a series of new comics in the UK, the only printing press available was the one used to print the publisher's line of romance and crime pocket libraries.

The new format proved a hit, especially with schoolboys, who could slip the slim, 64-page volumes into their blazer pockets. The big genre winner was war comics, with more than 10,000 war pocket libraries published in a period of around three decades (1960-1992), and original stories recycled numerous times for new audiences in Britain and abroad, where the books found a ready market in Europe, Scandinavia, Australasia, and South America.

Flying ace "Battler" Britton had proven such a popular addition to the line-up of the (primarily historical) *Thriller Picture Library* that more characters in war settings were created, including wartime special agent Spy 13 and RFC (Royal Flying Corps) ace Dogfight Dixon. Fleetway Publications launched a dedicated *War Picture Library* in September 1958, and before long a slew of other titles began appearing from a variety of publishers. Among them were *Combat Picture Library* (1959), *Battle Action in Pictures* (1959), *Air Ace Picture Library* (1960), *Picture Stories of World War II* (1960), *Battle Picture Library* (1961), *Air War Picture Stories* (1961), *Commando* (1961), *War at Sea Picture Library* (1962), *Sea War Picture Library* (1962), and *Attack! War Picture Stories* (1962).

Of these, *War Picture Library*, *Combat Picture Library*, and *Battle Picture Library*, published 2,103, 1,212, and 1,706 issues respectively; the sole survivor is DC Thomson's *Commando*, which published its 4,000th issue in April 2007.

The popularity of the books can be partly explained by the format, with each story complete in itself, although there have been a handful of characters (notably Battler Britton, Jeff Curtiss, and Maddock's Marauders) who fought their way through numerous unrelated episodes. Stories set in every theater of war—land, air, and sea—and, certainly in the early years, were written by authors who had seen combat themselves. There was a reality to the stories lacking in the heroics of weekly comics; the heroes may have been larger than life but their exploits were no more outrageous than the tales the readers might have heard from their fathers and grandfathers. Death was also part of the conflict.

Early prolific writers included Donne Avenell, Eric Hebden, A. Carney Allan, Roger Clegg, and William Spence, although recognized war novelists such as *633 Squadron*'s Frederick E. Smith and *Private Navy*'s David Satherley contributed. In contrast, the artists were primarily from Italy, Spain, and South America, among them big names such as Hugo Pratt, Gino D'Antonio, Ferdinando Tacconi, Solano Lopez, Jesus Blasco, Luis Bermejo, and Jose Ortiz. American artist John Severin also made one notable contribution.

The covers alone form an incredible array of war imagery. While Fleetway drew on the top Italian talents (Giorgio De Gaspari, Nino Caroselli, Jordi Penalva, and Allessandro Biffignandi), DC Thomson used a mixture of artists from Britain (Ken Barr, Gordon Livingstone, Ian Kennedy), Italy (Penalva, Aldoma Puig, Carlo Jacono), and Spain (Lopez Espi).

Despite their attraction, World War II comics had for the most part faded in the mid-1980s. Redevelopment healed the scars of war so long visible in Britain and Europe; no one was making blockbuster movies like *The Dam Busters* any more, and time and mortality had distanced new generations from the people who fought in the war. Soaring costs finally ended a war fought for 30 years in picture libraries, leaving only *Commando*.

Through its longevity, *Commando* has become something of a brand, inspiring reprint collections and calendars. In recent years, it has expanded its focus to take in conflicts other than WWII. The regularity of its schedule (eight titles per month, two of which are reprints) has meant that some artists, notably Gordon Livingstone, C. T. Rigby (both 1961-1999), Jose Maria Jorge (1969-present), and Denis McLoughlin (1982-2002) worked almost exclusively for *Commando* for much of their professional artistic careers.

▶ Allessandro Biffignandi was a star cover artist for Fleetway's *War* and *Battle* picture libraries, producing more than 400 covers for the company, including this evocative piece for the *Battle Picture Library* tale *The Trouble-Shooters*. In his native Italy he is better know for romance and erotic cover paintings.

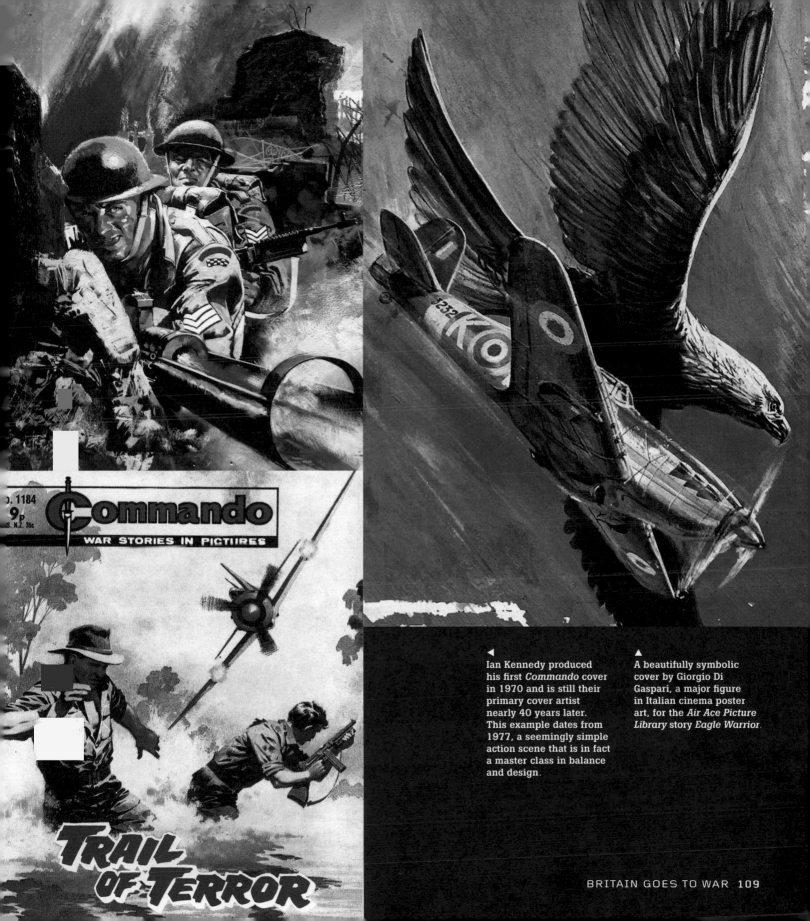

No. 1184
9p
U.S. N.Z. 35c

Commando
WAR STORIES IN PICTURES

TRAIL OF TERROR

◄ Ian Kennedy produced his first *Commando* cover in 1970 and is still their primary cover artist nearly 40 years later. This example dates from 1977, a seemingly simple action scene that is in fact a master class in balance and design.

▲ A beautifully symbolic cover by Giorgio Di Gaspari, a major figure in Italian cinema poster art, for the *Air Ace Picture Library* story *Eagle Warrior*.

WARLORD

"All-action, all-picture war stories" was how Scottish publisher DC Thomson sold their new war comic to its readership. Running for 627 issues to September 1986, *Warlord* was a weekly anthology title from the Dundee-based company that had been producing weekly adventure comics for boys since 1921.

It was the deliberate policy of *Warlord*'s first editor, Pete Clark, to begin each story with a splash panel and generally reduce the number of panels per page. This was a dramatic change of style from *The Victor*, *The Wizard*, and other such older, more staid Thomson titles, and helped open up the artwork and draw the reader in.

Where other anthologies included war among a more general mix of genres, *Warlord* was entirely devoted to conflict, with the majority of the early stories being set during World War II. The titular star of the comic was Lord Peter Flint, Britain's fictional top spy during WWII. Running in every issue, *Code-Name Warlord* featured Lord Peter in complete eight- to ten-page one-offs that allowed more in-depth storytelling than was the norm in British boys' comics of the era.

The character eventually commandeered the title's letter's page, *Calling Warlord Agents*, where he communicated directly with the reader.

The other major hero introduced in the September 1974 first issue of *Warlord* was "Union" Jack Jackson. A British Royal Marine—the sole survivor of a Japanese attack on his trans-Pacific troopship—he joined a US Marine Corps outfit until he could be reunited with his own countrymen. Alongside his American comrades, Private Sean O'Bannion and Sergeant Lonnigan, he fought the Japanese through the island-hopping campaigns of the Pacific theater, before the unit relocated to Europe for D-Day. There, UJJ, as he had become known, fought both German troops and attempts to repatriate him to a British unit. He proved to be popular with the readership, continuing on and off in the title for its entire run, while also appearing in the spin-off summer specials and annuals.

Warlord covered all aspects of 1940s warfare in the first few years of the title, through such series as the RAF pilot-starring *Killer Kane*, *Drake Of E-Boat Alley* (which featured a Royal Navy captain; see pages

▶
Union Jack Jackson—a British Royal Marine serving with a US Marine Corps outfit, seen here second from front on the left—painted a Union Jack on his helmet to distinguish himself from his compatriots.

◀
Occasionally boys' war comics featured kids in action or peril, doubtless for added connection with the readership. *The Boys of Terror Island* followed a group of school children shot down on their way to Australia and placed in jeopardy in the Pacific.

◀◀
Lord Peter Flint—*Code-Name Warlord*—was the star of *Warlord*, a James Bond-like wartime spy battling opponents in the Gestapo and the Japanese intelligence service.

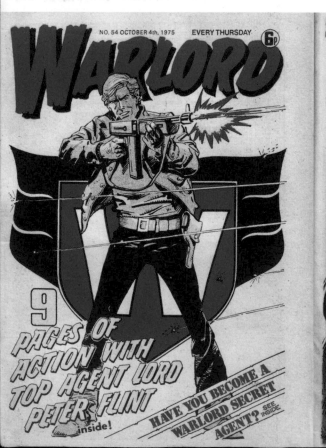

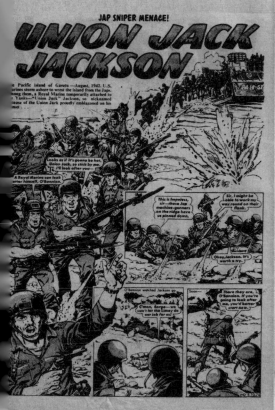

◀
Killer Kane starred Squadron Leader Kane of the Royal Air Force, clashing with German pilots over England during the Battle of Britain.

▲
Lord Peter Flint executes a daring escape from occupied mainland Europe in time to make it home for for supper, in *Code-Name Warlord*.

▶▲
Readers of *Warlord* could join the *Warlord* Club, and receive a wallet, a metal badge, and even a "secret code book!"

126–127), and *The Tankies* (which followed a British army tank crew), as well as *Sniper Kelly*, starring the eponymous British infantryman. Later it introduced American forces personnel—among them *Rayker*'s infantry Sergeant Rayker, and Marine Corps pilot Jake Cassidy, star of *Cassidy*—but also began chronicling the war from the other side. Among the German characters it debuted were Luftwaffe pilot Kurt Stalhman in *Iron Annie* and *Kampfgruppe Falken*'s disgraced soldier Heinz Falken.

As the title aged into the 1980s, DC Thomson introduced contemporary stories such as the World War III-set *Holocaust Squadron* and future combat stories such as *Sabor's Army*. Eventually sales dropped too low and the comic amalgamated into Thomson's longer-running *Victor* comic, with perennial favorites *Code-Name Warlord* and *Union Jack Jackson* surviving the merger.

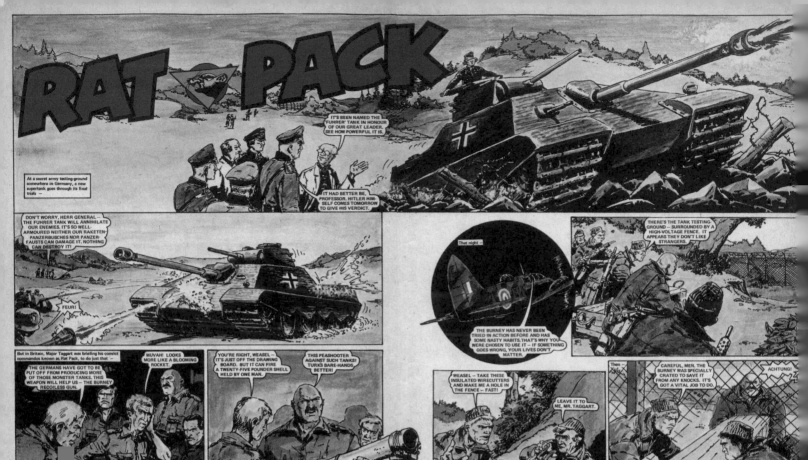

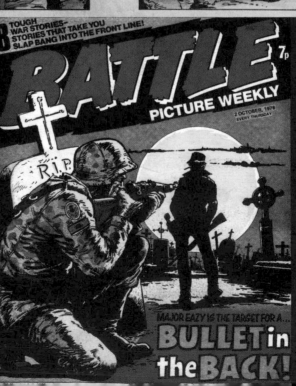

◄
Major Eazy was perhaps the most laidback officer ever to feature in a British war comic. Clearly influenced by *Kelly's Heroes*, the strip was written by Alan Hebden (son of *Rat Pack* writer Eric), by all accounts a rather laconic individual.

◄◄
Darkie's Mob was one of the more notorious stories in *Battle*, although the strip's title was misleading; Captain Joe Darkie was actually white.

BATTLE

◀

With art by future *2000 AD* star Carlos Ezquerra, *Rat Pack* was one of *Battle*'s most popular stories, a spin on *The Dirty Dozen* but with a stripped back cast of five: convicted criminals Turk, Weasel, Scarface, and Dancer, and their leader Major Taggart.

A wise man once said, "Competition is a painful thing, but it produces great results." Such was the case when DC Thomson launched *Warlord* in September 1974 (see pages 110-111). The arrival and success of the first weekly comic devoted entirely to war spurred IPC—Thomson's major rival—to develop a similar title of its own.

Burdened by a staid editorial department that was steeped in the traditional approach to British comics, editorial director John Sanders went in search of someone who could design and prepare a new contemporary boys' comic—one that could do battle with the unusually aggressive and harder-hitting *Warlord*. His quest led him to two freelancers, Pat Mills and John Wagner, who brought *Battle Picture Weekly* to UK newsagents in March 1975, only six months after *Warlord* premiered.

Recalling the development of the comic, editor Dave Hunt said, "The brief from the onset of the publication was to have a more honest approach to the fact that war is a killing zone—that flesh and bone is ripped to shreds when bullets or bombs strike mere

mortals. Brutal, maybe, but up to then comic book adventures had depicted war in the *Biggles* way, a sort of upper-class 'up and at 'em, chaps' when not a drop of blood was spilled!

"*Battle* was deliberately more realistic in its outlook," he continued. "If I'm honest then, yes, I was conscious of constantly treading a tightrope as far as excess violence was concerned. On reflection, I think some scriptwriters liked to push the barriers too far and I forever had to tone down what I considered to be excess realism. The key to most things, I felt, was always the quality of the script and artwork."

The first issue of *Battle* introduced seven ongoing features. There was *D-Day Dawson*, who had only a year to live; *Lofty's One-Man Luftwaffe*, about an escaped prisoner of war who fought the German air force from inside; and *The Flight of the Golden Hinde*, which featured Nazis hunting a replica of Sir Francis Drake's ship in the Indian Ocean. In addition, there was *Day of the Eagle*, starring secret agent Mike Nelson; *The Bootneck Boy*, about a diminutive orphan whose qualities as a scrapper get him into the marines; and the *Dirty Dozen*-like *Rat Pack*, in which Major Taggart orchestrates a prison breakout by four convicts. Their special skills were to prove useful to him on difficult and dangerous missions behind enemy lines.

Finally there was *The Terror Behind the Bamboo Curtain*, which was set in Burma. A story of life within a Japanese prisoner of war camp, it featured a fanatical camp commandant named Colonel Sado, whose main opponent was big Jim Blake. A crack jungle fighter, he was determined to escape and discover the mystery of the bamboo curtain.

Further down the line would come more great strips, among them *The Sarge*, *Major Eazy*, and *Darkie's Mob*, as well as the Mills-written *Charley's War* (see pages 48-49), which many consider the greatest war comics story of all time.

Absorbing several other IPC titles during its almost 13-year existence, *Battle* bit the dust in January 1988 after 673 issues.

▶

Reader interaction was always encouraged in British boys' comics, with regular competitions and vibrant letters pages. Above a typically exciting Ezquerra image, this October 1975 *Battle* cover trailed an interior photo feature where the young winners of a competition got to spend the day with the Royal Green Jackets at their Winchester barracks, tackling the assault course and even firing weapons!

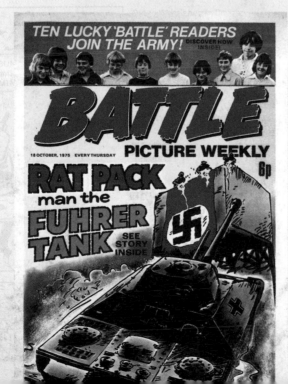

TEN LUCKY 'BATTLE' READERS JOIN THE ARMY! DISCOVER HOW INSIDE

BATTLE PICTURE WEEKLY

18 OCTOBER, 1975 EVERY THURSDAY 6p

RAT PACK man the FUHRER TANK SEE STORY INSIDE

OVER THE TOP

British comics publishers had a tendency to treat World War II with a touch more gravity than their American counterparts. Perhaps this was because Nazi forces got within 22 miles of the UK; perhaps it was due to the fact that the Luftwaffe blitzed virtually every major English, Scottish, and Welsh city and port on a regular basis; or perhaps it was because Britain fought a lone battle against Hitler and his cronies for two long years.

In any case, that said, the British weren't completely solemn about the conflict. The nation's natural tendency toward irreverence often shone through too.

Blatant humor strips aside, this manifested itself most obviously in a series whose star's titanic temper tantrums transformed him into something akin to a Second World War version of Marvel's rampaging Hulk. Introduced in a Charles Roylance–drawn story in the 1962 first issue of Fleetway's *Valiant*, Captain Hercules Hurricane would, when provoked, fly off the handle and into one of his "raging furies," lending him superhuman strength.

Captain Hurricane ran until 1976, far longer than another of Britain's off-the-wall soldiers did.

First seen in 1970 in the premiere issue of DC Thomson's re-launched *Wizard*, former shepherd Trooper Tipper of the Fellside Fusiliers took 13 weekly episodes to recover important plans that a hapless ram had got hooked on its horns. *Trooper Bo-Peep* had an apt tagline: "He's After a Sheep."

Predating *Trooper Bo-Peep* by five years was another Fleetway strip. The Jack Pamby-illustrated *Mighty Misfits*—which premiered in *Buster* on July 31, 1965, featured Socrates Smith and Albert "Bomber" Briggs, who referred to Germans as "sausage eating square-heads" among other things. The odd couple, the brains and brawn of "Ripper's Raiders," had a two-year run. However, the British Army's number one secret weapon had a career that lasted twice as long.

Initially drawn by Alex Henderson and debuting in the first (October 17, 1970) issue of IPC's *Thunder*, *Steel Commando* starred the Mark I Indestructible Robot. The seven-foot tall experimental mechanical marvel was also uncontrollable...except when Private Ernie "Excused Boots" Bates issued its commands. Together the pair fought the war out of *Thunder*

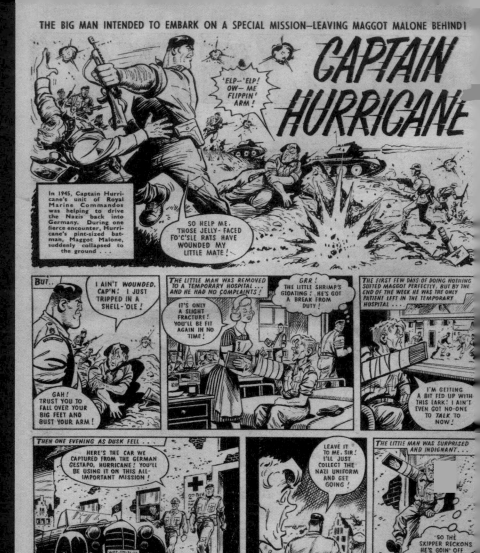

and into *Lion*, remaining there until 1974, when they moved to *Valiant* for the five-chapter *Captain Hurricane meets Steel Commando*.

Alongside berserkers, robots, shepherds and the like, schoolboys also played a part in the war against the Nazis...at least they did in comics.

Lion's *Andy's Army* followed Andy Campbell as he led three desperate criminals into Germany to wage guerrilla war on the Nazis. Campbell had broken them out of a British Army WWII prison camp commanded by his father in the inaugural installment of the short-lived series. The strip ran from September 28, 1968 to April 26, 1969.

Another schoolboy-centric *Lion* strip didn't last much longer. *General Johnny* began on February 7, 1970 and ended just over a year later, on March 13, 1971. It featured Johnny Quick, a military genius in the art of war games. The British army seemingly had no hesitation about employing the youngster as "a schoolboy general."

And just to show the Brits can go easily as far over the top as the Yanks, let's not forget *The Amazing Jack Wonder*. Another *Lion* strip, its eponymous star became an unwilling guinea pig for a new drug, one which imbued him with the ability to morph into virtually any object (animate or inanimate) he chose. He used his newfound power to briefly battle the Nazis in a series that ran from February 5, 1966 to May 28, 1966.

◀ Captain Hurricane's "raging furies" made it possible for the Royal Marine Commando to bend tank barrels with his bare hands or beat the stuffing out of countless "Sausage Noshers" (as he not-so-affectionately called his German foes) without working up a sweat.

▶ One of the most bizarre World War II stories to feature in a British comic was *Trooper Bo-Peep*. Bert Tipper's pursuit of the ram with the plans through the Western Desert was regularly interrupted when he would stumble across German troops or get into trouble with his own side.

WARTIME REGULARS

Unlike in the US, where anthologies were driven virtually to the edge of extinction by comic books devoted to a single character (or set of characters), British publishers have continued to favor the "variety show" format. Even so, recurring character and serialized storylines are an important aspect of the UK weeklies, which would take in a wide range of themes including Westerns, science fiction, sport, and action/adventure, as well as war.

One of the earliest of British comics' recurring war heroes was Ace Rogers, who debuted in Soloway's *Comic Adventures* in 1943's volume 3 #2. Sticking around until 1949, the Royal Navy Lieutenant's strip was entitled *Ace Rogers of the Submarine Salvo* at the outset. Initially he fought the Nazis before moving on to face the Japanese, at which point the series became *Ace Rogers of the Submarine Service*. Post-World War II, he became an amphibious adventurer.

Much later came a squadron of air aces, among them Battler Britton (1956), Paddy Payne (1957), and Braddock (1961) (see pages 124-125), as well as the first of the handful of teams that fought the Second World War on the pages of Britain's comics. Introduced in the 1960 first issue of Fleetway's *Buster, Phantom*

Force 5 was a quintet of military specialists whose exploits continued only until 1962.

As *Phantom Force 5* bowed out, two more comics combatants hit the beaches. One of British comics' major war characters, Captain Hurricane (see pages 114-115) was preceded historically by Union Jack Jackson, who had originally appeared in DC Thomson's prose weekly, *The Hotspur*. A Brit fighting with the US marines, he reappeared only briefly in the re-launched comic version of that title before achieving greater success in *Warlord* (see pages 110-111) 12 years later.

Three years after Hurricane and Jackson made their debuts came the *Mighty Misfits* (see pages 114-115) with the Deathless Men following a year later. Introduced in 1965's *The Hornet*, these anonymous, gray-masked escapees from Nazi concentration camps had previously appeared in *The Wizard*—another of DC Thomson's prose weeklies—beginning in 1942. They were the stars of *V for Vengeance*, a strip that ran in *The Hornet* until 1975 and then in *The Hotspur* from 1976 to 1980.

Another DC Thomson regular was *Killer Kennedy* (see also pages 126-127), while *Sergeants Four* came from the IPC barracks, premiering in 1971's *Jet* #1. The story of an Englishman, an Irishman, a Scotsman, and a Welshman (which sounds like the beginning of an old joke), the short-lived series followed the quartet as they returned to Dunkirk to retrieve the British Bulldog Banner (see pages 118-119).

Three years later DCT launched *Warlord* (see pages 110-111), a war-centric title that introduced a whole battalion of regulars, while IPC followed suit with *Battle* (see pages 112-113) in 1975, the same year Joe Bones made his debut in *The Victor*. Known as the Human Fly, although his Sergeant considered him a military disaster, his climbing skills kept him in action in the Thomson title until 1986.

Worthy of spotlighting among the later additions to the *Battle* roster is *Darkie's Mob*. Written by John Wagner and drawn by Mike Western, and running from August 1976 to June 1977, the series was set in the jungles of Burma.

▶
"Killer" Kennedy starred in *The Victor*, a torpedo boat captain whose war started off badly when he was dismissed from the Sevice for being too outspoken. This didn't stop him getting into trouble as a civilian, however.

▶▶
Explosives expert Sergeant "T.N.T." Telford had been captured when the Germans invaded Crete, but escaped and joined a partisan band, inflicting damage on the Germans at every opportunity in the pages of *Hotspur*.

▶
Predating *Escape to Victory* by over ten years, *The Barbed Wire XI* ran in *Tiger*, and followed British POWs at the Crag Stalag who had formed their own football team.

▶▶
Separated from his parents when the Germans invaded France in 1940, Tim Randolph was cared for by a strange old man who taught the youngster to control birds. The bizarre *Bird Boy* ran in *The Victor*.

◀
The violent and grim *Darkie's Mob* followed a band of lost soldiers, led by renegade Captain Joe Darkie, as they fought a personal guerilla war against the Japanese.

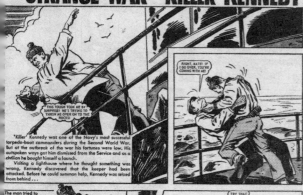

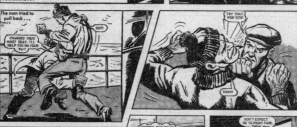

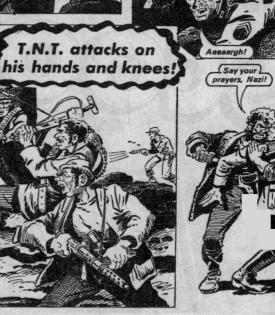

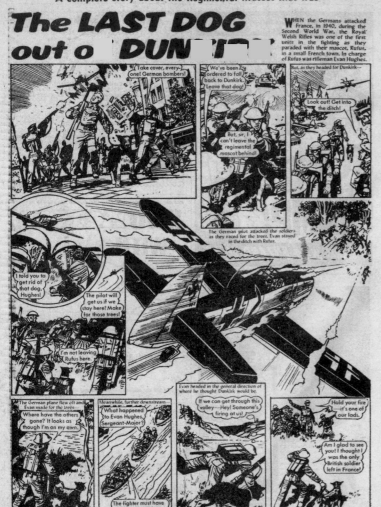

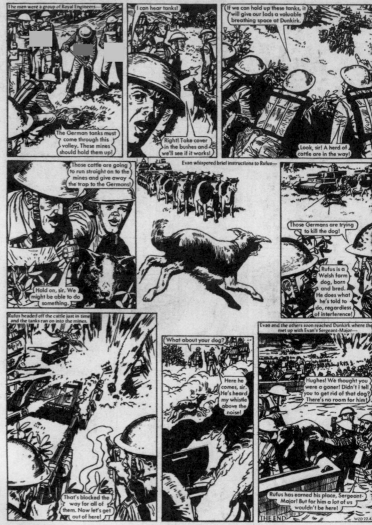

The LAST DOG out of DUNKIRK

HMS Pangbourne was one of a number of mine-sweepers at Dunkirk; after picking up wounded soldiers, the ship left Dunkirk after dark and ran aground on a sandbank. Luckily the tide was flowing and she managed to back off two hours later, her injured passengers little the wiser. After reaching Ramsgate and disembarking her cargo, she turned straight round and headed back to the fray, much to the surprise of one sergeant, who had slept so well he found himself back at Dunkirk!

A Story Of A "Miracle" Of The Last War!

THE VICTOR

EVERY MONDAY Price 5d

No. 188 SEPT. 26th 1964

THE PANGBOURNE AT DUNKIRK

32 THE VICTOR September 26, 1964

NEXT WEEK—"Desert Rescue," a story of heroism in World War I.

A VERY BRITISH DEFEAT

◄

One story that was set during the evacuation of Dunkirk was *The Last Dog out of Dunkirk*. A typically British comic strip, the 1972 two-pager—which ran in issue #121 of DC Thomson's *Wizard*—chronicled the life-saving act of Rufus, mascot of the then-fictional Royal Welsh Regiment as it was pushed back by the advancing German attack.

The battle of Dunkirk was described privately by then Prime Minister Winston Churchill as "the greatest British military defeat for many centuries." Ruthlessly pushed back and harried by the irresistible advance of the German forces, the Allied army found itself trapped on the beaches of Northern France and in danger of annihilation. In one of the largest military evacuations ever, between May 27 and June 4, 1940, 693 ships (39 Destroyers, 36 Minesweepers, 77 trawlers, 26 Yachts, and a variety of other small craft) brought back 338,226 military personnel to Britain.

Speaking to Parliament on June 4, Churchill revealed, "Our losses in men [at Dunkirk] have been 30,000 killed, wounded, and missing. Against this we might set the far heavier loss certainly inflicted upon the enemy. We have lost nearly 1,000 guns and all our transport, and all the armed vehicles that were with the army in the north.

"The best of all we had to give, has gone with the BEF [British Expeditionary Force] and although they had not the number of tanks they were a very well and finely equipped army," he added. "They had all the first fruits of all our industry had to give, and that is gone."

No single operation in the whole of the Second World War captured the popular imagination in Britain as did the transport of the remnants of the British Expeditionary Force back to England in the summer of 1940. The evacuation even entered the language—everyone in the UK knows what is meant by the "Dunkirk spirit."

Yet the retreat was also a humiliating defeat, and it is probably for that reason that this historical conflict has been more or less overlooked by British comics. That said, the heroism and bravery of the servicemen involved in that evacuation was celebrated by DC Thomson on several occasions in the true story feature that ran each week on the front and back covers of *The Victor*. Among those spotlighted were the crew of the Pangbourne (in 1964's #188); Sergeants East and Mitchell of the Royal Marines (1971's #533); the Gloucestershire Regiment (1971's #556, 1972's #602, and 1983's #1151); and Captain H. Ervine-Andrews of the East Lancashire Regiment (1974's #684). Ervine-Andrews was awarded the Victoria Cross for his role in the action.

On the fictional side there was *Sergeants Four*, which ran in all 22 issues of IPC's *Jet*. The series followed the quartet of non-commissioned officers as they returned to Dunkirk to recapture the army's most treasured war souvenir, the British Bulldog Banner, which had flown at Waterloo as well as in the Crimea and South Africa. After that initial mission, the four sergeants went on to act as an independent commando unit.

Such was the situation with most Dunkirk-related strips, where the evacuation would serve only as a springboard for each series' ongoing storyline. A case in point is *Skreamer of the Stukas*. Running in *Battle Picture Weekly* from September 16 to December 23, 1978, it followed 16-year-old Jimmy Fletcher, who illegally enlisted in the Royal Air Force so he could take revenge on Otto Skreamer, the German Stuka fighter pilot, who not only killed Fletcher's father as he was assisting Dunkirk evacuees but also led the air raid that destroyed the rest of the boy's family. The bloodthirsty veteran of the Spanish Civil War was as hated by his fellow Luftwaffe pilots for his murderous tactics as he was by the British.

Just over two years earlier *Battle* had premiered *The Unknown Soldier* (unrelated to the DC Comics character). Running from August 14 to October 16, 1976, it began on the beaches of Dunkirk, where Sergeant Tom Craddock (a.k.a. the Unknown Soldier) and three other soldiers were trying to stem the German advance. One of them—Corporal Dykes—shot the others to guarantee his own survival. Unfortunately for the cowardly corporal, Craddock survived, although without recollection of the incident. When the pair are posted to the same unit, Dykes tries to prevent the amnesiac sergeant (now Private "John Smith") from regaining his memory.

More hard-hitting and realistic was the very first issue of Fleetway's *War Picture Library*. Entitled *Fight Back to Dunkirk*, the 1958 64-pager told how a sergeant of the fictional Wessex Regiment made his way back through enemy lines after being cut off by the speed of the German advances.

TALES FROM THE OTHER SIDE

During World War II, the Allies faced a military alliance that included Fascist Italy and Imperial Japan. For the British, however, Nazi Germany was the main Axis threat. Even so, by the 1970s, British war comics were willing to include stories based around German characters, often with "good" ordinary Germans in conflict with the "bad" Nazi SS or Gestapo.

Before its 1977 merger with *Battle Picture Weekly*, IPC's *Action* comic—which, for its time, was deliberately provocative—ran the strip *Hellman of Hammer Force*. Written by Gerry Finley-Day, it featured Panzer Major Kurt Hellman fighting Allied tanks across Africa, Russia, and Europe. Inspired by Sven Hassel's World War II novels, Pat Mills, the Godfather of British comics, initiated the concept for what was the first German among Britain's war comic heroes: "I had to really press the publisher for permission because he was nervous of a possible backlash."

Hellman marched into *Action* on February 14, 1976 in the comic's first issue. *Battle* unleashed *Panzer G-Man* eight months later, when—on October 23, and as an example of a long-established tradition in the British comics industry—it absorbed another of its stablemates to materialize as *Battle Picture Weekly* and *Valiant*. Another Finley-Day tank-related character, Panzer Grenadier Kurt Slinger's adventures—initially drawn by Geoff Campion—took place on the Russian front.

It was a DC Thomson weekly, however, that took such "enemy" heroes to a new level of popularity. Following the path blazed by *Battle* and *Action*, 1977's *Warlord #152* introduced Panzer Major Heinz Falken. The disgraced officer led *Kampfgruppe Falken*, a punishment battalion on the Russian front. Having their German heroes fighting on the Eastern Front against Soviet forces was a plot device common to British war comics; it avoided having to show British troops being killed.

Explaining the rationale behind the introduction of such characters, editor Bill Graham commented, "Up until *Warlord*, the war stories in British comics were nearly all very jingoistic. We tried to get away from that, though we had our battles with management,

all of whom had seen service in World War II. We didn't want to tell stories about the Brits slaughtering the enemy in amazing feats of derring-do. We wanted to tell stories about all the fighting men in the major conflicts in a more realistic fashion."

Kampfgruppe Falken became a regular in *Warlord*, where Hellman's original artist, Mike Dorey, illustrated much of the series. The strip paved the way for many more German characters: Willi Kasner of the Africa Korps first appeared in issue #299 in *Big Willi*, while slightly further north in the Mediterranean Lieutenant Paul Van Leif commanded the eponymous E-boat in *The Shark*, which launched in 1979's issue #248.

The popularity of its German protagonists established, *Warlord* opted to use the European front as a backdrop, even if post D-Day series such as *Muller's Mob*, beginning in #368 (1981) generally showed the German army in retreat. Two years later, issue #440 brought a slight twist with the Austrian Corporal Gustav Heinemann in *Gustav's Cossacks*, while Wulf Stolberg appeared the following year in the Panzer story *Stolberg in Battle*, which began in #525. In addition, Heinz Falken returned in 1986's issue #601 in *Falken*, a prequel set before his demotion to the punishment battalion.

Warlord's other long-running German lead character was Kurt Stahlmann. The first of Thomson's "enemy" heroes introduced after the success of *Kampfgruppe Falken*, the pilot, who first appeared in 1979's #232, flew a slow Junkers Ju-52 transport plane—the titular Iron Annie—on the Eastern Front.

While hardly a glamorous aircraft, Annie was soon fitted with an anti-tank cannon retrieved from a crashed Stuka, giving the stories a more combative edge. Stahlmann's Dorey-drawn adventures continued in a prequel called *Blitzkrieg Bomber*, in which he flew a Heinkel He-111 bomber against the Poles in 1939, before moving to a sequel to the original *Iron Annie* stories in which he flew a Focke-Wulf FW-200 Condor maritime patrol bomber, attacking Allied shipping in the Atlantic in *The Fighting Condor*.

▶ ▶▶▶
The punishment battalion of *Kampfgruppe Falken* in *Warlord* were led by Panzer Major Heinz Falken, who had been sent to the penal battalion for failing to carry out atrocities ordered by his commander.

▶▶
In *Big Willi*, Willi Kasner commanded a Marder III tank. The Marders were built onto the chassis of the obsolete Panzer 38, removing the turret and replacing it with a high wall of armor. Unfortunately the tall silhouette made it more vulnerable to enemy fire.

▶
Panzer G-Man starred Kurt Slinger, who is wrongly accused of cowardice and is forced to fight as a Panzer Grenadier—the unfortunate "Dog Soldiers" who would run alongside the Panzer tanks.

▶▶
Kurt Hellman, the star of *Hellman of Hammer Force*, was a skilled commander but certainly no Nazi, as likely to make enemies on his own side as he was of the Allies.

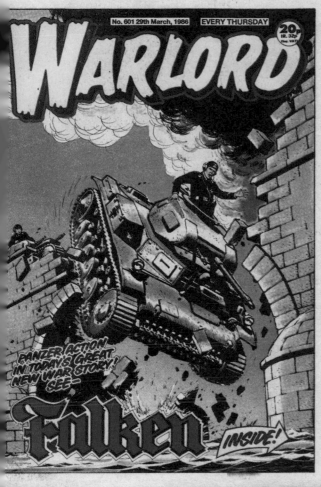

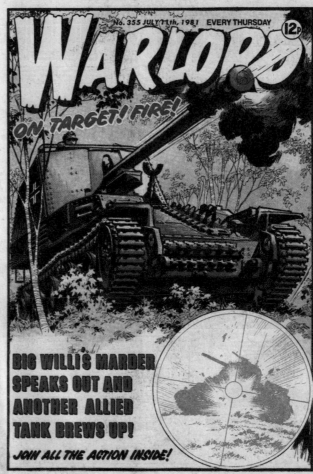

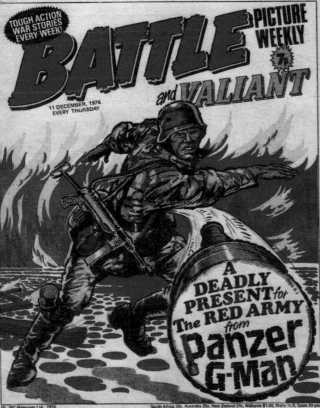

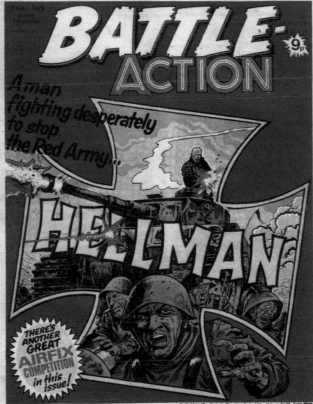

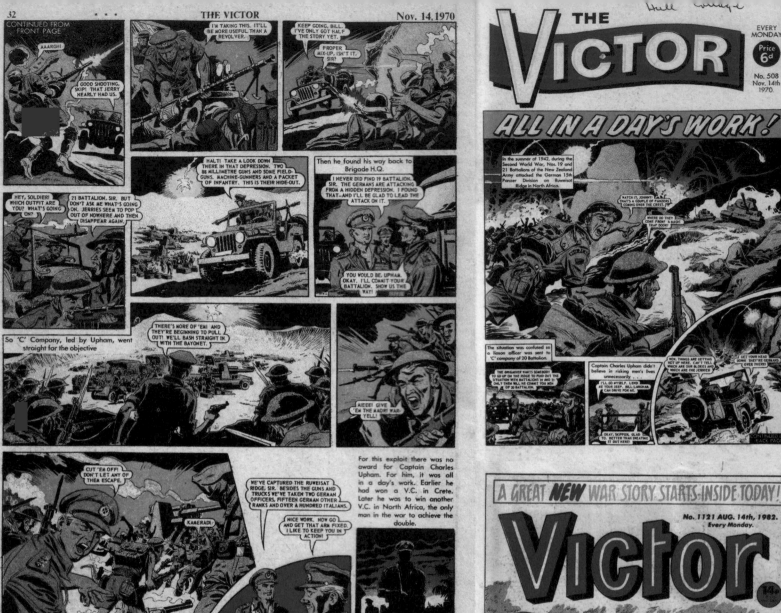

NEXT WEEK—The story of how an Aussie machine-gunner won the Military Medal!

Printed and Published in Great Britain by D. C. THOMSON & Co., Ltd., 12 Fetter Lane, Fleet Street, London, E.C.4.

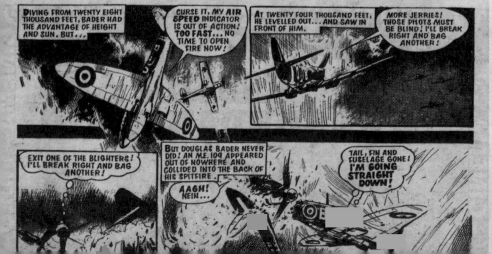

REAL WAR HEROES

◀ ◀◀
A typical example of *The Victor's* "true war" tales, this 1970 recounting of an episode from North Africa in 1942 focused on Captain Charles Upham's dangerous reconaissance mission. Upham did not win a Victoria Cross for this particular exploit, but had earlier been awarded a VC for his actions in Crete, and would win another during the North African campaign—the only man in the war to win two VCs.

◀
Another *Victor* cover story, this time detailing the British Naval Fleet's hunting of the German battleship Scharnhorst.

◀◀
Legendary pilot Douglas Bader—immortalized in the 1956 biopic *Reach for the Sky*—featured in this true life tale from *Battle*.

▶
Lasting just three issues, *True War* would often use photographs as part of the comic strips.

The majority of the war stories in British comics were fictional, with the best often written by veterans who had taken part in the conflicts themselves. Publishers, however, did also make it a definite policy to highlight the actions and bravery of actual participants in various campaigns.

Devoted specifically to that theme was IPC's aptly titled *True War*, a short-lived 1978 monthly that, unusually, incorporated black-and-white photographs as frames into many of the pages of artwork. Each issue featured two complete strips, one of which would detail a World War II campaign, such as the *Battle of the Atlantic* (in issue #2). The other story would focus on an individual, with #3—the final issue—featuring Wing Commander Guy Gibson VC, who led Lancaster bombers against the German Ruhr dams, an attack immortalized in the 1954 film *The Dam Busters*.

Britain's two weekly comics devoted specifically to war also featured factual stories, each title offering its own unique take.

IPC's *Battle Picture Weekly* included various short-lived series, among them *Battle Badge of Bravery*. This ran through the summer of 1975 with accounts of various deeds, among them the Dambusters raid. *Iron Cross of Courage*—which featured German war heroes—followed in early 1976, while *Battle/Action True Life Heroes* premiered three years later.

Launched in 1975, *Battle* also ran short biographical strips, one being the life of Douglas Bader. The Jim Watson-drawn story of the RAF pilot who had lost both legs before World War II but still became an ace flying against the Luftwaffe appeared in 1983.

DC Thomson's *Warlord* covered true tales more consistently than *Battle*, with two-page text stories illustrated mainly by Watson. These began in the 1974 first issue with the tale of the armed merchantman HMS Jervis Bay and its Irish captain, Fogarty Fegan, who earned a posthumous Victoria Cross for defending his convoy against the German pocket battleship Admiral Scheer. In later issues, these stories moved to the back page as illustrated features focusing more on individuals, such as the strip in December 1977's issue #169, which spotlighted Marcel Albert, the Free French fighter ace who flew Yak fighters for the Red Air Force and was eventually awarded the Hero of the Soviet Union medal.

Surprisingly, the best known of the non-fiction strips in British comics was not in a dedicated war title. DC Thomson's *Victor* adventure weekly had a long-running series entitled *True Stories of Men At War*. With only two pages, including a splash panel on the front cover, the storytelling was fast and to the point. Traditionally published in color on the front and back covers of the comic, *True Stories...* featured tales of individual acts of medal-winning heroism by British and Commonwealth forces during wartime.

As *Victor* premiered in February 1961, and the series ran in almost every issue for 30 years, some stories were reprinted while others were recounted more than once by different artists and writers.

FLYING ACES

The glamor boys of Britain's World War II forces were Royal Air Force (RAF) fighter pilots; a standing reflected in British comics.

Aces like Battler Britton and Paddy Payne could apparently fly anything; writers never let the differences in airspeeds, engine revs, and the myriad other technical difficulties involved in flying different aircraft types stand in the way of a good story.

Created by Michael Butterworth, writer of *The Rise and Fall of the Trigan Empire*, Wing Commander Robert Hereward "Battler" Britton first appeared in issue #361 of Amalgamated Press' weekly anthology title *Sun* on January 7, 1956. Initially drawn by Geoff Campion, his stories would continue through to August 1963, latterly in Fleetway's weekly *Valiant*. The heroic pilot could fly fighters, bombers, and even helicopters.

Different artists illustrated *Battler Britton* over the years. Among them were some of the best British combat artists, including Mike Western and Ian Kennedy. And in 2006, writer Garth Ennis and artist Colin Wilson resurrected the British pilot in a five-issue mini-series for US publisher WildStorm, an imprint of comic book publishing giant DC.

Paddy Payne had a similar repertoire of aircraft to Britton when he debuted in issue #284 (July 27, 1957) of *Lion*, another of Fleetway's weekly anthologies, where he continued until February 1972. Written by Mark Ross—a pen name for ex-RAF pilot

A. J. "Johnny" Sullivan—*Paddy Payne* was, like *Battler Britton*, illustrated over the years by many different artists, with arguably the best being future *Charley's War* artist Joe Colquhoun, who drew the strip from 1959 to 1964.

However, two fliers standout as being rather different from the norm: IPC's Johnny "Red" Redburn and DC Thomson's Matt Braddock VC.

Redburn was the star of *Johnny Red*, which premiered in the January 29, 1977 issue of *Battle Picture Weekly* (later *Battle-Action*, then *Battle*). Set in Russia, the strip began with the RAF pilot flying his Hawker Hurricane fighter from a CAM (Catapult Aircraft Merchantman) ship to protect an Arctic convoy from German bombers. Rather than ditching in the ocean, he landed in the Soviet Union, where he joined up with the Red Air Force Falcon Squadron.

For the strip's first two years, Colquhoun, whose detailed art realistically evoked the grimy and dangerous life on the Eastern Front, drew the gritty Tom Tully-written stories, making it a readers' favorite. John Cooper followed Colquhoun. Over the next five years, his art, cleaner and more dynamic than his predecessor's, kept the pilot in the top tier of the most popular strips, appearing regularly in the comic's color center pages.

In contrast to his comic contemporaries, Sergeant Pilot Matt Braddock VC did not fly single-seat fighters and was not even an officer. In Braddock, Thomson's editor William Blain effectively created a blue collar, rather than a white collar, worker who had little regard for authority when it prevented him fighting the war.

Like so many of DC Thomson's long running characters, Braddock appeared in different comics, the first being *The Rover*. Launched in #1414 (August 2, 1952), his debut was titled *I Flew with Braddock*, a text serial narrated by Sergeant George Bourne, the pilot's navigator, who always accompanied the pilot on missions.

Together the duo transferred to *The Victor* in 1961, where their original *Rover* text stories formed the basis of many of their strip adventures. In 1974, they moved again, into new stories in the more modern *Warlord* comic.

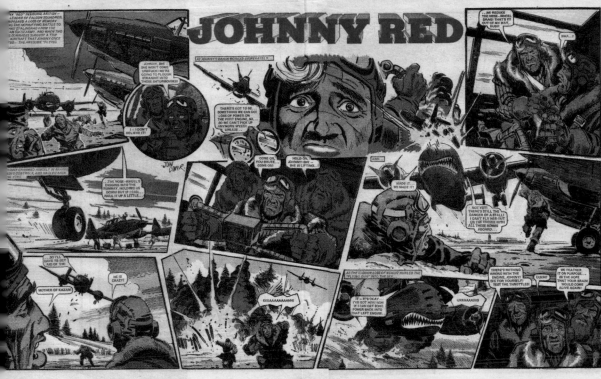

JOHNNY RED

◄

Johnny Red was one of the most popular stories in *Battle*, following 19-year-old British pilot John Redburn's adventures with Russia's Falcon Squadron.

◄◄

Alongside his appearances in *Valiant*, *Battler Britton* also starred in the digest-sized *Thriller Picture Library* in long, single issue stories.

◄◄

An early appearance for *Battler Briton*, in the November 29, 1978 edition of *Sun Weekly*.

◄

Johnny Red loses yet another colleague to the Germans on this explosive 1977 *Battle-Action* cover.

◄◄

Squadron Leader Paddy Payne and his pal Dick Smith were often left at the mercy of the Germans in the pages of *Lion*.

◄◄◄

Seargeant Pilot Matt Braddock made three appearances in the bimonthly *Red Dagger* title, including this one in the penultimate issue.

◄◄◄◄

Braddock's text serial, *I Flew with Braddock*, which originally appeared in *The Rover*, was subsequently published in book form.

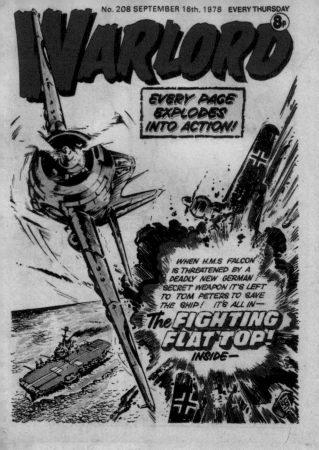

No. 208 SEPTEMBER 16th, 1978 EVERY THURSDAY 8p

WARLORD

EVERY PAGE EXPLODES INTO ACTION!

WHEN H.M.S FALCON IS THREATENED BY A DEADLY NEW GERMAN SECRET WEAPON IT'S LEFT TO TOM PETERS TO SAVE THE SHIP! IT'S ALL IN—

The FIGHTING FLAT TOP! INSIDE—

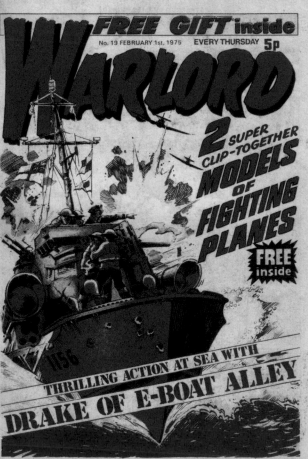

FREE GIFT inside

No. 19 FEBRUARY 1st, 1975 EVERY THURSDAY 5p

WARLORD

2 SUPER CLIP-TOGETHER MODELS OF FIGHTING PLANES

FREE inside

THRILLING ACTION AT SEA WITH

DRAKE OF E-BOAT ALLEY

THE SENIOR SERVICE

As an island nation, Great Britain has always been dependent on the sea. And while there have been naval forces since the reign of King Alfred the Great in the late 9th century, the modern Royal Navy can trace its lineage to the rein of King Henry VIII, who created a "Navy Royal" in the early 1600s.

The Royal Navy entered World War II as the largest fleet in the world. The oldest of the British military forces, "The Senior Service" as it was known has featured in many of the British weekly boys' comics, from the motor torpedo boat captain *Killer Kennedy* in DC Thomson's *Victor* to the Q-ship decoy vessel *HMS Smokey Joe* in *Warlord*, another DC Thomson title. Yet it was rare for any of the weekly comics to feature the Navy's capital ships, such as cruisers or battleships, since, while they were impressive vessels, they took part in comparatively little combat action.

Warlord, however, did run a strip about a British aircraft carrier—the fictional HMS Falcon—in *The Fighting Flat Top*, beginning in issue #199 in July 1978. Even then, the ship was primarily a backdrop to tell short stories of various Fleet Air Arm pilots and aircrew. With each story set during different battles in different locations, the series maintained little consistency during its relatively short run.

With capital ships offering little in the way of continuous action for the scriptwriters, the comics tended to concentrate on the smaller craft which were involved in a wider range of combat situations. *Battle Picture Weekly*'s contribution was the corvette, *HMS Nightshade*. Written by John Wagner with art by Mike Western (helped by Ron Tiner), His Majesty's Ship Nightshade began her adventures in issue #200 (dated January 6, 1979) of the IPC title, which had merged with *Action* three years earlier to become *Battle Picture Weekly/Action*. George Dunn, who bears a remarkable resemblance to Western, narrated the strip. In it he tells his young grandson, Davy, of his wartime service on board the small corvette.

Yet of all the various British naval craft, the small but heavily armed and fast moving motor torpedo boats, or MTBs, gave scriptwriters the greatest scope

◄

The Fighting Flat Top was a rare instance of an aircraft carrier featuring in a British war comic.

►

HMS Nightshade began with the ship's role in the Allied retreat from Dunkirk, before moving to the Battle for the Atlantic.

►►

Crewmen aboard the HMS Nightshade react to the "strategic withdrawal" from Dunkirk in this early episode of the serial.

◄

"E-Boat Alley" was the name given to the stretch of water more commonly known as the English Channel. "E-Boat" stood for "enemy boat," although to the Germans they were known as "S-Boots" or "Schnell boots"—"fast boats."

for entertaining stories. *Warlord's* longest running naval character was MTB Captain Lt. Drake. He commenced service for *Warlord* in issue #18 (dated January 25, 1975), in the Ron Smith-drawn *Drake of E-Boat Alley*, which was set in the English Channel in 1940. Drake's vessel often took on its German equivalent, the E-Boat, as well as assisting British pilots shot down over the water and dropping British agents on the French coast. The character proved popular enough over his 18-week run to be brought back, firstly in the Mediterranean in *Drake of Malta* in issue #51 (September 1975) and later in the Pacific in *Drake against the Rising Sun*, beginning in October 1978's issue #214.

THE TURNING POINT

IS THIS TOMORROW

AMERICA UNDER COMMUNISM!

World War II was arguably America's last great just war; the civilian population all agreed that Hitler, the Nazis, and the Japanese military *had* to be stopped, for the free world to remain as such. But in the years following WWII, this overly simplistic worldview of black and white, good versus evil, began to blur with the start of the Cold War.

With the rise of communism spreading from the USSR to infect the Far East, Cuba, and South America, the US suddenly felt surrounded by a dangerous, alien ideology that threatened its very survival. The first "hot" war to come out of this political attrition was the Korean War in 1950. After World War II, Korea was split in half—along the 38th parallel—by the allies, with America occupying the lower half and Russia aiding the North—similar to what had happened in Germany. But North Korea wanted to see the country reunited by any means necessary and—backed by the Soviets—the North Korean army attacked the South on June 25, 1950.

What ensued was a savage conflict that saw both the Chinese and American armies drawn into direct battle on Korean soil. While young American men were drafted up again, there was more reluctance to fight than previously. After all, the US had only just emerged from a lengthy war; things were no longer so clear-cut after World War II, and subsequently support for overseas "police actions" dropped greatly.

President Harry Truman and Senator Joe McCarthy tried to maintain support for the war by instilling a climate of fear with the "Red Scare," implying that there were fifth columnist communists infiltrating and undermining America—the so-called "reds under the bed." But this authoritarian scaremongering—then as now—simply turned off the younger generation. Beatniks—the proto-hippie movement of the 1950s, identified by Jack Kerouac as the lost or Beat generation—were anti-establishment, and so, in turn, anti-war, and they began a generational split that would become a chasm over the next 20 years.

Despite this, the majority of war comics in the early 1950s were still typically jingoistic saber-rattlers, with blue-eyed blond-haired US farm boys fighting racist caricatures of North Korean and Chinese soldiers. It took visionary editor/writer/artist Harvey

Kurtzman to turn things around when he saw the futility of the war and addressed it in EC Comics' *Two-Fisted Tales* and *Frontline Combat*. Kurtzman's characters were mostly just regular G.I. Joes or civilians trying to survive inside a war zone. He based his eight-page stories on solid research, his own war experiences, and—most importantly—on interviews with returning veterans from Korea. This gave the tales an immediacy, rawness, and truth unseen previously in American war comics.

After three years of bitter fighting in Korea a ceasefire was agreed to by both sides on July 27, 1953. The war left 33,742 American soldiers dead, 92,134 wounded, and 51,000 MIA. Neither side had particularly won—the border remained at the 38th parallel—and this stalemate left many Americans at home wondering what the point of it all was. The Korean conflict, for many years, was simply known as the Forgotten War.

By the time America entered the Vietnam War in 1961, civilian sentiments toward overseas conflicts was turning from apathy to hostility, and the comics for a new generation would reflect this.

▲
Published by the Catechetical Guild Educational Society in 1947, *Is This Tomorrow* depicts an America crippled by homegrown Communists. More than four million copies of the comic book are estimated to have been distributed.

We had been engaged by three Mig fighters who obviously hadn't heard the good news.

WHERE ARE YOU *BIG DADDY?*

I CAN'T WAX ALL THREE OF THEM SON--YOU'RE GONNA HAFTA *PULL UP!*

DO YOU COPY? *PULL UP!*

BANDITS'VE TORN MY FLAPS AND RUDDER TO SPLINTERS, PAPPY-SHE HASN'T GOT IT IN HER! I THINK I GOTTA GO!

SUFFERIN' SUZIE!!

One of Harvey Kurtzman's EC highlights was *Two-Fisted Tales* #26, which told the story of the battle of the Changjin (Chosin) Reservoir, where a large group of US and British soldiers were trapped by the Chinese army deep in North Korea in November-December 1950 and had to fight a long-running battle to escape. Their retreat was told from the numerous perspectives of Marines, Korean civilians, and even a stray dog.

For many years the Korean War hasn't been represented in comics, until Darwyn Cooke's 2004 opus *The New Frontier*, which saw a re-imagining of the DC Comics universe with pilots Hal (Green Lantern) Jordan and Ace Morgan fighting at the end of the war, alongside Lois Lane and Jimmy Olsen.

131

G.I. JOE

Although these days the name G.I. Joe evokes thoughts of Hasbro's hugely popular line of action figures (or "dolls for boys" as cynics dub them), the phrase has its beginnings in World War II, where it came to suggest the ordinary trooper, the faceless infantryman.

Many wartime supplies were marked G.I. (as in Government Issue) and cartoonist Dave Breger simply tacked the somewhat anonymous "Joe" onto that label to create the title for a series of cartoons that debuted in *Yank* magazine on June 17, 1942.

By the end of the war G.I. Joe had moved into common parlance; there was even a 1945 movie—*The Story of G.I. Joe*—although it had no connection to Breger's cartoons.

Five years later, with the police action known as the Korean War beginning to simmer, Ziff-Davis brought the army's everyman into comics. More than that, the publisher gave him a specific identity. One of the first war comics to star a continuing character, *G.I. Joe* spotlighted G.I. Joe Burch, a perpetually smiling infantryman who was in conflict with his Sergeant at least as often as he was with the Communists.

Launched in 1950 with #10, the title—which took a light-hearted approach to war—often sported covers by *Mars Attacks* artist Norman Saunders, and featured frequent contributions by artist Bob Powell. It ran 56 issues until 1957, with one of its even more comedic back-up strips landing its own short-lived comic in 1952. Subtitled *G.I. Joe's Sidekicks, The Yardbirds* managed just a single Dan "*Archie*" DeCarlo-drawn issue.

A seemingly complementary title premiered from Stanhall in 1953. Lasting 11 issues, *G.I. Jane* was a risqué humor title replete with lingerie and nudity.

In 1964, DC Comics introduced its own G.I. Joe. Inspired by the first wave of Hasbro's action figures, he featured in six strips across two issues [#53-54] of its try-out title, *Showcase*. Despite the involvement of writer Robert Kanigher and artists Ross Andru, Russ Heath, and Joe Kubert, the stories were generic war tales.

It was another 18 years before another G.I. Joe comic book appeared. Licensed from Hasbro and subtitled *A Real American Hero*, the 1982 Marvel series featured an action figure-based elite counter-terrorist strike force. It was as far removed from a war comic as a spear is from an atomic missile.

► ►▼
Much less well known than his more modern counterpart, G.I. Joe Burch was a corn-fed farmboy who took an almost zealous delight in knocking the stuffng out of sundry Communists in the 1950s. Cover artist Norman Saunders later gained fame as the artist on the *Mars Attacks* cards, one of the most successful non-sports cards series ever created, and the inspiration for the Tim Burton film.

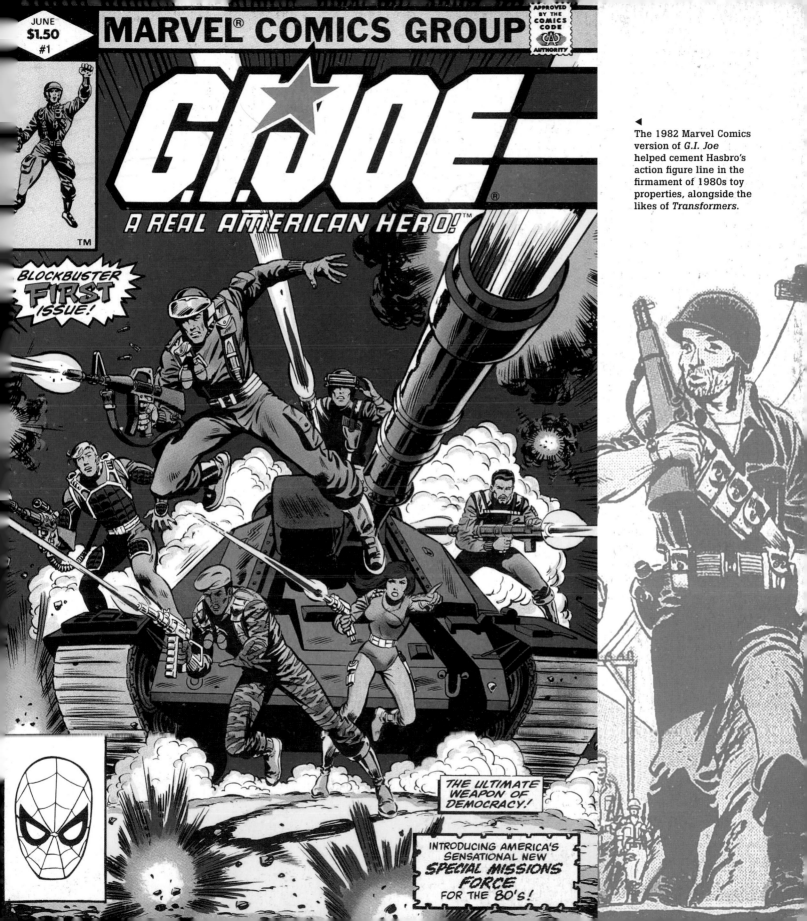

KOREAN COMBATANTS

◀ ◀◀

While there is no apparent connection between the 1951 *Combat Kelly* series and the 1972 *Dirty Dozen*-inspired re-launch from writer Gary Friedrich and artists Dick Ayers and Jim Mooney, 1998's *Marvel Vision* #28 claimed the same man is the star of both comics.

◀▼ ◀◀▼ ◀◀◀▼

Men's Action became *Battle Brady* in 1953 with #10, but then bit the dust with #14, although its Texan star resurfaced in 1954's *Battle* #27.

It would be foolish to suggest that the comic book version of the Korean War was won solely by Atlas troops, but this 1950s predecessor of Marvel Comics certainly put more than its fair share of regulars into the field.

First into action in that Asian conflict was the most successful: Combat Kelly, the Commie-killing infantryman described by his commanding officer as (among other things) a "gold-bricking, girl-crazy, chow-gulping, battle-batty G.I." A veteran of World War II, the career soldier debuted in the 1951 first issue of his own title, which ran 44 issues until 1957.

Having also featured in two issues of the comic six years earlier, he next appeared in another two issues of *Battle* and then, seemingly, in a 1972 revival of his own series. This was titled *Combat Kelly and the Deadly Dozen* and concluded after nine issues with the death of virtually everyone in Kelly's squad.

Another of Marvel's World War II heroes that also saw service in Korea was Sgt. Fury, although the irascible non-com and his Howling Commandos didn't make it to that theater until two years after their 1963 first appearance. But getting back to Kelly's two-dimensional Korean War contemporaries, there was also the similarly named Combat Casey. Effectively a red bearded clone of Kelly, Casey made his debut in

a seven-pager written by Hank Chapman and drawn by Robert Sale in the 1953 fifth issue of *War Combat*, which changed its name to *Combat Casey* with #6. The comic ended with 1957's #34. Its star—another World War II veteran—also appeared in *Combat Kelly* #17 (1953) and in 1958's *Battle* #61.

In between Kelly and Casey came another generic frontline G.I., one whose name was a variation on Atlas' alliterative comics Combats. Battle Brady entered the fray in 1952's *Battle Action* #5. Created by Hank Chapman and artist Joe Maneely, he went on to appear in issues 6-7 and 10-12 of that series before gaining his own short-lived title—the former *Men's Action*—with 1953's #10.

Even though a ceasefire was declared in 1953, Atlas continued to "pour" troops into Korea. Among them was "Iron Mike" McGraw. The "greatest gyrene of them all" and his best friend-cum-sidekick "Gunny" Gorski were first seen waging war on the Godless Commies in a 1954 six-pager in *Marines in Battle* #1. They also turned up in the second issue of another Korean latecomer's own title, featuring alongside him in a crossover. *He* was Devil-Dog Dugan, a gung-ho marine whose somewhat humorous exploits were initially drawn by Jim McLaughlin. Launched in 1956, *Devil-Dog Dugan* became *Tales of the Marines* with #4 and *Marines at War* an issue later. With the second name change Dugan—Atlas' last Korean comic book conscript—was gone, his time in Korea over.

Preceding Dugan by a year was another generic soldier, "Rock" Murdock, a.k.a. "The Fighting Gyrene." First seen in action in a six-pager drawn by Ross Andru and Mike Esposito for 1955's *Marines in Action* #1, he and his best friend/sidekick/foxhole buddy Scuttlebutt took on North Korean and Chinese troops through all 14 issues of the series, which bought the farm in 1957. The following year they resurfaced for one final clash in *Marines in Battle* #23.

◀

As well as their Korean outing—seen here in 1965's *Sgt. Fury and His Howling Commandos Annual* #1—the Howling Commandos also battled the Commies in Vietnam, as shown in *King-Size Special* (a.k.a. *Annual*) #3.

WARFRONT: TRUE WAR TALES?

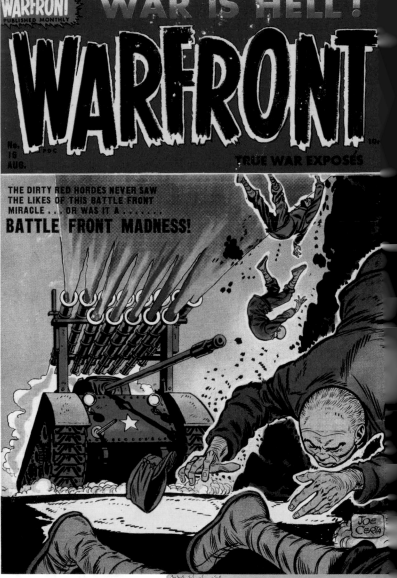

Throughout history nations have sought to honor their heroes. So it was with America and the Korean War, even though that particular conflict—sometimes called the Forgotten or the Unknown War, due to it being a major 20th century war that gets far less attention than World War II, which preceded it, and the Vietnam War, which succeeded it—was officially termed a police action in the US.

As it had done for US combatants in Europe and the Pacific during the Second World War, America's comic book industry paid tribute to the servicemen that fought in Asia during that three-year conflict, with Nedor Publications among the first publishers to acknowledge Korea's real life heroes. Appearing in 1951's *Real Life Comics* #58, *Action over Korea* was a four-pager spotlighting the valor of Ensign Ray Sanders and Lieutenant Bill Severns.

Premiering virtually simultaneously with that issue was Harvey Features Syndicate's *Warfront*. The comic carried a cover line proclaiming *True War Exposés*, but this was at best misleading and at worst an outrageous exaggeration. The writers and artists *may* have grounded their stories in truth, but the absence of verifiable dates and locations suggests *Warfront* differs little from its overtly fictional counterparts.

This didn't stop Harvey Features pushing the reality angle, however, as an extract from issue #11's editorial reveals:

"*Warfront* travels everywhere and anywhere. It covers the battle area like an entire staff of war correspondents. Its motto is truth and it's spelled out in the greatest group of true stories ever lived! Grim reality...authentic action...true fury—all under fire on the warfront!"

The series ran 35 issues until 1958. A four-issue revival in 1965 still maintained a modicum of "true story" material but—with its cover featuring the Rambo-like Dynamite Joe ("America's Explosive Marine")—all pretence of *Warfront* being reality-based *really* went out the window.

Harvey launched a companion series in 1952. Even the editorials of *True War Experiences* reflected the same stance as *Warfront*, although #2's was perhaps a little more honest. Among other things, it stated:

"Only facts can tell the truth. And the facts are our weapons. Names have been changed...for obvious reasons. But reality sticks out like the glinting point of a bayonet!"

More than four decades later, Dark Horse published a more factual one-shot. Released in 1994, *Medal of Honor Special* was written by *The 'Nam*'s Doug Murray, who followed it with a proposed five-issue series. This featured the story of Lieutenant Thomas Hudner—the first to win the highest US military decoration during the Korean conflict—in #4. That actually proved to be *Medal of Honor*'s final issue.

▲ ▶
The sensationalistic covers of *Warfront* were typical of the approach of the comic, often jingoistic and bearing little relation to the reality on the ground.

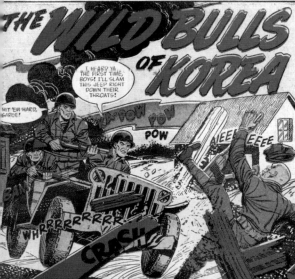

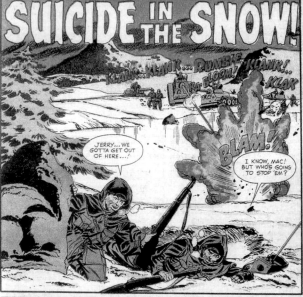

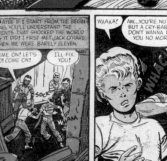

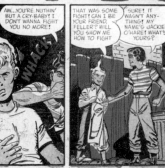

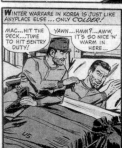

◄ ◄ Despite its title, *True War Experiences*—published by Harvey Features and lasting just four issues—exhibited pretty much the same grip on reality as its sister comic, *Warfront*.

◄ The story *Traitor* appeared in the fourth issue of *Warfront*, and told the tale of a deserter from the North Korean Army. The strip managed a modicum of sympathy for its "hero."

◄ ◄ Interior page from the *True War Experiences* story *The Wild Bulls of Korea*, which attempted to introduce some background color to otherwise one-dimensional characters.

◄ Issue #14 of *Warfront* included the story *Suicide in the Snow*. No more "factual" than any other strip in the comic, it did at least show how Korean winters can be somewhat harsh and unforgiving.

137

COLD WAR

Like the Sword of Damocles, the specter of nuclear Armageddon hung over the civilized world throughout the 1950s and 1960s—the hottest period of the era known euphemistically as the Cold War.

Paranoid but not paralyzed by the menace from the USSR, the possibility of atomic bomb attacks permeated through American society, reaching into its entertainment most conspicuously in such movies as *On the Beach* (1959) and 1964's *Fail-Safe* and *Doctor Strangelove or: How I Stopped Worrying and Learned to Love the Bomb!* A world poised on the brink of doomsday also inspired several comic book publishers.

First off the launch pad was St. John Publishing's *Atom-Age Combat*, which premiered in 1952. The series—which lasted just five issues—was somewhat directionless, with #1 focusing on long-range warfare, #2 wandering off into the realms of science fiction, and #3 coming back down to Earth with more traditional war stories. St. John re-launched the title in 1958 but—after just one issue—it migrated to Fago Magazines, which axed it after just two more.

Following close behind the original incarnation of *Atom-Age Combat* came Ace Periodicals' *Atomic War!*, which offered a pessimistic look at the realities of conflict where nuclear attack is a looming option. As the editorial message in #2 had it:

"The purpose of this book is clear. We want everyone—friend and foe alike—to know the utter devastation that another war will bring to all, the just as well as the unjust. We hope that all who read this magazine will think about this—and pray that what you see here will never happen."

The pre-eminent title inspired by the Cold War is the disheartening and pessimistic *When the Wind Blows* by Raymond Briggs. The Hamish Hamilton graphic novel is made all the more uncomfortable by Briggs utilizing the lead character from his previous Hamish Hamilton children's book, 1980's *Gentleman Jim*. The simple-minded and resolutely cheerful lavatory cleaner and his wife Hilda take in the news around them, never really understanding how it could impact on their lives. As military tensions escalate, they recall the World War II spirit and take the feeble, and ultimately ineffectual, precautions laid out in the official leaflet. Throughout everything, they retain a misplaced faith in the authorities to ensure their wellbeing in any event. Their faith in the powers that be never falters, even when the nuclear missiles have struck and they're succumbing to radiation sickness, awaiting help that will never arrive.

When the animated film version was released in 1986, the Cold War had but three years left to run. Removed from contemporary global politics, the scenario, eminently believable and powerful on publication in 1982, survives with luster marginally diminished. Briggs' central point, however, that the authorities have no concern for the ordinary man, continues to be relevant.

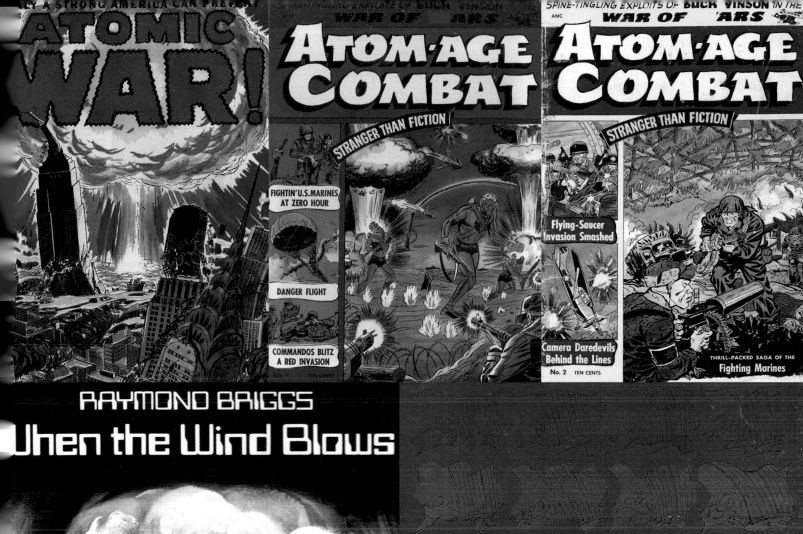

WE'D COME THROUGH THIS LITTLE VILLAGE ON THE WAY OUT, I DON'T THINK IT HAD A NAME, IT SURE WASN'T ON ANY MAPS. WHEN WE HIT IT ON THE WAY BACK I KNEW WE WERE CLOSE TO THE LZ. ANYWAY, WHEN WE WENT THROUGH THE VILLAGE IT SEEMED DESERTED-- *THAT* SHOULD HAVE TIPPED US OFF. BUT THE FIRST THING WE KNEW, WE WERE CATCHING FIRE FROM ALL DIRECTIONS!

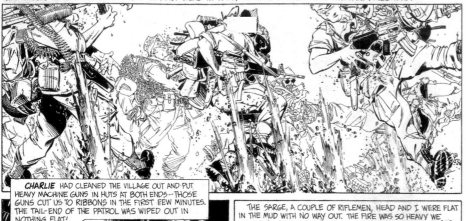

CHARLIE HAD CLEANED THE VILLAGE OUT AND PUT HEAVY MACHINE GUNS IN HUTS AT BOTH ENDS--THOSE GUNS CUT US TO RIBBONS IN THE FIRST FEW MINUTES. THE TAIL-END OF THE PATROL WAS WIPED OUT IN NOTHING FLAT!

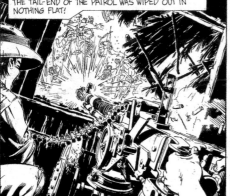

THE SARGE, A COUPLE OF RIFLEMEN, HEAD AND I WERE FLAT IN THE MUD WITH NO WAY OUT. THE FIRE WAS SO HEAVY WE COULDN'T RAISE UP ENOUGH TO THROW A GRENADE, BUT A *'79* MIGHT DO.

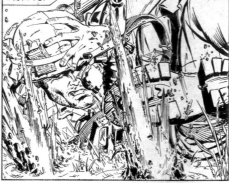

HEAD STILL HAD HIS, BUT WAS DAMN NEAR OUT OF ROUNDS. HE'D FIRED OFF A BUNCH AT THE AMBUSH, AND LOST A COUPLE WADING A RIVER ON THE WAY BACK. HE SHOUTED TO ME THAT HE HAD ONE *H.E.* (*HIGH EXPLOSIVE*) LEFT. AND HE PLUGGED THAT SUCKER AT THE MG BEHIND US.

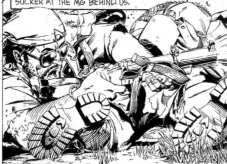

WELL, HIS SHOT WAS RIGHT ON, BUT A '79 ROUND HAS TO *ROTATE* A CERTAIN NUMBER OF TIMES AFTER IT'S FIRED TO ARM THE EXPLOSIVE--THAT'S SO YOU DON'T ACCIDENTLY HIT A TREE OR BUSH IN FRONT OF YOU AND BLOW THE CRAP OUT OF YOURSELF. THAT HUT WAS JUST TOO CLOSE.

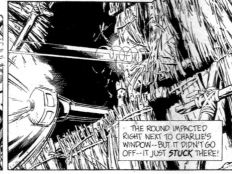

THE ROUND IMPACTED RIGHT NEXT TO CHARLIE'S WINDOW--BUT IT DIDN'T GO OFF--IT JUST *STUCK* THERE!

10

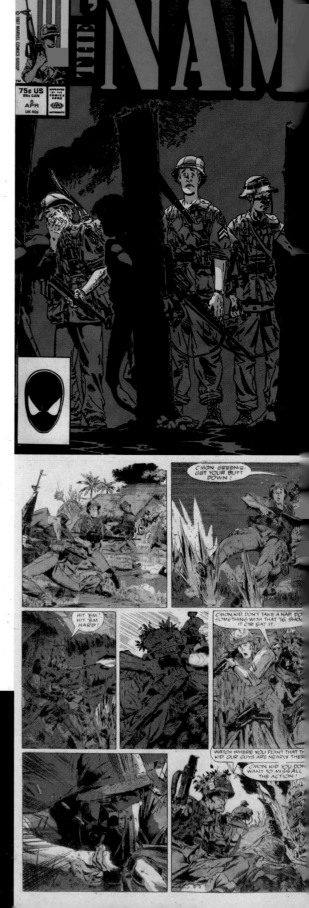

▲
Before the ongoing full color *The 'Nam* series began, writer Doug Murray and artist Michael Golden produced four episodes of precursor *The 5th to the 1st* for Marvel's black and white *Savage Tales* mag.

▶
Ed Marks finds himself in the thick of the action in the debut issue of *The 'Nam*. Michael Golden's 13-issue run on the comic is considered the golden age of the title.

THE 'NAM

A surprise success in the 1980s, *The 'Nam* chronicled the progress of an army squadron in Vietnam, starting with the induction process for the newly conscripted in 1966. Unusually for comics, the Marvel title progressed in real time, with each monthly gap in publication moving the story and characters forward another 30 days.

Writer Doug Murray, himself a Vietnam vet, had been penning anecdotal pieces about his experiences, and Marvel contacted him about adapting them for the 1985 relaunch of its black and white anthology magazine, *Savage Tales*. The reader response was so positive that—after only four episodes—a regular title was rapidly scheduled.

It was important to Murray that the comic—which premiered in 1986—educate as well as entertain. As he noted, "One of the things I knew about Vietnam by the '80s was that a lot of vets, and I include myself in the group, just were uncomfortable talking about experiences. I wanted a way to at least tell a part of the story to the kids and maybe get other people to talk about it as well."

Another early decision was to sidestep politics and present the reactions and experiences of ordinary people in situations of extreme terror. Murray described the average soldier's tour of duty as "long periods of boredom punctuated by eternal moments of terror." An integral part of the success of the comic

was spectacular pencil artist Michael Golden. Despite considering the Vietnam War "a confused, nasty, embarrassing moment," Golden was obsessive in ensuring the accuracy of the hardware and combined that with a more relaxed version of his exaggerated cartoon style for the cast. Golden left *The 'Nam* after 1988's #13. His replacement was another Vietnam vet, Wayne Vansant. The artist, who specialized in drawing war comics, illustrated all but a handful of the rest of the series, which ran 84 issues until 1993.

Murray and Golden's initial viewpoint was Private Ed Marks, seen from his first day in Vietnam until he completed his tour. Starting as naïve and innocent, Marks saw friends die, senseless murder, and inexplicable carnage before leaving Vietnam a different person. He'd later return as a journalist.

In telling it the way it was, *The 'Nam* didn't shy away from controversy, and was all the better for it. Racism, fragging (assassinating unpopular officers), the viewpoint of the Viet Cong, and the shabby attitude towards homecoming vets all received an airing.

Later, the real timescale was dropped, the jingoism ramped up, and Marvel's popular assassin The Punisher was shoehorned into the title. *The 'Nam* may have run 84 issues but those that have their place in comics history are the nigh on four years'-worth written by Murray and particularly those 12 of the first 13 on which he collaborated with Golden.

◀

Michael Golden's covers for *The 'Nam* were often highly arresting, as on this one for 1987's issue #5, showing Vietnamese villagers tortured by the Viet Cong.

▶

This panel from *Savage Tales* #1 wryly comments on the unrealistic nature of many war comics. The "mature readers" nature of *Savage Tales* meant that topics such as drug use could be more explicitly addressed than in the regular *The Nam* series.

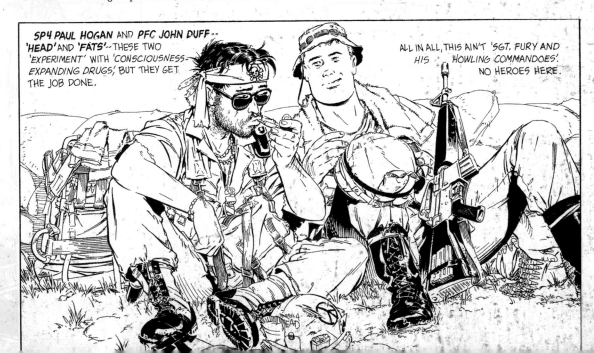

SP4 PAUL HOGAN AND PFC JOHN DUFF-- 'HEAD' AND 'FATS'--THESE TWO 'EXPERIMENT' WITH 'CONSCIOUSNESS-EXPANDING DRUGS,' BUT THEY GET THE JOB DONE.

ALL IN ALL, THIS AIN'T 'SGT. FURY AND HIS HOWLING COMMANDOES'. NO HEROES HERE.

VIETNAM JOURNAL

APPLE Comics ™

Maj. Hugh M. Fanning — MIA since 10/31/67
What you can do — see page 29.

POW·MIA

No. 10
$2.25
$2.75 in Canada

VIETNAM JOURNAL ™
by Don Lomax

The Plain of Reeds

In the 1960s, Don Lomax served his time as a Vietnam conscript. In common with many others, he lived through experiences that stayed with him. But unlike the majority, he made copious notes during his tour of duty, and 20 years later these would serve as the starting point for *Vietnam Journal*, launched by Apple Comics in 1987.

Lomax's art is cartoon influenced, which is probably just as well, because a further 20 years after original publication his comics stand among the most graphically violent ever published. Lomax drew war as he witnessed it, as it was, with few punches pulled to assuage the faint-hearted. The effects of bullets on the body, so long a shorthand currency in comics, were shown in spurting and deadly detail, and in issue #7 (1988) the leg of a helicopter pilot, already horrendously burned, just comes off when a medic attends to him. Perhaps we should be glad the stories are in black and white instead of full color.

These are not, however, rushes for thrill seekers. Lomax delivers a dense narrative, packed with detailed terminology. Although in one sense the comic is very one-sided, barely questioning the rights or wrongs of the entire situation, in other areas Lomax provides a world of grays. A recurring character is manipulative CIA agent Henry Rhein, a man who doesn't particularly care how many US soldiers are wounded or killed in whatever mission he's carrying out.

Lomax represents his own personality and viewpoint via Scott Neithammer, a war correspondent called "Journal" by the troops, referring to his habit of constantly taking notes. He's there at the pivotal moments of the campaign as well as for smaller moments. In 1989's #11, Journal delivers a baby, all the while harangued by a Viet Cong soldier whose sister it is giving birth. It's a tense and life-threatening situation involving people unable to communicate in a common language.

The comics also contained text pages expanding on the bigger picture that was the background to that issue's story, and ran campaigns for soldiers still believed to be captives in Vietnam after two decades. Lomax—who also wrote the last 14 issues (#70-84) of *The 'Nam* for Marvel in 1992-1993—followed *Vietnam Journal* with two mini-series focusing on the Tet Offensive (1992) and the bloody battle at Khe Sanh (1993). He also wrote and drew 1990's *High Shining Brass*, relating the Vietnam experiences of Robert Durand, who operated behind Viet Cong lines.

Dong Thap Muoi, or the Plain of Reeds, is on the north bank of the Mekong river, close to the Cambodian border. A dangerous area during the war, it is now an ecotourism destination.

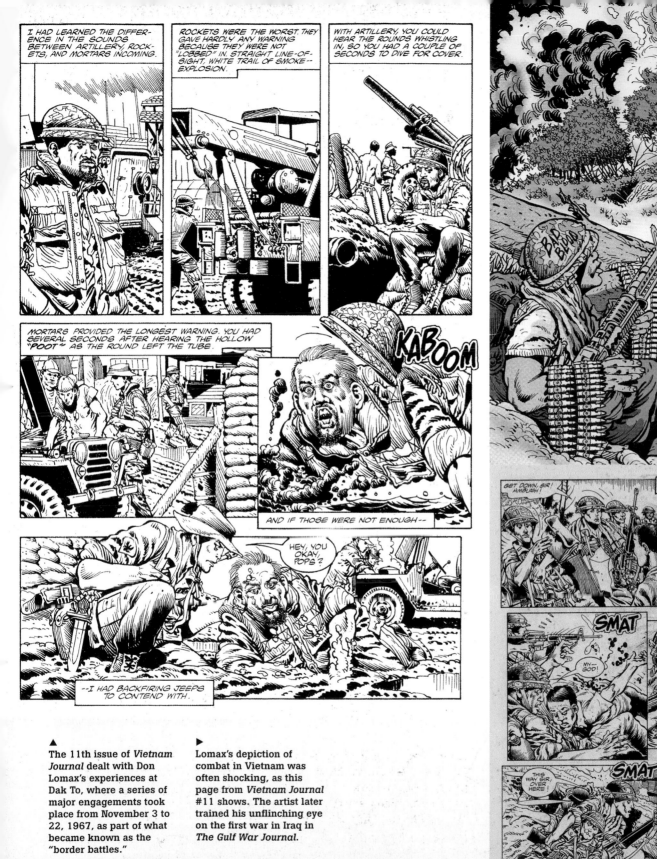

The 11th issue of *Vietnam Journal* dealt with Don Lomax's experiences at Dak To, where a series of major engagements took place from November 3 to 22, 1967, as part of what became known as the "border battles."

Lomax's depiction of combat in Vietnam was often shocking, as this page from *Vietnam Journal* #11 shows. The artist later trained his unflinching eye on the first war in Iraq in *The Gulf War Journal*.

TALES OF THE GREEN BERET

The attitude of American comics publishers had changed by the time US involvement in Vietnam escalated from a role as military advisors to full-blown combatants. During World War II and, to a lesser extent, the Korean war, publishers had flooded the newsstands with patriotic titles. There were very few contemporary stories about Vietnam.

Two decades might have passed since the Second World War, but with its kid hero, simplistic stories, unquestioning patriotism, and racist depictions of the Vietnamese, Lightning Comics' 1967 title *Tod Holton: Super Green Beret* was a World War II comic in everything but setting. Pre-pubescent Tod acquires a magic Green Beret that transforms him into an adult super-soldier, and—in stories mainly by Fawcett's *Captain Marvel* writer Otto Binder and Golden Age Timely Comics artist Carl Pfeufer—conveniently transports him to Vietnam, or battles of the past where a Super Green Beret will turn the tide. It lasted just two issues.

Starting in 1966, the newspaper strip *Tales of the Green Berets* was a more serious effort. Naming his 1965 novel *The Green Berets*, the strip's nominal author, Robin Moore, had trained with the US elite armed soldiers and accompanied them to Vietnam. His book would form the basis of the 1968 John Wayne film of the same name; Moore also co-wrote the lyrics for the patriotic song *The Ballad of the Green Berets*, a worldwide hit in 1966.

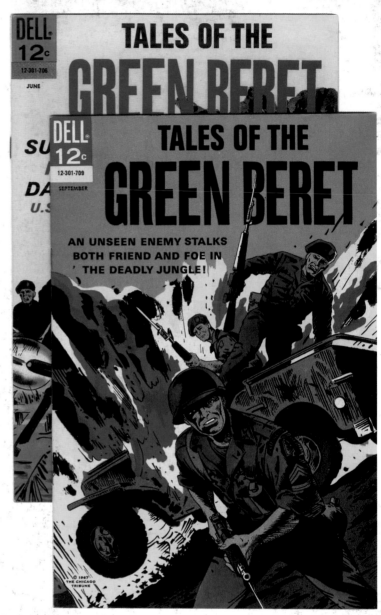

GIANT SIZED

TOD HOLTON SUPER GREEN BERET

APPROVED BY THE COMICS CODE AUTHORITY

ACTION LIKE NO ACTION EVER BEFORE!

THE CURTAIN RISES ON A NEW WAR HERO! NOT A TOUGH VETERAN ENLISTEE! NO, IT IS A TEEN-AGE BOY, TOO YOUNG TO ENLIST, WHO CREATES AMAZING LEGENDS AS A SUPER-SOLDIER BY MEANS OF FANTASTIC SUPER POWERS!

CRACK!

5 BIG STORIES PLUS TRUE COMBAT ACTION and SPECIAL BONUS... A FREE PIN-UP POSTER

◄ The newspaper strip *Tales of the Green Beret* was distributed by the Chicago *Tribune* Syndicate, and benefitted from exquisite artwork by *Sgt. Rock* artist Joe Kubert.

◄◄ ▲ Spinning off from the newspaper strip, Dell's *Tales of the Green Beret* boasted covers and stories by legendary war comics artist Sam Glanzman.

▲ ◄◄ Tod Holton—the titular *Super Green Beret*—may have only lasted two issues of his own comic, but he managed to pack in telepathy, telekinesis, and even time travel!

Although Moore's name appeared prominently on the strip, Jerry Capp, brother of *L'il Abner* cartoonist Al, actually wrote the stories. Renowned *Sgt. Rock* artist Joe Kubert had signed up for an adventure strip spotlighting the bravery of the Green Berets in a non-political context, but found himself continually having to downplay Capp's right wing politics. He quit after two years, following which the strip lasted another few months drawn by John Celardo—best known for his long run on the *Tarzan* newspaper strip—before the changing public opinion of the Vietnam War killed it.

Lasting just five issues, the *Tales of the Green Beret* comic book, drawn by Sam Glanzman (an old hand at war comics), was a short-lived 1967 Dell spin-off, while Blackthorne repackaged the Kubert stories as comics in 1986. ACG followed suit 14 years later.

The dying days of DC's long-running *G.I. Combat* sporadically featured Bravos of Vietnam, a squad of marines led into battle by Sgt. Bullett. The Robert Kanigher-written series appeared between 1983 and 1986 (#254, 267-270, 273, 275, 277, and 281), while flashbacks to Vietnam are an integral part of *Cinder And Ashe*, Gerry Conway and José Luis Garcia-Lopez' excellent 1988 thriller for DC.

Possibly the best single story dealing with Vietnam not mentioned elsewhere is Will Eisner's 2000 collection of stories *Last Day in Vietnam* (Dark Horse). The title is a slight misnomer, however, as it also includes recollections of the Korean War.

Between 1951 and the late 1970s, Eisner produced features on preventative maintenance for *PS*, an army magazine, and twice shipped out to combat zones to talk with serving soldiers. His 1967 trip to Vietnam preceded the Tet Offensive, and the troops he met were cocky, confident men sure they were doing the right thing. Eisner's cartooning, though, humanizes them by smoothing their rough edges, and, as in all his work, presenting rounded people rather than ciphers and clichés.

ANTI-WAR UNDERGROUND COMIX

Vietnam was America's first war that was truly unpopular with its citizens. A newly liberated younger generation was questioning their parents' values. This forceful youth movement was quite simply not prepared to lay down their lives for their country, regardless of the draft.

This tense and emotive atmosphere gave rise to the highly politicized "underground comix" scene, centered around San Francisco, the home of the counterculture movement. Foolbert Sturgeon (a.k.a. Frank Stack) created the satirical comic *The New Adventures of Jesus* in 1969, in which the bemused Messiah returns to 20th century America and tries to make sense of society. Stack followed this up a year later with two more issues, including the third, his political satire *Jesus Meets the Armed Services*, published by Rip-Off Press in 1970. The funny and poignant anti-war comic became a classic.

Underground cartoonist Gregg Irons and writer/cartoonist Tom Veitch took things a step further with their grotesque *The Legion of Charlies* comic book, published in 1971 by Last Gasp. Veitch and Irons juxtaposed two horrific events that, together, marked the end of America's innocent hippy era: the Tate murders by the Charles Manson "family," and the My Lai massacre by US troops. Using the soldiers' call sign, Charlie Company, to tie the two events together, the comic was an outrageous, over-long story, which descended into an over-the-top taboo-shattering mélange of horrific imagery.

When African American politician Julian Bond was expelled from the Georgia House of Representatives for opposing the war in Vietnam in 1966, he wrote and self-published a political comic, simply entitled *Vietnam*. Drawn by T. G. Lewis, it uniquely reflected the African American anti-war stance. The comic book astutely pointed out that many African Americans were still treated as second class citizens in the deep south of the US, so why should they go and fight and die in a "white man's war"?

Even those comedic perennial stoners, *The Fabulous Furry Freak Brothers*, by Gilbert Shelton, couldn't escape the war, with Fat Freddy desperately trying (and failing) to avoid the draft by pretending to be gay. His eventual solution was to leap out of a window instead.

World War II cartoonists like Will Eisner empathized with this new, angry generation of comics creators. "I understood where they were coming from," Eisner later said. "I was sympathetic with the idea that we should get out. But it was hard to sympathize with the street action because of the kind of person I am."

WARREN ON BLAZING COMBAT

What EC Comics' *Frontline Combat* and *Two-Fisted Tales* were to the US in the 1950s, so Warren Publishing's *Blazing Combat* was to the country in the mid-1960s.

Recalling the conception of the forward-thinking black and white war comic, which launched in 1965, publisher Jim Warren revealed that he knew the magazine was going to be a risky venture. "During those days I was not a total liberal; I had a militant right-wing approach to many problems, but at the same time I was not a macho, gung-ho war fanatic."

Continuing, Warren referred to Harvey Kurtzman, who had masterminded the earlier EC titles. "Harvey and I disagreed constantly—but I listened to him and he listened to me. I said, 'One of the things I love, Harvey, was your war comics with [EC publisher] Bill Gaines.' The emphasis in *Blazing Combat* was not blood and gore...The stories had a humane approach. I was against the war in Vietnam because I've never believed in limited war. Either you go to war to win—and win quickly and decisively—or you stay out.

"I thought what Harvey had done for Bill Gaines should have separated in some way from the EC horror comics. Harvey's early work was the inspiration for *Blazing Combat*. I told Harvey *Blazing Combat* editorial was not going to be pro-war or blood and guts," he explained. "It was going to be anti-war, and that I had the perfect writer and editor for this title named Archie Goodwin, because Archie and I think exactly like Harvey does about war. So between Harvey's catalyst, Archie's ability, and my own personal philosophy, we had a great stroke of luck.

By the time *Blazing Combat* launched, Goodwin was already the chief scriptwriter on Warren's *Creepy*, having spent a couple of years at Harvey Comics. He soon became editor of the entire Warren line, and wrote all but one of *Blazing Combat*'s 29 stories.

"If Archie had not had [Kurtzman's] mindset, *Blazing Combat* wouldn't have been the critical success it was," Warren continued. "I had these great artists, I had Archie, and I had the drive to produce the book, knowing full well that we were going up against strong resistance. The pro-Vietnam mentality at the time was immense—you can't believe how strong it was—because America had been consistently lied to. Washington and the Pentagon were not telling us the truth. Had they been honest, we wouldn't have had this gung-ho spirit and the war might not have been escalated. We know now, but we found out too late.

"So here's Harvey, who is the guiding spirit, and here's Archie, who is the perfect editor to do it—and here is my distributor, saying, 'Uh oh! Wait until our wholesalers—many of them belonging to the American Legion—see this!' They found out very fast that it was anti-war. The magazine had magnificent, poignant stories, and I was proud of it! It said things that had to be said. I was more proud of *Blazing Combat* than anything I had published; I loved *Famous Monsters*, *Creepy*, and *Eerie*—they were all my children—but the pride I have in those four issues of *Blazing Combat* is unsurpassed. Frank Frazetta's covers were incredible. They belong in the National Gallery," Warren stated in conclusion.

Wholesale and retail resistance to *Blazing Combat* resulted in poor sales and the magazine folded after just four issues. Nevertheless it was a major milestone in the development of American war comics.

▶
Famed fantasy artist Frank Frazetta provided all four of *Blazing Combat*'s instantly recognizable, iconic covers.

▶▶
Joe Orlando provides the art for this hard-hitting story from *Blazing Combat* #1, showing the brutal treatment meted out by the South Vietnamese Army to prisoners.

▶▶▶
From *Blazing Combat* #4, Gene Colan's fluid linework and gray tones bring home the harsh reality of warfare.

◀ ▶ ▶▼
Previously known for the horror title *Creepy*, Warren's war comic was suitably horrific in its own right, not least on these gruesome Frazetta covers for issues #2, 4, and 1.

▶▶ ▶▶▶
Unflinching depictions of warfare in Vietnam from *Blazing Combat* #3 and #2, as drawn by the mighty Joe Orlando.

A WARREN MAGAZINE 35¢

BLAZING COMBAT

JAN. No. 2

NEW TREND IN ACTION STORIES

ILLUSTRATED EXCITEMENT IN WAR

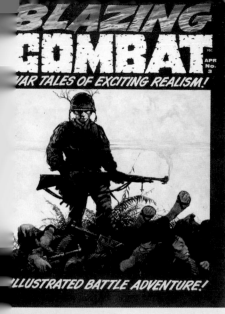

BLAZING COMBAT

APR No. 3

WAR TALES OF EXCITING REALISM!

ILLUSTRATED BATTLE ADVENTURE!

BLAZING COMBAT

A WARREN MAGAZINE 35¢

JULY No. 4

ILLUSTRATED FRONTLINE ACTION!

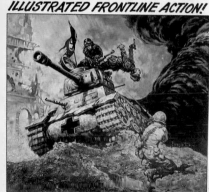

BOLD REALISM OF BATTLE FURY!

BLAZING COMBAT

A WARREN MAGAZINE 35¢

OCT. No. 1

WAR ACTION—COLLECTOR'S EDITION

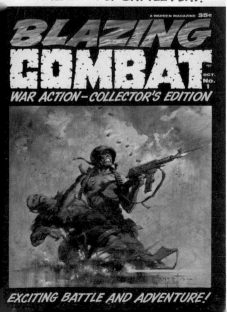

EXCITING BATTLE AND ADVENTURE!

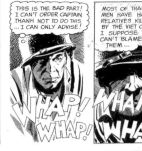

1230 HOURS... THE MORNING'S WORK: TWO PRISONERS. THE SOUTH VIETNAMESE INTERROGATE THEM THE ONLY WAY THEY KNOW HOW... BY TORTURE!

WHAP!

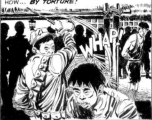

THIS IS THE BAD PART! I CAN'T ORDER CAPTAIN THANH NOT TO DO THIS ... I CAN ONLY ADVISE!

WHAP! WHAP!

MOST OF THANH'S MEN HAVE HAD RELATIVES KILLED BY THE VIET CONG... I SUPPOSE YOU CAN'T BLAME THEM ...

WHAP! WHAP!

THEM ROCKET GRENADES THIS ONE!

YOU CAN'T CONVINCE THEM IT'S WRONG! THAT IT'S ALL FOR NOTHING!

WHAP! WHAP!

THAT'S ENOUGH, CAPTAIN THANH! IT'S OBVIOUS YOU'RE NOT GOING TO GET ANYTHING OUT OF THIS MAN!

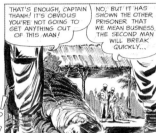

NO, BUT IT HAS SHOWN THE OTHER PRISONER THAT WE MEAN BUSINESS. THE SECOND MAN WILL BREAK QUICKLY...

PSYCHOLOGY, I THINK YOU AMERICANS WOULD CALL IT! BEGIN WITH THE SECOND PRISONER!!

HHHHHH...

COUGH! SPUTTER GAG

GASP AAAG GULP

ENOUGH, CAPTAIN THANH! THE MAN WON'T TALK!

YOU'RE SHOCKED, LIEUTENANT CREW! WHEN WILL YOU LEARN THIS IS A GUERILLA WAR AND MUST SOMETIMES BE FOUGHT WITH GUERILLA METHODS?!

NO! NOT MY RICE! NOT THAT! I WON'T LET YOU! I WON'T--

GET OUT! GET OUT OF HERE, OLD MAN! THIS IS A WAR! GET OUT!

EEEEEEEEEEEEEEEEEEEEEEEEEE

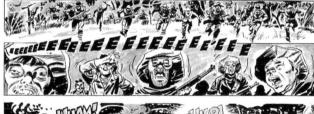

WHAM!

WHUMP!

NOW! SWEEP THE FIELD! BURN 'EM OUT! BURN 'EM OUT!

FRRRROOOOOOOM!

THAT'S IT! B COMPANY'S ZEROED IN ON 'EM! LET'S GO!

GOOD OL' SCOTTY!

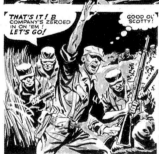

KEEP IT UP! HUSTLE! THEY'RE SANDWICHED BETWEEN US AND THE MORTAR FIRE...DON'T LET 'EM GET AWAY!

POW! POW! KROW! BUDDY!

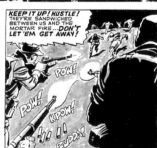

THE SOUTH VIETNAMESE TROOPS MARCH AWAY UNMINDFUL OF THE CHARRED RICE PADDY OR THE STRAW HAT FLOATING ON THE MUD OF ITS FLOOR... EVEN AS LUONG WAS UNMINDFUL WAR SOONER OR LATER TOUCHES EVERYONE...THEY MARCH AWAY, AND THE DESTRUCTION, LIKE THE HAT AND RICE PADDY BECOMES PART OF THE LANDSCAPE!

UGH!

POW! POW!

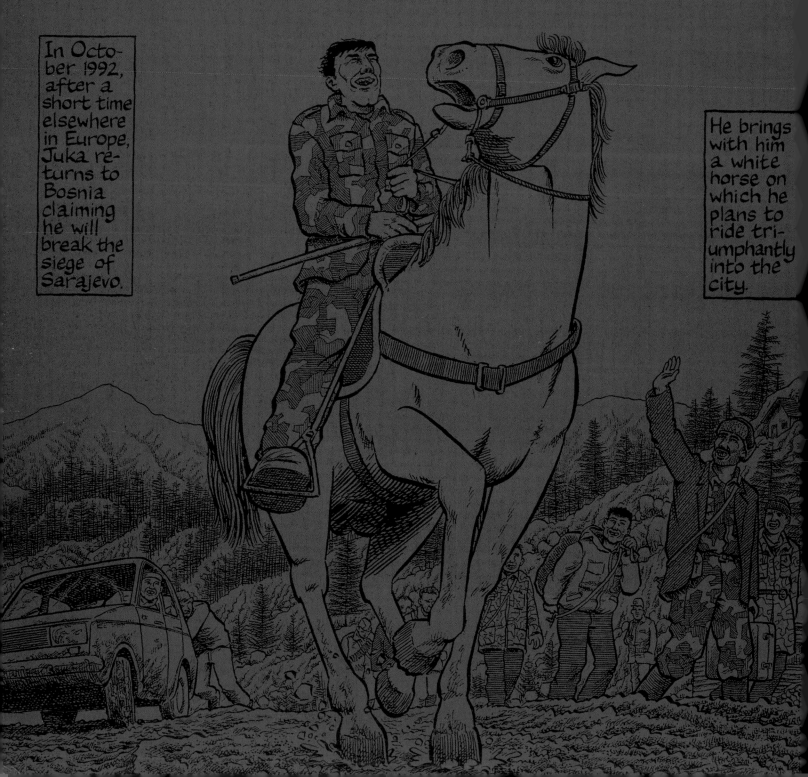

In October 1992, after a short time elsewhere in Europe, Juka returns to Bosnia claiming he will break the siege of Sarajevo.

He brings with him a white horse on which he plans to ride triumphantly into the city.

COPING WITH 9/11

In September 2001, the US found itself in a collective state of shock. There had been no widespread realization that the country was at war, and not since Pearl Harbor 60 years previously had an enemy attacked home territory. The citizens of New York behaved stoically and with a civil mindedness echoing the spirit of 1940s London.

Comics reflected this confusion and rediscovered concern for neighborliness. One certainty was a renewed respect for the emergency services, and Marvel Comics released three mini-series focusing on the police, firemen, and paramedics, all titled *Call of Duty*. Coming from a publisher almost exclusively known for superheroes, however, realistic portrayals of the emergency services at work sat uneasily alongside the more familiar superhero tropes of the Marvel Universe.

A number of the remaining comics companies produced three volumes titled *9-11*, respectively by Alternative Comics, DC Comics, and a united Dark Horse, Image, and Chaos Comics. Work was donated by the writers and artists, as were profits, shared among charities and the families of the bereaved, which more than justified the publications, no matter the mixed bag they were creatively.

Interestingly, in a combined 600 pages, only creators Dwayne McDuffie and Denys Cowan move beyond shock and sorrow to view the bigger picture, and in the light of US military actions since 2001 their prescience is both commendable and depressing. Theirs is one of several strips setting superheroes alongside real world tragedies, which, however well intentioned, still jars.

Among the eclectic mixture in these volumes, Michael Moorcock's recollections of the London blitz are illustrated by Walt Simonson, and those of Alan Moore's family depicted by Melinda Gebbie alongside his pleas for reason. Darwyn Cooke highlights the contribution of the emergency services; Bill Stout's chat with a Croatian taxi driver is a reminder of the generous spirit that previously characterized US foreign policy; and Peter Kuper manages to place everything in perspective.

Personal stories and recollections abounded in the *9-11* anthologies, but perhaps the best autobiographical comic about September 11 was by Danish artist and New York resident Henrik Rehr. Originally titled *Tuesday*, but collected as *Tribeca Sunset* (iBooks, 2005), Rehr lived within shouting distance of the twin towers, and his children attended school nearby. As the events of the day unfold, Rehr is both puzzled eyewitness and terrified father; he also relates his experiences over the following months, as his apartment remains uninhabitable.

Art Spiegelman, too, delivered his recollections and afterthoughts in the form of 10 full-page syndicated newspaper strips, collected by Pantheon in 2004 as *In the Shadow of No Towers*.

In 2006 veteran comic creators Sid Jacobson and Ernie Colón published their graphic novel adaptation of the official report into the events of September 2001 through Hill & Wang. *The 9/11 Report: A Graphic Adaptation* transformed the dry report into what should become the definitive school text on the event. Colón is a consummate artist, and his depictions never stray into sensationalism.

▶
Collected as *Tribeca Sunset* in 2005, Henrik Rehr's recollections of September 11 and the days following are touching and poignant, as the artist is separated from his wife and oldest son in the confusion. This striking image is from the back cover of the book.

▶ ▶
Alex Ross' cover for the second volume of *9-11* is one of the more successful attempts to combine the fictional superheroes with the day's real life heroes, who tower over an awed Superman. Eric Drooker's cover for the first volume takes a more reflective, subtle approach.

▶ ▶ ▶
The *Spirit* creator Will Eisner contributed this shattering page to the *9-11: Emergency Relief* anthology, summing up the shock felt by many.

AXE

OLEXA

WAR FIX

NBM
ComicsLit

◄ ◄▲
**Graphically illustrating
David Axe's recollections
and reporting from Iraq,
artist Steve Olexa pulls no
punches in his depictions
of daily bomb blasts and
mass graves.**

COMICS JOURNALISM

War journalism in comics is a difficult topic. Mainstream comics readers subsist for the most part on a diet of exaggerated violence with minimal consequences. So when artist Steven Olexa illustrates a photograph of a distraught Iraqi woman embracing the body of her recently shot partner in 2006's *War Fix*, there's the additional ghastly realization that this actually occurred.

Written by journalist David Axe and published by ComicsLit, *War Fix* is Axe's love letter to the addictive quality of covering war. No matter how appalling the incidents he witnessed—and they are extremely appalling—the adrenaline pull was so great that he sacrificed his comfortable existence to endanger his life in Iraq. He returned physically unharmed, but his addiction cost him his relationship.

As of writing, Axe's blog (www.warisboring.com) places him in Chad, a country hosting any number of rebel groups wanting to replace an irrevocably corrupt regime. The blog links to a flickr page (http://www.flickr.com/photos/david_axe/sets/72157594507913388/) in which Matt Bors illustrates more of Axe's war experiences. There are 29 strips to date, depressingly living up to the title of *War is Boring*.

Comics journalism was inadvertently pioneered by Joe Sacco. Sacco had already published some autobiographical material about his European trips in Fantagraphics Books' 1988 series *Yahoo!* when he first visited Palestine in 1991, drawn there by an obsession with the first Gulf War that led him to investigate the reasons for political instability in the Middle East.

He traveled in the predominantly Palestinian areas of Israel, the Gaza Strip, West Bank, and East Jerusalem, talking to the Palestinians and learning about the everyday oppression and persecution that fueled their enmity with Israelis. He drew up their stories as comics, first as nine issues of *Palestine* (1993). Fantagraphics reissued these first as a pair of collections, then a single book. Most recently, it reformatted *Palestine* as a deluxe hardback complete with background sketches and notes, photographic reference, and explanatory interviews.

That *Palestine* has remained in print for 15 years is testament both to Sacco's skills and to the pertinence of the stories he passed on. If anything, the deprivation and oppression has hardened in recent years, leading to even stronger retaliation. Anyone wanting to understand the conflict (as Sacco did) can find no more relevant and accessible way in than *Palestine*.

THE LANDMARK WORK OF COMICS JOURNALISM FROM THE CREATOR OF *SAFE AREA: GORAZDE* — FINALLY COMPLETE IN ONE VOLUME

Joe Sacco

Palestine

"Gripping... a political and aesthetic work of extraordinary originality."
—from the new introduction by EDWARD W. SAID

EXIT WOUNDS

Where Joe Sacco tackled the Israel–Palestine conflict as an outsider, chronicling the miseries of individual Palestinians, Israeli cartoonist Rutu Modan approached the subject as an insider. The result is a remarkable insight into a society where, for most Israelis, the Palestinians barely register.

Born and raised in Israel, Modan made her name creating cartoons and comic strips for the country's leading daily newspapers. She become a co-founder and member of Actus Independent Comics (a.k.a Actus Tragicus), a collective and publishing house for alternative comics artists, and co-editor of the Hebrew edition of *MAD* magazine. Modan had already gained international recognition for her work when *Exit Wounds* was published by Drawn and Quarterly in the US in 2007, but the graphic novel proved a major hit, both critically and in terms of sales.

Exit Wounds follows Koby Franco, a young Tel-Aviv cab driver who learns his estranged father may have been killed, the victim of a suicide bomber. With the help of his father's girlfriend, Franco investigates the suicide attack, trying to determine if it was indeed his father who died, and in the process learns a lot about the man he barely knew.

Measured and subtle, *Exit Wounds* draws a vivid picture of contemporary Israel, a land where the threat of violence has become everyday, lingering at the fringes of ordered society. The focus is Koby Franco and his search for his father, but the backdrop of checkpoints, TV and newspaper reports of bombings, and barely acknowledged anti-occupation protests gives a vivid sense of a war waged on the sidelines. Modan's unfussy art emphasizes the almost mundane nature of this modern day conflict, her simple line and flat colors depicting a world on the surface so seemingly ordinary, and yet hiding disturbing and dangerous undercurrents.

Exit Wounds was named as one of *Time* magazine's graphic novels of the year in 2007, and won the 2008 Eisner Award for Best New Graphic Novel. Joe Sacco called it "profound, richly textured, humane, and unsentimental;" Modan has since had a collection of earlier short form comics, *Jamilti and Other Stories*, published by Drawn & Quarterly, while *The New York Times Magazine* began publishing her graphic serial, *The Murder of a Terminal Patient*, in June 2008.

While the cover of *Exit Wounds* includes a panel of the explosion at the bus station at Hadera, inside the graphic novel we never see the bombing; the suicide attack and its aftermath are reported in newspapers, as in this example, but never witnessed first-hand.

Modan peppers *Exit Wounds* with little vignettes and seemingly throwaway background details, but in fact they all go to building up a convincing portrait of how the ramifications of the occupation seep into day-to-day Israeli life.

His kids were sure he'd gone underground, hiding from loansharks.

It took them a couple of months to figure out that something must have happened to him.

* #$$@!

exit wounds rutu modan

Hey, Buddy!

IDF Spokesperson

I was here a couple of weeks ago in a cab?

Don't remember.

I'm looking for a girl who's stationed here.

What's her name?

What? When?

Two weeks ago.

I don't know. I think it begins with an N. She was kind of tall...

You mean Numi. The Giraffe. She got discharged.

But don't worry, we won't let her get away. Girls in the office will know where to find her.

Army checkpoints are a fact of life in Israel, but for Israelis they are no obstruction to everyday living, acting more as a nagging reminder of the conflict's consequences.

TH VICTIM-FOREIGN WORK

There has been no positive ident of the fifth victim in last week bombing in Hadera. The body, been transferred to the Fore Abu Kabir, is presumed to tourist or a foreign worker, approximately five feet sev The public is being ation that may be

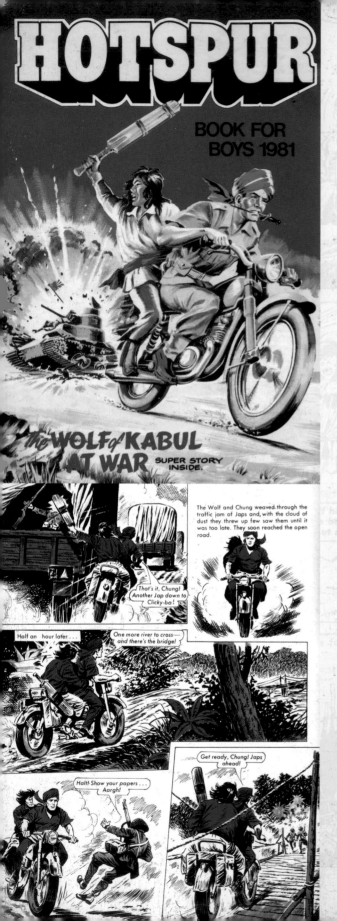

HOTSPUR

BOOK FOR BOYS 1981

The WOLF *of* KABUL AT WAR SUPER STORY INSIDE.

The Wolf and Chung weaved through the traffic jam of Japs and, with the cloud of dust they threw up few saw them until it was too late. They soon reached the open road.

That's it, Chung! Another Jap down to Clicky-ba!

Half an hour later . . .

One more river to cross—and there's the bridge!

Get ready, Chung! Japs ahead!

Halt! Show your papers . . . Aargh!

OF CLICKY-BAS & .303S

War has been ever-present in Afghanistan for more than 100 years, but, while it may be a permanent feature in today's headlines, comics have only rarely used the country as a backdrop for stories of conflict and combat.

Although hard to classify as a war story per se, DC Thomson's *The Wolf of Kabul* is undoubtedly the most famous of the comics characters who wandered the country's war-torn landscape. Disguised as a native—and easily able to pass as one if it weren't for his giveaway blue eyes—2nd Lieutenant Bill Sampson was an agent of the British Intelligence Corps. He operated on India's Northwest Frontier, where he tackled "wily Pathans" and other unfriendly tribesmen armed with just two knives.

Sampson's constant companion was his native servant Chung, whose lethal weapon of choice was a cricket bat he lovingly referred to as "Clicky-ba." After bouts of skull smashing, Chung would tearfully apologize: "Lord, I am full of humble sorrow—I did not mean to knock down these men—'clicky-ba' merely turned in my hand."

First seen in the original 1922 incarnation of *The Wizard*—a prose story weekly—Sampson and Chung made their comics debut in 1961's issue #102 of *The Hotspur*. Initially drawn by J.T. Higson, their exploits continued in the weekly until 1975. Six years later, they resurfaced in *Buddy*, which lasted until 1983. A prequel, *Young Wolf*, covered Sampson's childhood beginning in the 1974 inaugural issue of *Warlord*.

Far more contemporary was Garth Ennis's *303*. Drawn by Jacen Burrows, the 2004 Avatar Press six-parter focuses on an unnamed Russian Spetsnaz colonel investigating a downed plane in Afghanistan. It's a crash that has also attracted the interest of British and US forces.

However, as the writer explained, "It's the story of a rifle, first and foremost, a .303 calibre Lee Enfield bolt-action rifle, almost a hundred years old but none the worst for it. This was the weapon that took the British army through two world wars and survived in its service until long after the second; it still shows up today from time to time, carried by tribesmen and guerrilla fighters in some of the world's most brutal conflicts. The Lee Enfield is one of the great success stories of killing technology; it's simple to use, what

◄ Cover of the 1981 *Hotspur* hardcover Annual, showing the Wolf of Kabul with his companion Chung, swinging his trademark cricket bat, "Clicky-ba."

► Garth Ennis and Jacen Burrows' *303* follows a Russian Spetsnatz colonel who fought in Afghanistan in the 1980s as he makes his way across the country. Burrows accurately depicts Afghanistan as a bleak, unforgiving place.

◄ Lieutenant Bill Sampson, a.k.a. the Wolf of Kabul, and his trusty assistant in the midst of another somewhat-less-than-realistic adventure from the pages of *Hotspur*.

► Cover of the third issue of *303*, as the unnamed Russian colonel confronts an Apache helicopter on the plains of Afghanistan.

flaws it possesses are few and far between, and it'll withstand a good deal of very rough treatment indeed before it stops doing what it says on the tin.

"This particular Lee Enfield, however, is not just some artefact long overdue for retirement. High in the war-ravaged mountains of Afghanistan, the rifle falls into the hands of a man who plans to do the unthinkable: who sets out on a journey across whole continents, who fights his way through killing grounds both terrible and unexpected, all so he can fire a single bullet at the most important target in the world," added Ennis, who also wrote *War Stories* (see pages 84–85).

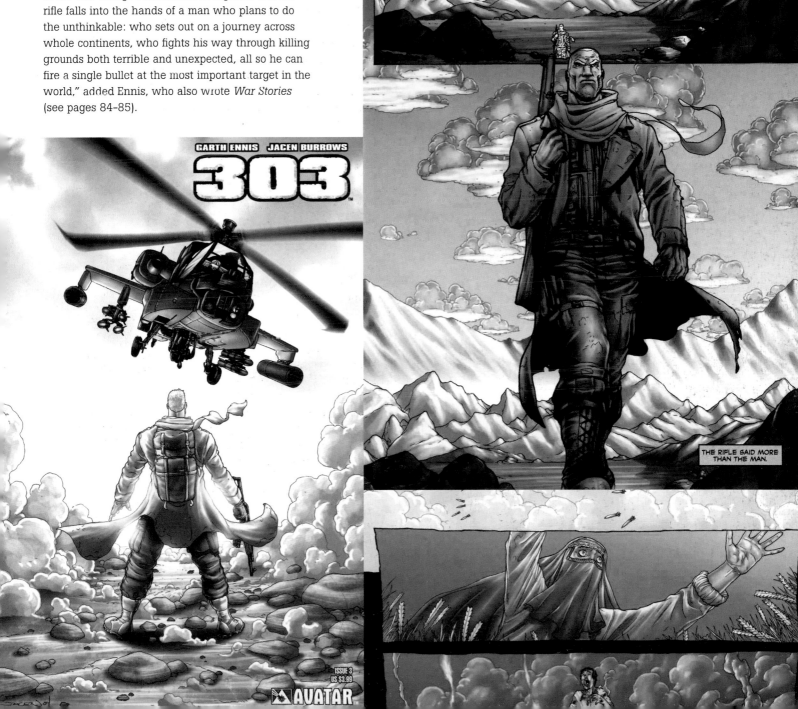

GARTH ENNIS · JACEN BURROWS

303

THE RIFLE SAID MORE THAN THE MAN.

ISSUE 3
US $3.99

AVATAR

COMBAT ZONE

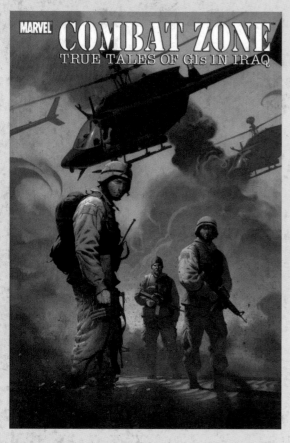

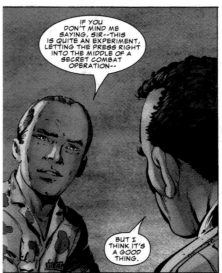

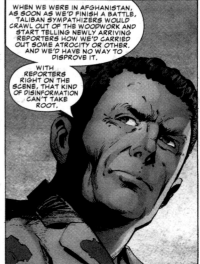

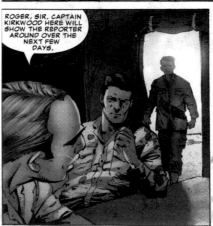

◄

Esad Ribic's painted cover for *Combat Zone*, with its purposeful-looking troops and gliding helicopters, sets the tone for the positive portrayal of the Iraq war inside.

▼

In this page from *Combat Zone*, characters discuss the new tactic of "embedding" reporters with military units, thus controlling the flow of information from the theater of operations.

combination of rumored difficulties finding an artist for what was being touted as a "controversial" story and, one suspects, lack of pre-publication orders from the nation's retail outlets.

Over the years, war comics have become increasingly poor sellers in America's superhero-dominated market, but *Combat Zone* may have suffered more than most because of its writer's blatant political leanings. The editor-in-chief of *The American Enterprise*, who subsequently went on to become President George W. Bush's Domestic Policy Adviser and Director of the Domestic Policy Council, Zinsmeister delivered a book that was by no means a factual account of the war in Iraq. Instead, it offered a right wing-biased look at the conflict.

When American forces led British soldiers and their other allies into Iraq in 2003, Marvel Comics were—as ever—eager to jump on a bandwagon, in this case the initial wave of public support the invasion had engendered in the US.

For the writer of the project, Marvel turned to Karl Zinsmeister, a journalist embedded with the 82nd Airborne during the initial phase of the incursion. He was also the author of two books about his experiences: 2003's *Boots on the Ground* and the following year's *Dawn over Baghdad: How the US Military is Using Bullets and Ballots to Remake Iraq*.

Teamed with Dan Jurgens—an artist far better known for his superhero work, especially the high profile *Death of Superman*—the writer produced *Combat Zone*. Initially intended as a 2004 five-parter, it didn't appear until the following year. In the interim it morphed into Marvel's first original graphic novel in ages after running into multiple delays, a

▲
Awaiting deployment to Iraq in Kuwait, US troops shoot the breeze and display their somewhat limited knowledge of the world beyond their country's borders.

▶ ▲
A sandstorm, or "sirocco," hits the US training camp in Kuwait.

As *Publishers Weekly* noted in a review of his earlier *Boots on the Ground*, it was "conservative polemic and a vivid portrait of American infantrymen in action. Zinsmeister, who was embedded with the army as a correspondent for the *National Review*, makes no bones about his unabashed support for the war, and for the American military in general."

Focusing on the 82nd Airborne, *Combat Zone* was subtitled *True Tales of G.I.s in Iraq*. Unfortunately, with changed names and incidents combined, Zinsmeister's one and only foray into comics was less documentary and more docudrama.

Anyone wanting a less-biased account of G.I.s fighting in the Middle East may prefer Apple's *Desert Storm Journal*, in which Don Lomax brings his *Vietnam Journal* protagonist, Scott "Journal" Neithammer, out of retirement to cover the eponymous 1990–1991 conflict across eight issues beginning in 1991. While Lomax's sympathies obviously lie with the men on the ground—the 82nd Airborne again—he does at least offer a more unprejudiced view of the politics of the war.

PRIDE OF BAGHDAD

For a contemporary American writer, taking on the topic of the most recent war in Iraq is a difficult proposition. The conflict was initially jingoistically popular in the US, surfing a surge of patriotic "anti-terrorism," yet a significant percentage of the world's remaining population considers the war misguided at best.

Brian K. Vaughan came up with a unique solution after reading a 2003 news report about lions escaping Baghdad Zoo as US forces bombarded the city. He used the lions as a metaphor for the Iraqi people, allegedly liberated by US forces, yet facing a future under freedom far more dangerous than the certainties they'd previously endured in captivity.

Part of that future was to prey upon their fellows freed from captivity, as more terrifying creatures in turn preyed upon them. The thoughts of the lions voiced to each other reflected the doubts and fears of the Iraqi people, freed, yet cut adrift.

That's not to say Vaughan overplays the metaphor for a heavy-handed slab of polemic. "I didn't want to shove beliefs down readers' throats—I wrote this because I had conflicted options regarding the war. I wrote to ask myself hard questions, rather than to give readers answers," related the writer. He also provided an adventure story and by attributing human adult thoughts and responses to animals delivered a new take on a relatively undermined genre in comics.

Pride of Baghdad's lions are no cute and cuddly Disney big cats. Readers may get an insight into their fears and motivations, but these lions behave as lions would in the wild. There's no doubt that Zill is the pack leader. The older Sofa may taunt and prod, but she accepts his overall authority. Everything is new to the cub Ali, who has only ever known life in the zoo, while the other female, Noor, craves freedom, but when it arrives in explosive fashion she's uncertain and tentative. All discover freedom doesn't match their expectations, particularly the unknown, represented by invading forces and their technology.

Published by Vertigo (DC Comics' mature readers imprint) in 2006, *Pride of Baghdad* would be something else entirely without the contribution of Belgian artist Niko Henrichon, who delivers realistic lions, stunning natural scenery, and a palette accentuating the effects of war. He also delivers a pathos and emotional resonance without which the inevitable climax would be far poorer. This may be the only graphic novel about lions loose in a city, but it's the best.

▶ ▶▶
Belgian artist Niko Henrichon vividly portrays the moment when US aircraft, on a bombing run over Baghdad, drop ordnance on the unsuspecting animals in Baghdad Zoo.

▶
The escaped lions face many hazards in the Baghdad warzone, but their most dangerous encounters are invariably with other animals, including this bear, kept as a pet by a city denizen.

▶▶
Little love is lost between the zoo's "inmates." The young cub, Ali, is kidnapped by a tribe of monkeys, forcing his grandmother, Sofa, to rescue him.

▶▶
The lions are surprised by advancing tanks.

◀
Now loose, the lions pass under the "Hands of Victory," huge arches in the center of Baghdad. The arches were based on a concept sketch by Saddam Hussein himself.

TROUBLED SOULS

◀

The cover to Fleetway's 1990 collection of *Troubled Souls* features protagonist Tom Boyd and Damien McWilliams, the IRA man who coerces Boyd into planting a bomb.

◀◀

Garth Ennis has said of the bloody history of Northern Ireland, "Really, the problem in Northern Ireland is just an exaggerated version of the problem everywhere else: the wrong people are in charge, on every side, in every organization."

Comics have rarely dealt seriously with the rather euphemistically named "Troubles" in recent Irish and Northern Irish history, perhaps because the potential to offend in both Britain and the US was too great.

A major historical cause of the conflict was Oliver Cromwell's 17th century rampage through Ireland, when tens of thousands were massacred. Exceptional John Severin artwork graced Steve Englehart's snapshot story in *Amazing High Adventures* #1, in which Cromwell encounters and outwits a druid. A contrite IRA bomber was a supporting character in Marvel's 1970s superhero series *Iron Fist*, but there has only been a single serious work on the Irish situation within living memory.

For all his later success in covering historical wars, writer Garth Ennis first made his mark in comics writing about the war on his doorstep. Set in a 1980s Belfast beset by random explosions, sectarian murder, and associated violence, *Troubled Souls* was originally serialized in 1989 in issues #15–20 and #22–27 of *Crisis*, UK publisher Fleetway's political comic that wore its bleeding heart on its sleeve. When collected, the publisher promoted *Troubled Souls* with hyperbole such as "straight from the streets of the city" and "a story that's as alive as today's headlines." That's as may be, but the core of *Troubled Souls* is the sympathetic character of an innocent out of his depth.

Life rocks for Belfast teenager Tom. Okay, his dad errs toward protestant bigotry, but Tom sees the wider picture, and besides, he's just managed to hook up with Liz, the girl he's been fancying from a distance. Then he's targeted by an IRA member and told to plant a bomb. If he wavers or runs, his friends and family will suffer the consequences.

Caught between a rock and a hard place Tom plants the bomb and it detonates. From that point Ennis still manages to surprise with adept characterization, switching expectations and aptly reflecting the title. An adroit conclusion leaves no doubt on how Ennis feels about his lead.

Working on his first professional strip, John McCrea models Tom's friend Dougie on himself, and his artwork progresses from episode to episode, as he grows ever more confident, experimenting with his storytelling. The streets of Belfast come alive in a manner only attributable to a native, and the cast are largely folk you'd want to share a pint with.

Ennis and McCrea returned to supporting characters Dougie and Ivor a year later in *For A Few Troubles More* [*Crisis* #40–43 and #45–46] and then over several series of *Dicks* (for US publishers Caliber and Avatar), but played them for laughs as woefully inadequate private eyes.

THE ENGLISH LET THE SCOTS OFF WITH IT... WELL, APART FROM *CONDEMNING* THEM, OF COURSE. VITAL, EVEN THEN.

JUST IRISH PEOPLE DEAD, AFTER ALL. THEY HAD MORE PRESSING BUSINESS IN LONDON.

AYE, THEY STILL DO.

◀

An evocative summation of the roots of the Troubles in Northern Ireland, as depicted by John McCrea.

◀◀

Troubled Souls supporting characters Dougie and Ivor as they appear in Ennis and McCrea's series *Dicks*.

SAFE AREA GORAŽDE

Having produced perhaps the first work of comics journalism to detail the lives of Palestinians living under oppression (see pages 154–155), Joe Sacco's next project took him to Bosnia in 1996.

The town of Goražde was by that time the only UN-operated safe haven in Eastern Bosnia, and as such existed in a peculiar limbo. The inhabitants knew that only the presence of United Nations troops prevented the Serbs in the surrounding hillsides from invading the town; yet the town was also a sanctuary for other Bosnian refugees able to work their way through Serb occupied territory.

On top of that, there was the uncertainty of the peace talks then taking place in the US. Should they fail altogether, Goražde's twilight status would perpetuate. Even if the talks ended in success, there was still a strong possibility that to appease the Serbs and guarantee the safety of Sarajevo, Goražde would be among the territory sacrificed to Serbia.

Amid all this, Sacco arrived as a UN accredited journalist and began conversations. There was an immediate introduction to the contradictions of Goražde, as Sacco talked with his assigned translator. Expecting tales of horror and deprivation, her primary concern that Sacco bring her a pair of Levi 501s on his next visit took him aback. As he talked with more and more people, he realized that this seemingly casual surface masked intensely troubled pasts, and through listening to first-hand recollections of the years before his arrival, Sacco learned some appalling truths.

A Muslim attempts to sell his videotape compilation of mutilated and dying Serbs; random Serb atrocities appall as neighbor turns on neighbor; the horror of Srebrenica is recounted by a survivor; and even collecting essential UN airdrops involves life-threatening dangers. Throughout everything, Sacco is aware that should the situation deteriorate, his own status is transitory. He will be able to return to 40" televisions and monster burgers, although at one stage being held a week in Sarajevo he acquires a greater understanding of how it feels to be trapped.

Sacco's commentary on Bosnia wasn't just limited to Fantagraphics' *Safe Area Goražde* (subtitled *The*

War in Eastern Bosnia 1992–1995). A sequel of sorts to that 2002 book followed in 2004. *The Fixer* (Drawn & Quarterly) concerns a return to Bosnia in 2001 and a re-acquaintance with Neven, a Bosnian Serb whose war experiences include periods of service under some notorious warlords. Sacco also wrote and drew two shorter pieces collected as *War's End: Profiles from Bosnia 1995–1996* (Drawn & Quarterly, 2005). *Christmas with Karadzic* concerns Sacco's attempts to interview the Bosnian Serb leader, while *Soba* is about a charismatic artist who had to plant landmines during the war.

Reflecting on his success, Sacco noted, "You have to learn to be mousey and quiet at the right times." He may not have personally lived through the war, but in acting as repository for the memories of dozens who did, Sacco ensured their recollections received an audience around the world.

◄
In *The Fixer*, Sacco focuses on Neven, a Bosnian Serb living between the lines, ready to offer help at the right price. It's to Sacco's credit that Neven is portayed as a rounded, fully fleshed-out, largely sympathetic character.

►
The first page of *Safe Area Goražde* presents a dramatic portrait war-torn Bosnia, as the UN convoy—with Joe Sacco—makes its way to Goražde.

►►
The massacre at the town of Srebrenica was one of the most notorious and horrific events of the war. Sacco's depiction of the war crime is almost unbearably vivid.

►
Designated a "safe haven" by the United Nations, Goražde became a destination for refugees, although the protection afforded the city was at best ineffectual.

No-man's-land

nearing Gorazde

In the fall of 1995, the future of Gorazde and its 57,000 inhabitants was by no means clear...

Together with thousands of men and boys captured by the Serbs in the break-out to Tuzla, they were exterminated.

It was the largest mass killing in Europe in 50 years.

All-told, in the ambushes and executions, more than 7000 Muslim men were killed.

At a briefing on July 14, while the Srebrenica calamity was still unfolding, Janvier seemed to unilaterally abandon the notion that the U.N. would defend any safe area other than Sarajevo. Gorazde, he said, was "perfectly capable of defending itself." As for Zepa:

IT IS ABSOLUTELY CLEAR THAT WE CAN'T REINFORCE ZEPA.

WE CAN'T DEFEND ZEPA AS A RESULT.

Within several days, Zepa would fall to the attacking Serbs with barely a murmur from those who had once proclaimed it a safe area.

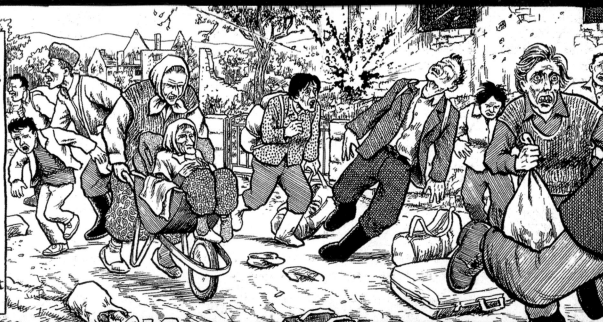

Not waiting for further clarification, the Serbs launched an offensive that conquered all government territory in the Drina Valley from Mededa to Ustipraca. Refugees streamed into Gorazde while the Serbs began a relentless bombardment of the town.

FAX FROM SARAJEVO

Politics forged Yugoslavia, stitching it together from three distinct territories, a by-product of the post-World War I reconstruction of Europe. Generations later, ethnic tensions resurfaced as communist regimes collapsed throughout Europe, eventually leading to war. In March 1992, Bosnia Herzegovina declared its independence from the crumbling Yugoslavia, and at the age of 40, Ervin Rustemagic returned home to Sarajevo.

Rustemagic was known to comics creators all over Europe as the guiding light of Strip Art Features, the agency through which he represented dozens of talents whose work he placed with the top European publishers. When trouble kicked off in Yugoslavia, Rustemagic opened a Dutch office and moved his family to Holland. They couldn't settle, and by March 1992, the situation in Bosnia looked to be heading towards a peaceful resolution.

The night he returned, the Serb forces switched from attacking remote towns and focused their attacks on Sarajevo. Far from a joyous reunion with friends and family, Rustemagic found himself in a war zone.

As the situation deteriorated around him, he maintained contact with the outside world by sending faxes to writer Martin Lodewijk in Holland, artist Hermann Huppen in Belgium, and American artist Joe Kubert. These faxes described the horrors he and others witnessed as the Serbs accelerated their policy of ethnic cleansing, and they formed the basis of the book Joe Kubert illustrated to tell Rustemagic's story.

Published by Dark Horse Comics in 1998, *Fax from Sarajevo* combines the atrocities suffered under Serbian attack with the very human story of Rustemagic as a man doing all he can to survive and protect his family. It's to Joe Kubert's credit that despite his years of drawing fictional war stories, there's never a moment's doubt that he's telling a real story. Such are Kubert's deft touch and cinematic strengths that for all the scenes of snipers killing children, rape camps, and massacres, these are not the most horrific moments. They occur when, after two years, Rustemagic has escaped the city and is facing an administrative brick wall in his desperate attempts to secure his family's freedom.

In an endnote, Kubert wrote, "If you feel that this story is a stretch of the imagination, too much to be believed, I can fully understand that reaction. In reading and rereading Ervin's faxes I felt the same way."

During his years editing war comics for DC, Kubert would conclude stories with an exhortation to "Make war no more." It's a sad testament that, years later, Kubert would produce his best story about the war experiences of a close friend.

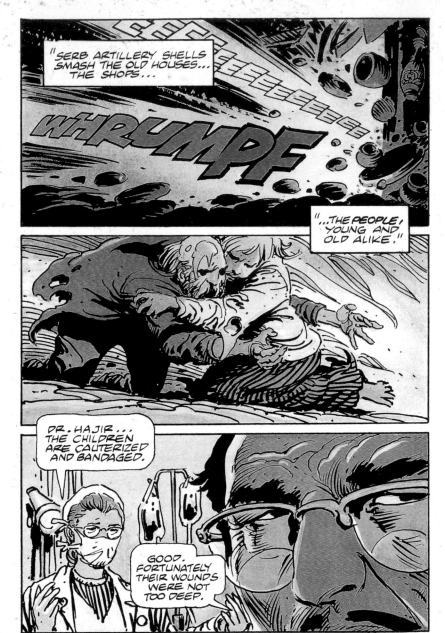

▲
The siege of Sarajevo by Serb forces lasted nearly four years—one of the longest in modern warfare. An estimated 12,000 people lost their lives, with 50,000 injured.

▶
The horrors perpetrated in Bosnia and Sarajevo were fresh in the memory when *Fax from Sarajevo* was published in 1998, the war having ended only two years earlier.

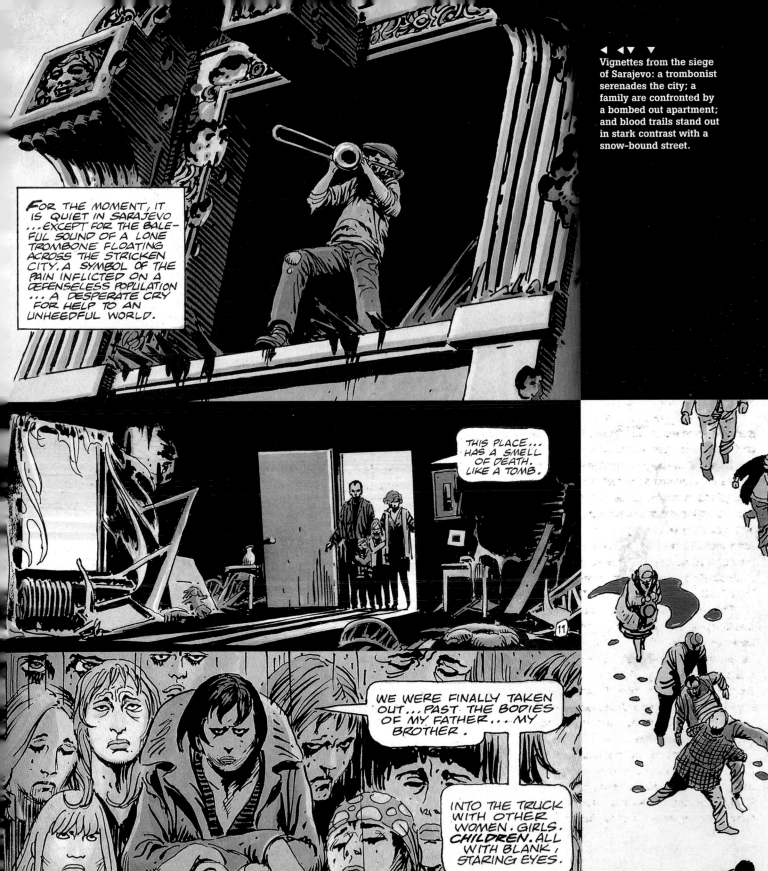

FOR THE MOMENT, IT IS QUIET IN SARAJEVO ... EXCEPT FOR THE BALEFUL SOUND OF A LONE TROMBONE FLOATING ACROSS THE STRICKEN CITY. A SYMBOL OF THE PAIN INFLICTED ON A DEFENSELESS POPULATION ... A DESPERATE CRY FOR HELP TO AN UNHEEDFUL WORLD.

THIS PLACE ... HAS A SMELL OF DEATH. LIKE A TOMB.

WE WERE FINALLY TAKEN OUT ... PAST THE BODIES OF MY FATHER ... MY BROTHER.

INTO THE TRUCK WITH OTHER WOMEN. GIRLS. CHILDREN. ALL WITH BLANK, STARING EYES.

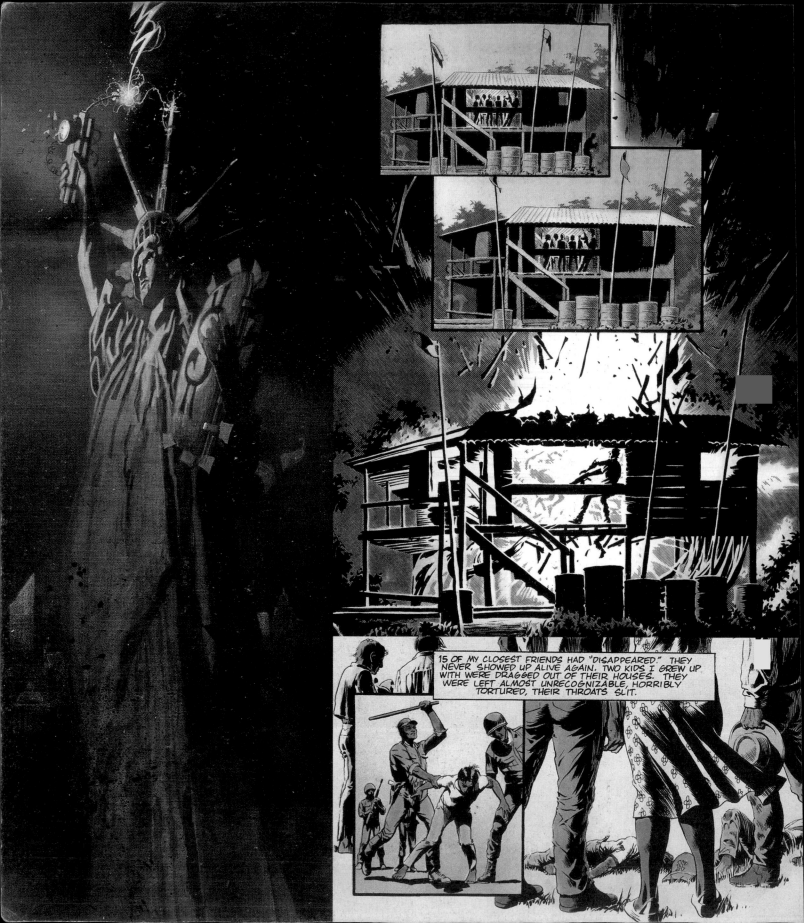

15 OF MY CLOSEST FRIENDS HAD "DISAPPEARED." THEY NEVER SHOWED UP ALIVE AGAIN. TWO KIDS I GREW UP WITH WERE DRAGGED OUT OF THEIR HOUSES. THEY WERE LEFT ALMOST UNRECOGNIZABLE, HORRIBLY TORTURED, THEIR THROATS SLIT.

BROUGHT TO LIGHT AND REAL WAR STORIES

◄

The episode recounted in the *Flashpoint* half of *Brought to Light* is the 1984 press conference convened by Eden Pastora, leader of the peasant army ARDE, which was bombed by an agent believed to be connected to the CIA.

◄◄

This confrontational image opens *Shadowplay*, the Alan Moore/Bill Sienkiewicz half of *Brought to Light*. The Statue of Liberty is drawn holding a primitive explosive device.

►

The organization Citizen Soldier, spotlighted in the second issue of *Real War Stories*, continues to challenge US military actions across the globe, most recently in Iraq.

◄

As detailed in *Real War Stories* #1, the "disappeared" of El Salvador numbered ordinary citizens, often whose only crime was to be in the wrong place at the wrong time, or to not have the correct papers.

Not all war involves thousands of soldiers, hundreds of planes and tanks, and a full media corps reporting on every element of the campaign. Some wars are murky affairs, involving the covert destabilization of another state's government—wars hidden from the public.

The war stories published by Eclipse in the late 1980s were produced in cooperation with organizations attempting to secure improved rights for those serving in the armed forces, and wanting to ensure the US government was transparent and accountable. These were not gung-ho fighting men's comics, but shone a light into gloomy corners some people would prefer remained un-illuminated.

Published in 1989, *Brought to Light*—occasionally referred to as *Eclipse Graphic Novel* #30—was a flipbook. Alan Moore, then reaching the first heights of his popularity with *Watchmen*, wrote *Shadowplay: The Secret Team*, a coruscating polemic detailing the long history of US interference beyond its borders,

REAL WAR STORIES

CITIZEN SOLDIER

propping up the most appalling dictators in the name of preventing the taint of communism. A memorable description notes the blood of people murdered by the forces of US ally Chiang Kai-shek would fill a swimming pool. Bill Sienkiewicz provided suitably spiky art.

The other section, *Flashpoint: The LA Penca Bombing*, was Joyce Brabner and artist Tom Yeates' account of a specific event, an alleged CIA-organized bombing at La Penca aimed at killing a popular Nicaraguan nationalist who wouldn't play ball with that US intelligence agency.

Two years earlier, Brabner had edited the first of the only two issues of *Real War Stories* for Eclipse. It detailed the experiences of peace activists and service people persecuted and jailed for holding onto their beliefs, and the horrors inflicted on the ordinary population of El Salvador to protect US business interests. The US Department of Defense attempted to prevent the distribution of the comic.

The second issue, which followed in 1991, spotlighted the US military's immunity from prosecution for its actions. The families of the significant number of armed forces personnel dying in training through unsafe procedures and plain sadism are entitled to only the most basic information about the deaths of their loved ones. Rectification of life-threatening equipment known to be faulty over a period of years only happens when concerned parties sue the contractors, and bodies of soldiers killed in accidents are further mutilated to provide a more plausible explanation for their deaths. One sailor had to make use of a bucket and rags to mop up a carcinogenic substance for which regulations required protective clothing be issued.

The Christic Institute, heavily referenced for *Brought to Light*, was bankrupted after a failed court case, but Citizen Soldier and the Central Committee For Conscientious Objectors, who cooperated with *Real War Stories*, continue to act in the best interests of US citizens.

FIGHT FOR THE FALKLANDS

On March 19, 1982, Argentinean forces raised their national flag on the British Overseas Territory of South Georgia. After little reaction from Britain, the Argentinean military then invaded the main Falkland Islands on April 2. Three days later the British government dispatched a naval taskforce to the southern ocean. By April 25, South Georgia was back in British hands and on June 14, the Argentine forces in the Falklands surrendered to the British. Over 900 lives had been lost during the fighting.

The British comics history of the Falklands War is unusual in having been told in three different fashions—in a documentary style comic strip, in factual features, and in a fictional adventure strip.

The factual strip, *Fight for the Falklands*, written by John Wagner and illustrated by Jim Watson, began in IPC's *Battle*, dated September 18, 1982, and ran until March 19, 1983. It charted the main events of the conflict with land battles tending to overshadow naval and aerial clashes. Wagner did not shy away from the military losses, detailing the attack on the British troop ships RFAs Sir Tristram and Sir Galahad, and the still controversial sinking of the Argentinean cruiser ARA General Belgrano. Watson's gritty art style complemented the messy conditions of the South Atlantic, while Wagner's script maintained a fairly even-handed approach to the conflict, only rarely straying into heavily pro-British rhetoric.

Rather than creating a comic strip about the Falklands, DC Thomson's *Warlord* ran a full two-page center spread of art surrounded by text and several black and white photos. *The Falklands File* ran for 20 weeks beginning in issue #427, dated November 27, 1982. This mixture of art and photographs in factual military features had been a component of *Warlord*'s formula since its first issue in 1974, and it covered different aspects of the conflict from the battles to the equipment used.

Battle would return to the Falklands from January 24 to August 29, 1987, with a story entitled *Invasion!* written by the comic's editor Terry Magee and illustrated once again by Jim Watson. *Invasion!* detailed the fictional adventures of East Falkland schoolboy Tommy Baker as he harassed the occupying Argentinean troops after the invasion had occurred. His subsequent imprisonment by the Argentineans allowed the British fleet to reach the islands and he escaped during a British bombing raid to help the British forces against the invaders.

Other books on the subject include British author Raymond Briggs' graphic novel cum "children's" book, *The Tin-Pot Foreign General and the Old Iron Woman*—a savage satire on a pointless war, where the only victims were the soldiers. Writers B. Asso and J. Rideau and artists Daniel Chauvin and M. Uderzo produced *Biggles Recounts: The Falklands War*, a nicely illustrated, but simplistic, 48-page documentary graphic novel. US comics documenting the Falklands conflict are even rarer, but Antarctic Press did publish *Duel* in 2006, a series of stories about air battles by creator Ted Nomura; issue #2 focused on the jet dogfights of the South Atlantic in 1982.

▶
Although largely factual, *The Falklands File* in *Warlord* adopted a decidedly flag-waving stance. This was unsurprising, however; the feature began a matter of months after the end of hostilities, and the conflict had proved particularly popular with the British.

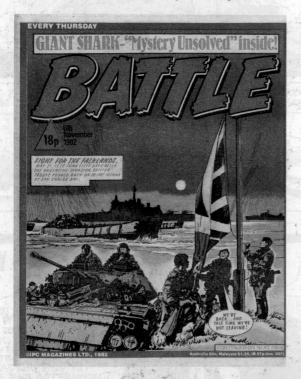

◀
The November 6, 1982 cover of *Battle* showed the moment the main British force landed on the Falklands on May 22 of that year, raising the Union Jack in triumph.

▶
There were, of course, no real schoolboy helpers assisting the British soldiers in the Falklands Conlict. But in *Invasion!*, published in *Battle* in 1987, writer Terry Magee tells a compelling tale of what many readers of the comic would have imagined themselves doing if they had been on the Islands in the dark days of 1982.

TED RALL, GARY TRUDEAU, AND THE TALIBAN

The subject of war hasn't only been the preserve of comic books; many newspaper strips have dealt with sensitive political conflagrations around the globe, most notably Gary Trudeau's long-running strip, *Doonesbury*. Started in 1970, *Doonesbury* followed the trials and tribulations of two college roommates, Mike Doonesbury and "BD." Always with a strong political message, Trudeau railed against the Vietnam War with witty, ironic humor, and in 2004 turned the spotlight on America's war in Iraq.

Having joined the army BD is sent to Iraq and—after almost 34 years—readers finally saw his head without some sort of helmet, on April 21, 2004. That same strip revealed that he'd lost a leg, later exclaiming "Son of a bitch!!!" which caused the strip to be dropped by several newspapers. BD later appeared on the cover of *Rolling Stone* #954 with his amputated leg. While deeply opposed to the wars, Trudeau has always supported the troops by listing the names of soldiers killed in Iraq in five strips between 2004-2007. The website *Doonesbury. com* regularly lists dispatches written by real troops fighting in Iraq, and the strip continues to feature anonymous soldiers in the front line.

In 2005, *The Long Road Home* traced BD's recovery after losing his leg, with a foreword by Presidential candidate Senator John McCain. Ten years earlier, McCain had denounced Trudeau over a strip attacking Bob Dole's exploitation of his war record, stating, "Suffice it to say that I hold Trudeau in utter contempt." But by 2005, McCain and Trudeau had made peace. Proceeds from *The Long Road Home* and its sequel, *The War Within*, go to the Fisher House charity—where families of injured soldiers can stay nearby while they recover.

Because of his association with the military wounded, Trudeau has been given numerous awards, including the Commander's Award for Public Service by the Department of Army, the Commander's Award from Disabled American Veterans, and the President's Award for Excellence in the Arts from Vietnam Veterans of America. Trudeau's most recent collection—a parody about Afghanistan and America's foreign policies—was *Tee Time in Berzerkistan*, released in 2009. The Pulitzer Prize-winning *Doonesbury* is now syndicated in around 1,400 newspapers worldwide, and continues to be politically challenging.

Another cartoonist who is no stranger to controversy is Ted Rall. In 1991 Rall's cartooning career took off and in 1995 he was awarded the Robert F. Kennedy Journalism Award for Cartoons. A year later he was one of three finalists for the Pulitzer Prize, and in 1998 he created color strips for *Time* and *Fortune* magazines. He created his graphic novel *Search and Destroy* in 2001.

Shortly after the 9/11 attacks, Rall drew a strip entitled *Terror Widows* that accused the bereaved of jumping on the chat-show bandwagon to talk about their grief. He was universally condemned for his

▲
The moment in *Doonesbury* when it's revealed BD has lost a leg. Trudeau holds back the full realization of BD's plight until the final panel.

▶
The *Doonesbury* collection *The Long Road Home* is subtitled *One Step at a Time*, as BD accustomizes to life as an amputee.

▶
In an effort to better understand the war in Afghanistan, Ted Rall traveled there in 2001 and soon discovered that the news reports coming out of the country were not always entirely accurate.

▶▶
The situation in Afghanistan in 2001 was messy and confused. Episodes like the violent mix-up shown here by Rall were commonplace.

▶▶▲
In just four panels, Ted Rall neatly sums up how many Americans feel about the futility of the "war on terror."

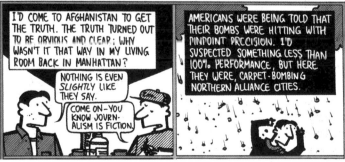

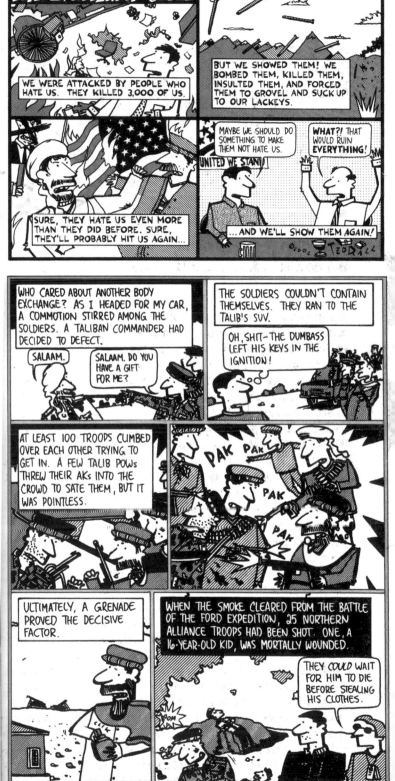

biting satire, confirming his belief that "America was becoming repressive, paranoid, and vicious."

In 2001 Rall "escaped" to Afghanistan to report on the war for KFI Radio and Village Voice. His harrowing experiences were collected in the 2002 book *To Afghanistan and Back*, a mixture of reportage, photography, graphic novel, and cartoons, revealing the insanity and bleakness of a messy, confused war.

COVER GALLERY

The late 1940s and 1950s are widely regarded as the zenith for US war comics, and in particular war comic book covers. Gathered together over the next few pages are a selection of some of the best examples from that era—covers that pack an artistic punch; that live long in the memory; that tell us something about the danger, the horror, the excitement, or the terror of warfare.

▶
Lee Elias,
True War Experiences #4
(Harvey, 1954)

▶▶
Artist unknown,
War Battles #5
(Harvey, 1952)

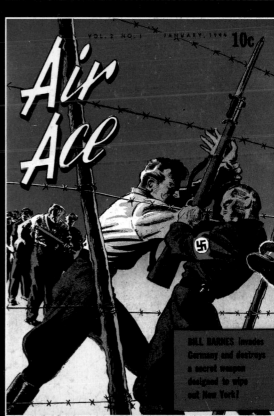

▶
Lee Elias,
Fighting Fronts! #1
(Harvey, 1952)

▶
L. B. Cole,
The Horrors of War #12
(Star, 1953)

▶▶
Jack Kirby,
Foxhole #1
(Mainline, 1954)

▶
Wally Wood,
Frontline Combat #15
(EC, 1954)

▶▶
Reed Crandall,
G.I. Combat #1
(Quality, 1952)

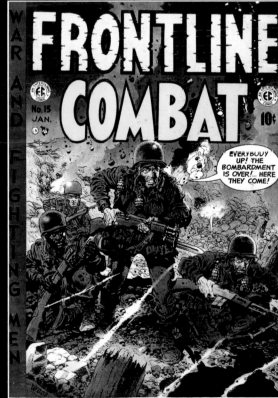

Everett Raymond Kinstler,
U.S. Tank Commandos #1
(Avon, 1952)

▶

Artist unknown,
This is War #5
(Standard, 1952)

▶▶

Curt Swan,
Star Spangled War Stories
#131 (DC, 1952)

▶

Artist unknown,
Never Again #1
(Charlton, 1955)

▶▶

Harvey Kurtzman,
Two-Fisted Annual #1
(EC, 1952)

Joe Maneely,
War #45
(Atlas, 1957)

Sol Brodsky,
War Adventures #1
(Atlas, 1952)

▶▶
Bob Jenny,
War Stories #7
(Dell, 1943)

▶
Don Heck,
War Fury #4
(Comic Media, 1953)

▶▶
Artist unknown,
Yanks in Battle #4
(Quality, 1956)

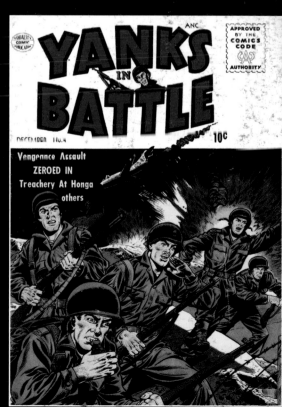

ART CREDITS

Every effort has been made to credit the artists and/or publishers and copyright holders whose work has been reproduced in this book. We apologize for any omissions, which will be corrected in future editions, but hereby must disclaim any liability.

KEY:
T Top
B Bottom
L Left
R Right
C Center
BG Background

2 Charlie Adlard, *White Death*,
 © 2002 Rob Morrison & Charlie Adlard
3 F. H. Townsend, *Well Done, the New Army!*, *Punch* magazine
4TL Herb Trimpe & Bob McLeod, *G.I. Joe* #1,
 © 1982 Marvel Comics/Hasbro
4TC Joe Kubert, *Showcase* #58,
 © 1965 DC Comics
4TR Artist unknown, *Warfront* #22,
 © 1954 Harvey Comics
4CL Jacen Burrows, *303* #2, Avatar
 © 2004 Garth Ennis & Jacen Burrows
4CR Joe Certa, *Warfront* #16,
 © 1953 Harvey Comics
4B Giorgio Di Gaspari, *Air Ace Picture Library: Eagle Warrior*, © IPC Media
6-7 Garth Ennis & Russ Braun, *Battlefields: The Night Witches* #1, Dynamite, ©
 2008 Spitfire Productions Ltd.
8 Everett Raymond Kinstler, *With the U.S. Paratroops Behind Enemy Lines* #4,
 Avon Publications, © HarperCollins
9 Artist unknown, *How Boys and Girls Can Help Win the War* #1,
 © 1942 Parents' Magazine
10 Harry Anderson, *U.S.A. is Ready!* #1,
 © 1941 Dell Comics
13L Maurice Whitman, *Fight Comics* #82,
 © 1952 Fiction House
13C L. B. Cole, *Captain Flight Comics* #7,
 © 1945 Four Star
13R Everett Raymond Kinstler, *With the U.S. Paratroops Behind Enemy Lines*
 #4, Avon Publications, © HarperCollins
14 L. B. Cole, *Eagle Comics* #1,
 © 1945 Rural Home
15 Artist unknown, *Battle Picture Weekly*,
 IPC, © Egmont

CHAPTER 1
16 Enrique Alcatena, *Spike: Midshipman Coward*, © DC Thomson
17 Artist unknown, *Pirates Comics* #1,
 © 1950 Hillman Periodicals
18 John Severin & Will Elder, *Two Fisted Tales* #21: *Pigs of the Roman Empire*,
 © 1951 EC Comics/Gaines Estate
19TL Eric Shanower, *Age of Bronze: Sacrifice*,
 Image Comics, © 2004 Eric Shanower
19TR Frank Miller, *300*, Dark Horse Comics,
 © 1998, 1999, 2006 Frank Miller Inc.
19B Frank Miller, *300*, Dark Horse Comics,
 © 1998, 1999, 2006 Frank Miller Inc.
20 Wally Wood, *Two Fisted Tales* #22,
 Massacre at Agincourt!,
 ©1951 EC Comics/Gaines Estate
21 Warren Ellis & Raulo Caceres,
 Crécy, Avatar © 2007 Warren Ellis
22TL Reed Crandal, *Buccaneers* #27,
 © 1951 Quality
22TR Will Eisner, *Hawks of the Seas*,
 Kitchen Sink © Will Eisner
22B Jack Kirby, *The Black Buccaneer*,
 © Lincoln Newspaper Syndicate
23 Steve Epting, *El Cazador*,
 © 2003 Crossgeneration Comics
23BG Reed Crandall, *Piracy* #2,
 © 1955 EC Comics/Gaines Estate
24 Eric Parker, *Swift: Max Bravo*,
 The Happy Hussar © Look and Learn
24BG John Bolton, *Amazing High Adventure*
 #4, © 1986 Marvel Comics
25 Enrique Alcatena, *Spike: Midshipman Coward*, © 1980 DC Thomson
26T Harvey Kurtzman, *Two Fisted Tales* #25,
 © 1952 EC Comics/Gaines Estate
26BL John Severin, *Two Fisted Tales* #37,
 © 1954 EC Comics/Gaines Estate
26BC John Severin, *Two Fisted Tales* #38,
 © 1954 EC Comics/Gaines Estate
26BR Wally Wood, *Frontline Combat* #13,
 © 1953 EC Comics/Gaines Estate

CHAPTER 2
28 Everett Raymond Kinstler, *Kit Carson* #1,
 Avon Publications, © HarperCollins
29 Everett Raymond Kinstler, *Fighting Daniel Boone* #1, © I. W. Publications
30BG Milo Manara, *Indian Summer*,
 © 1983 Hugo Pratt & Milo Manara
31 Gene Fawcette, *Custer's Last Fight*,
 Avon Publications, © HarperCollins
31TL Artist unknown, *Fighting Indians of the Wild West!* #1, Avon,
 © HarperCollins
31TR Artist unknown, *Famous Indian Tribes* #2, © 1972 Dell Comics

31B Jack Jackson, *Commanche Moon*,
 © 1979 Jack Jackson
32L Gary Hallgren, Willy Murphy,
 Ted Richards & Gilbert Shelton,
 Give Me Liberty!, © 1976 the authors
32R Fred Ray, *Star Spangled Comics* #116,
 © 1951 DC Comics
32BG John Severin & Will Elder, *Two-Fisted Tales* #29, © EC Comics/Gaines Estate
33TL Wally Wood, *Two Fisted Tales* #28,
 © 1952 EC Comics/Gaines Estate
33TR John Severin, *Two Fisted Tales* #29,
 © 1952 EC Comics/Gaines Estate
33BR Ogden Whitney, *Herbie* #8, ACG,
 © Roger Broughton
34L Neal Adams, *Tomahawk* #126,
 © 1970 DC Comics
34TR Bob Brown, *Tomahawk* #90,
 © 1964 DC Comics
34BR Edmond Good, *Star Spangled Comics*
 #69, © 1947 DC COmics
35 Scott Chantler, *Northwest Passage*,
 Oni Press, © 2005 Scott Chantler
36 Lou Cameron, *Classics Illustrated*
 #129, © 1955 Classics Illustrated
37 Artist unknown, *Davy Crockett: Frontier Fighter* #3,
 © 1955 Charlton Comics
38 Jack Davis, *Two Fisted Tales* #35,
 © 1953 EC Comics/Gaines Estate
39 Artist Unknown, *Classics Illustrated*
 #98, © 1952 Classics Illustrated
40 Leonardo Manco, *Apache Skies*,
 © 2002 Marvel Comics
41L Joe Maneely, *Two-Gun Kid* #17,
 © 1954 Marvel Comics
41R Artist unkown, *The Lone Ranger*,
 © 1948 Dell Comics
42T Everett Raymond Kinstler, *Kit Carson*
 #1, Avon Publications,
 © HarperCollins
42B Jesus Blasco, *Cowboy Comics: Kit Carson and the Cheyenne War*,
 © 1961 IPC Media
43L Nicholas Alascia, *Billy the Kid* #34,
 © 1956 Charlton
43TR Artist unknown, *Cowboy Western* #53
 © 1955 Charlton
43BR Artist unknown, *Cowboy Western* #53
 © 1955 Charlton

CHAPTER 3
44BG Charlie Adlard, *White Death*,
 © 2002 Rob Morrison & Charlie Adlard
45 Artist unknown, *Victor* #116,
 © 1963 DC Thomson
46 Edmond J. Sullivan, *The Kaiser's Garland*, © 1915, W. Heinemann

139TR Artist unknown, *Atom-Age Combat #2*, © 1952 St. John

139BL Raymond Briggs, *When the Wind Blows*, Penguin, © 1982 Raymond Briggs

139BR Raymond Briggs, *When the Wind Blows*, Penguin, © 1982 Raymond Briggs

140L Michael Golden, *Savage Tales: The 5th to the 1st*, © 1985 Marvel Comics

140TR Michael Golden, *The 'Nam #1*, © 1986 Marvel Comics

140BR Michael Golden, *The 'Nam #5*, © 1986 Marvel Comics

141 Michael Golden, *Savage Tales #1*, © 1985 Marvel Comics

142 Don Lomax, *Vietnam Journal #10*, © 1987 Don Lomax

143 Don Lomax, *Vietnam Journal #11*, © 1987 Don Lomax

144BL Carl Pfeufer, *Super Green Beret #1*, © 1967 Lightning Comics

144TR Sam Glanzman, *Tales of the Green Beret #3*, © 1967 Dell Comics

144CR Sam Glanzman, *Tales of the Green Beret #4*, © 1967 Dell Comics

144BR Joe Kubert, *Tales of the Green Beret* © Chicago Tribune Syndicate

145 Carl Pfeufer, *Super Green Beret #1*, © 1967 Lightning Comics

146TL Foolbert Sturgeon, *Jesus Meets the Armed Services*, © 1972 Foolbert Sturgeon

146BL Greg Irons & Tom Veitch, *The Legion of Charles*, © 1971 Greg Irons & Tom Veitch

146R Foolbert Sturgeon, *Jesus Meets the Armed Services*, © 1972 Foolbert Sturgeon

148 Frank Franzetta, *Blazing Combat #2*, © 1966 Warren Magazines

149TL Frank Franzetta, *Blazing Combat #3*, © 1966 Warren Magazines

149CL Frank Franzetta, *Blazing Combat #4*, © 1966 Warren Magazines

149BL Frank Franzetta, *Blazing Combat #1*, © 1965 Warren Magazines

149TC Joe Orlando, *Blazing Combat #1*, © 1965 Warren Magazines

149BC Joe Orlando, *Blazing Combat #2*, © 1966 Warren Magazines

149RT Gene Colan, *Blazing Combat #4*, © 1966 Warren Magazines

149RB Joe Orlando, *Blazing Combat #3*, © 1966 Warren Magazines

CHAPTER 7

150BG Joe Sacco, *The Fixer: A Story from Sarajevo*, Drawn & Quarterly, © 2003 Joe Sacco

151 Joe Kubert, *Fax from Sarajevo*, Dark Horse Comics, © 1998 Joe Kubert

152BGT Paul Chadwick, *9-11 Artists Respond*, © Paul Chadwick

152BGB Henrik Rehr, *Tribeca Sunset*, IBooks, © 2005 Henrik Rehr

153T Henrik Rehr, *Tribeca Sunset*, IBooks, © 2005 Henrik Rehr

153BL Alex Ross, *9-11 Volume 2*, © 2002 DC Comics

153BC Eric Drooker, *9-11 Volume 1*, © 2002 DC Comics/Eric Drooker

153BR Will Eisner, *9-11: Emergency Relief*, © 2002 Will Eisner

154 David Axe & Steve Olexa, *War Fix*, ComicsLit, © 2006 David Axe & Steve Olexa

155 Joe Sacco, *Palestine*, Fantagraphics, © Joe Sacco

156 Rutu Modan, *Exit Wounds*, Drawn & Quarterly, © 2007 Rutu Modan

157 Rutu Modan, *Exit Wounds*, Drawn & Quarterly, © 2007 Rutu Modan

158T/B Artist unknown, *Hotspur Annual* 1981, © 1981 DC Thomson

159L Jacen Burrows, *303 #3*, Avatar, © 2004 Garth Ennis & Jacen Burrows

159TR Garth Ennis & Jacen Burrows, *303 #1*, Avatar, © 2004 Garth Ennis & Jacen Burrows

159BR Garth Ennis & Jacen Burrows, *303 #2*, Avatar, © 2004 Garth Ennis & Jacen Burrows

160L Esad Ribic, *Combat Zone: True Tales of G.I.s in Iraq*, © 2005 Marvel Comics

160R Dan Jurgens, *Combat Zone: True Tales of G.I.s in Iraq*, © 2005 Marvel Comics

161 Dan Jurgens, *Combat Zone: True Tales of G.I.s in Iraq*, © 2005 Marvel Comics

162 Brian K. Vaughan & Niko Henrichon, *Pride of Baghdad*, Vertigo, © 2006 Brian K. Vaughan & Nico Henrichon

163 Brian K. Vaughan & Niko Henrichon, *Pride of Baghdad*, Vertigo, © 2006 Brian K. Vaughan & Nico Henrichon

164L Garth Ennis & John McCrea, *Troubled Souls*, © 1990 Fleetway/Garth Ennis/ John McCrea

164TR Garth Ennis & John McCrea, *Troubled Souls*, © 1990 Fleetway/Garth Ennis/ John McCrea

164BR Garth Ennis and John McCrea, *Dicks*, Caliber, © 1997 Garth Ennis & John McCrea

165 Garth Ennis & John McCrea, *Troubled Souls*, © 1990 Fleetway/Garth Ennis/ John McCrea

166 Joe Sacco, *The Fixer: A Story from Sarajevo*, Drawn & Quarterly, © 2003 Joe Sacco

167 Joe Sacco, *Safe Area Goražde: The War in Eastern Bosnia 1992-1995*, Fantagrpahics Books, © 2002 Joe Sacco

168 Joe Kubert, *Fax from Sarajevo*, Dark Horse Comics, © 1998 Joe Kubert

169 Joe Kubert, *Fax from Sarajevo*, Dark Horse Comics, © 1998 Joe Kubert

170L Alan Moore & Bill Sienkiewicz, *Brought to Light: Shadowplay: The Secret Team*, Eclipse Comics, © 1989 Alan Moore & Bill Sienkiewicz

170TR Tom Yeats, *Brought to Light: Flashpoint: The LA Penca Bombing*, Eclipse Comics, © 1989 Joyce Brabner & Tom Yeates

170BR Tom Yeates, *Real War Stories #1*, © 1987 Eclipse Comics

171 Tom Yeates, *Real War Stories #2*, © 1987 Eclipse Comics

172 Jim Watson, *Battle*, © 1982 Egmont

173T Artist unknown, *Warlord #427: The Falklands File*, © 1982 DC Thomson

173B Jim Watson, *Battle: Invasion*, © 1987 Egmont

174 Gary Trudeau, *Doonesbury: The Long Road Home*, © 2005 G. B. Trudeau

175TL Gary Trudeau, *Doonesbury: The Long Road Home*, © 2005 G. B. Trudeau

175BL Ted Rall, *To Afghanistan and Back*, © 2002 Ted Rall

175TR Ted Rall, *To Afghanistan and Back*, © 2002 Ted Rall

175BR Ted Rall, *To Afghanistan and Back*, © 2002 Ted Rall

176 © 1954 Harvey Comics

177 © 1952 Harvey Comics

178 © 1954 Marvel Comics

179TL © 1945 Dell Comics

179TR © 1952 Stanmor

179BL © 1953 Standard

179BR © 1944 Street & Smith

180 © 1952 Harvey Comics

181TL © 1953 Star Comics

181TR © 1954 Mainline

181BL © 1954 EC Comics/Gaines Estate

181BR © 1952 Quality Comics

182 © 1952 Avon/HarperCollins

183TL © 1952 Standard

183TR © 1952 DC Comics

183BL © 1955 Charlton Comics

183BR © 1952 EC Comics/Gaines Estate

184 © 1957 Marvel Comics

184TL © 1952 Marvel Comics

184TR © 1943 Dell Comics

184BL © 1953 Comic Media

184BR © 1956 Quality Comics

INDEX

ACKNOWLEDGMENTS

This one's for my nan—who introduced me to the joys of reading while I was still a toddler—and to my cousin Alan, who expanded my literary horizons, but it's also for everyone who has touched my life down the decades and made me the person I am today.

This book wouldn't have been nearly as good without the contributions of Jeremy Briggs, Richard Burton, Brian M. Clarke, Steve Holland, Nick Jones, Tim Pilcher, Steve White, and Frank Plowright, who I must single out for the assistance he gave in helping me shape the book's final form. There's also Will Morgan, who, along with others working behind the scenes, helped plug visual gaps.

I'm also grateful to Garth Ennis for his foreword, to all the comics creators who have kept me entertained for more years than I care to remember, to Tim Pilcher for being mad enough to suggest I write this book, and to my editor, Nick Jones, who had the patience to put up with me!